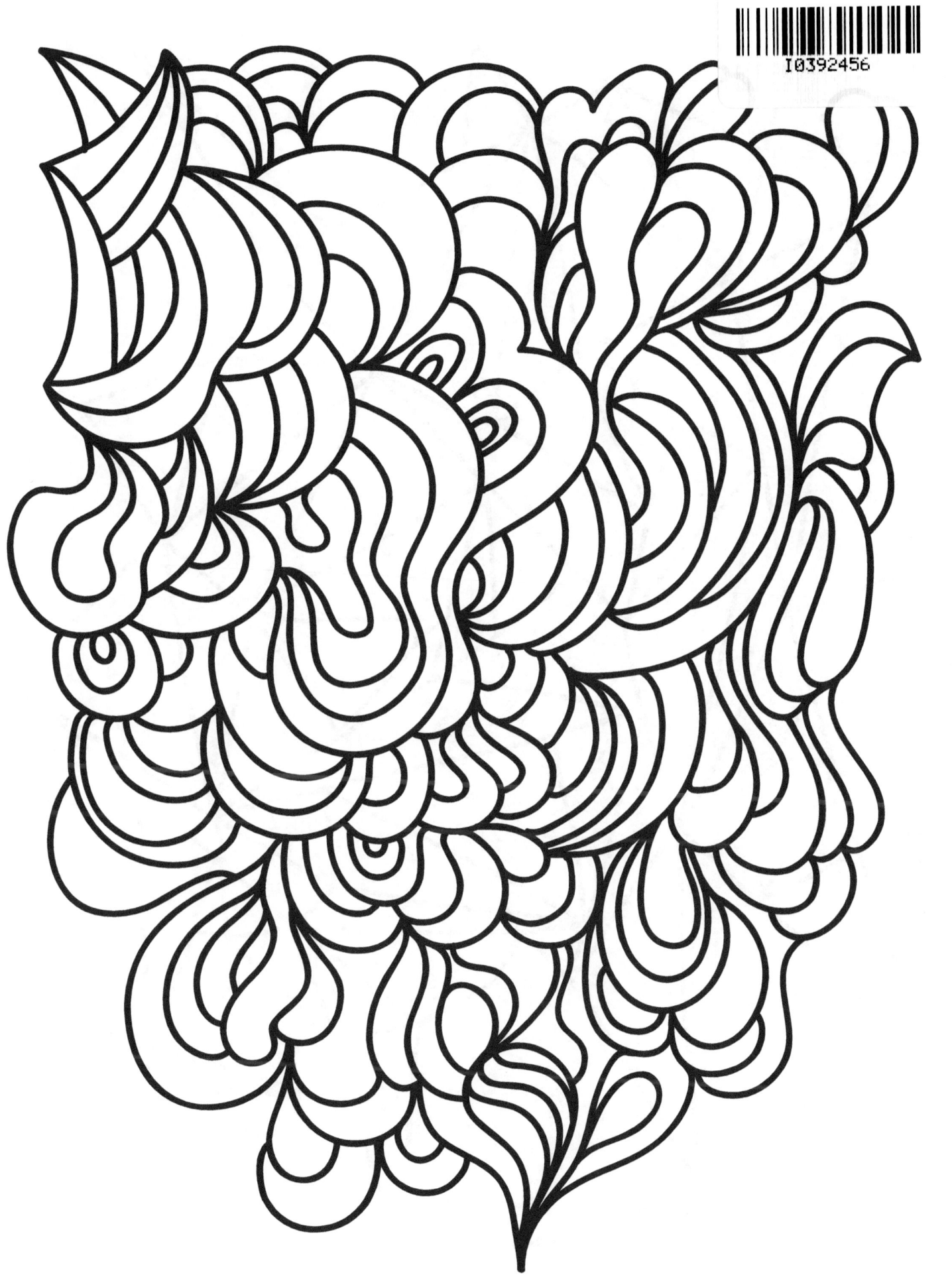

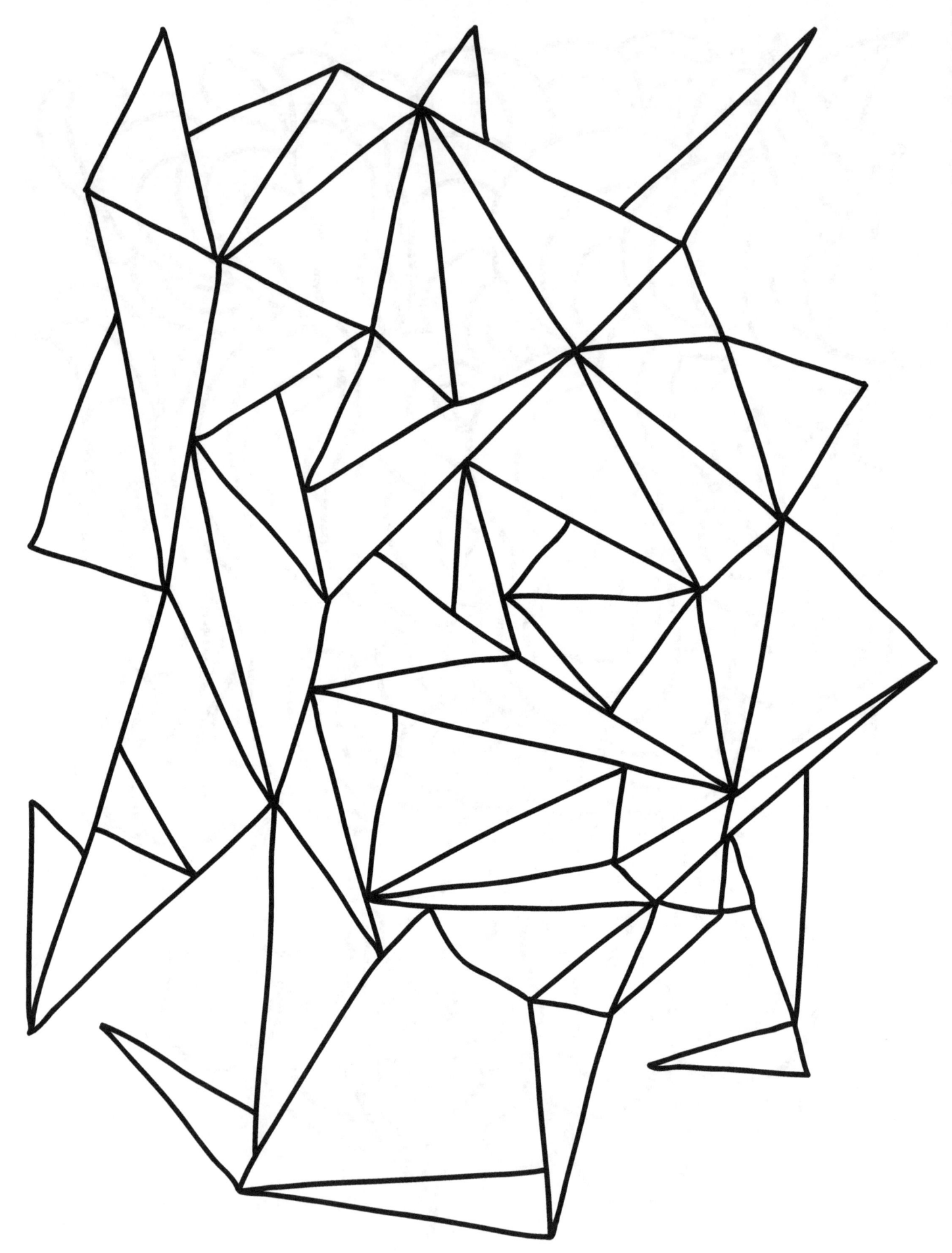

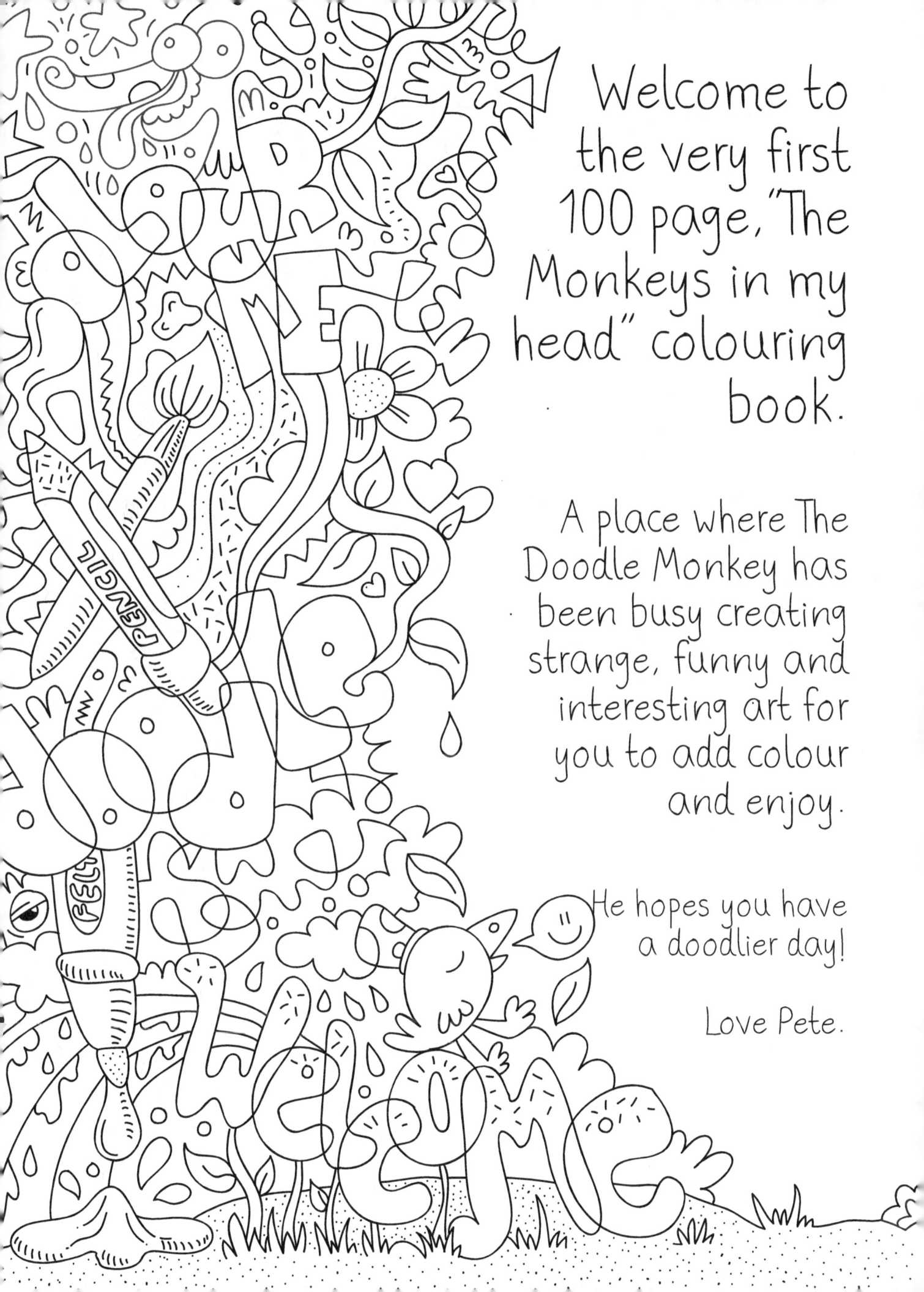

Welcome to the very first 100 page, "The Monkeys in my head" colouring book.

A place where The Doodle Monkey has been busy creating strange, funny and interesting art for you to add colour and enjoy.

He hopes you have a doodlier day!

Love Pete.

LEGAL GUBBINS

Copyright © 2016-2019 Peter Jarvis (The Doodle Monkey)

The moral right of the author has been asserted. Apart from any fair dealing for the purposes of research or private study, or criticism or review, as permitted under the Copyright, Designs and Patents Act 1988, this publication may only be reproduced, stored or transmitted, in any form or by any means, with the prior permission in writing of publisher, or in the case of reprographic reproduction in accordance with the terms of licences issued by the Copyright Licensing Agency. Enquiries concerning reproduction outside those terms should be sent to publisher.

Peter Jarvis - The Doodle Monkey
Email: doodles@thedoodlemonkey.com
Web: www.thedoodlemonkey.com

ISBN-13: 978-1536918120
ISBN-10: 1536918121

Designed and illustrated by: Peter Jarvis (The Doodle Monkey)

PLEASE DON'T STEAL!

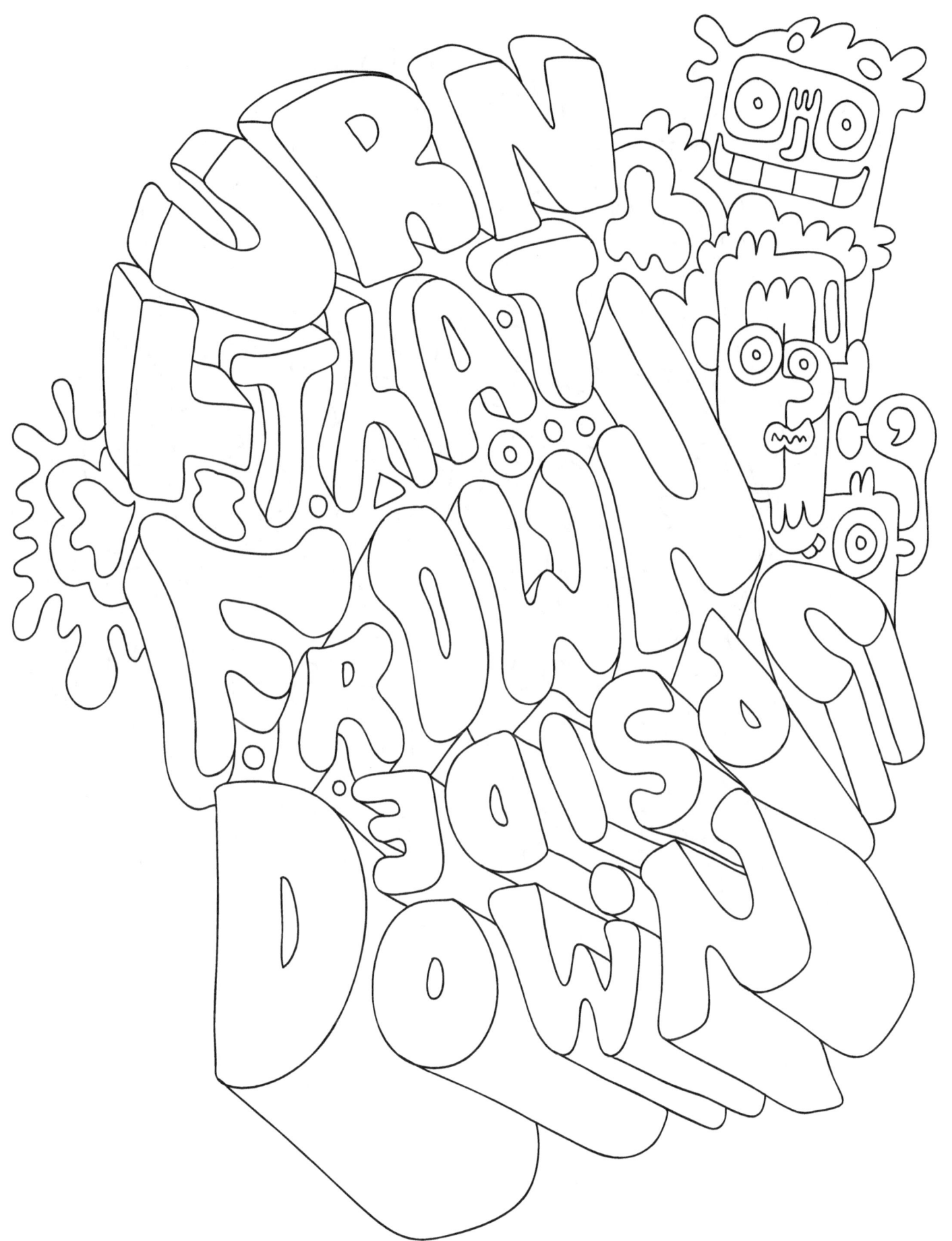

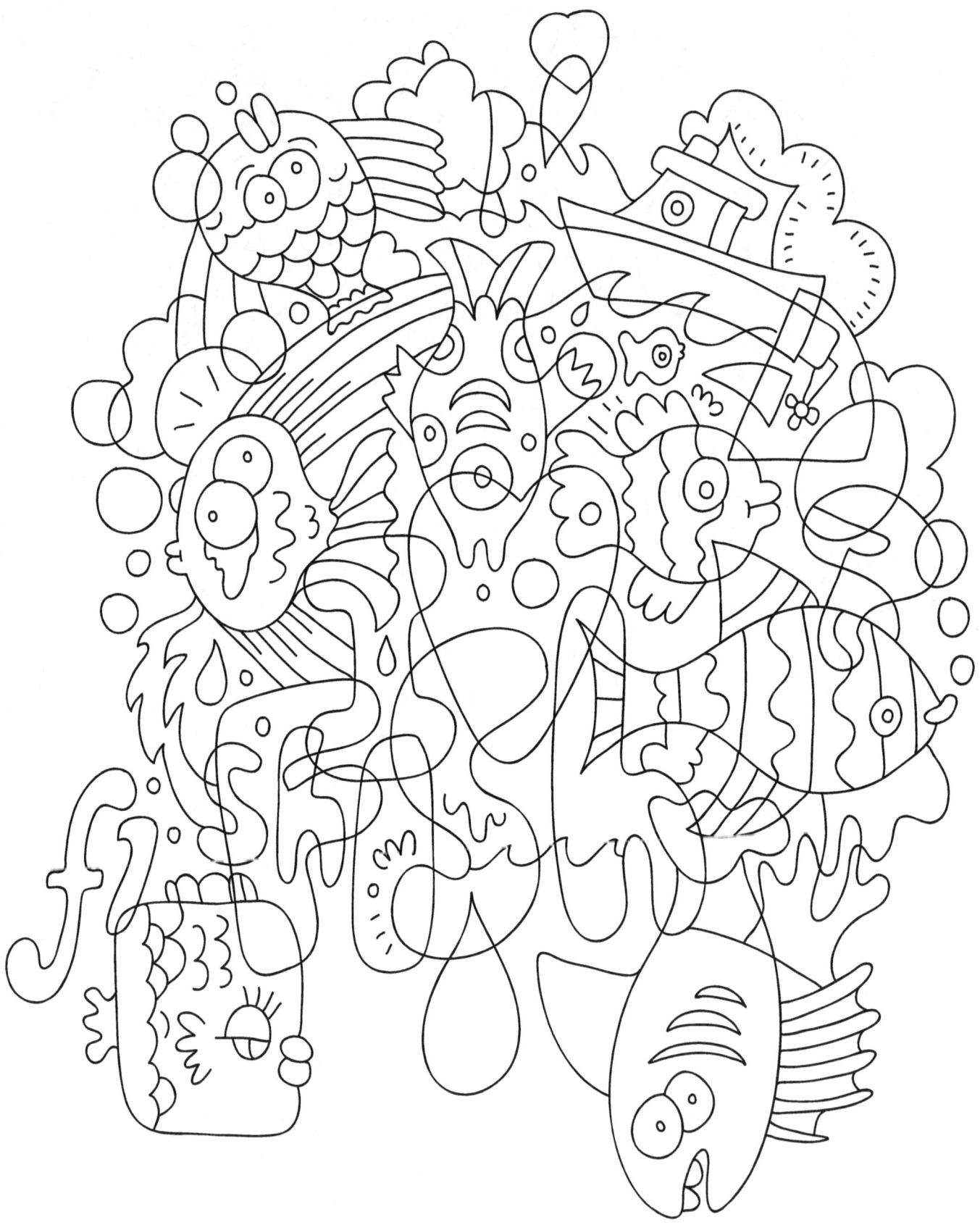

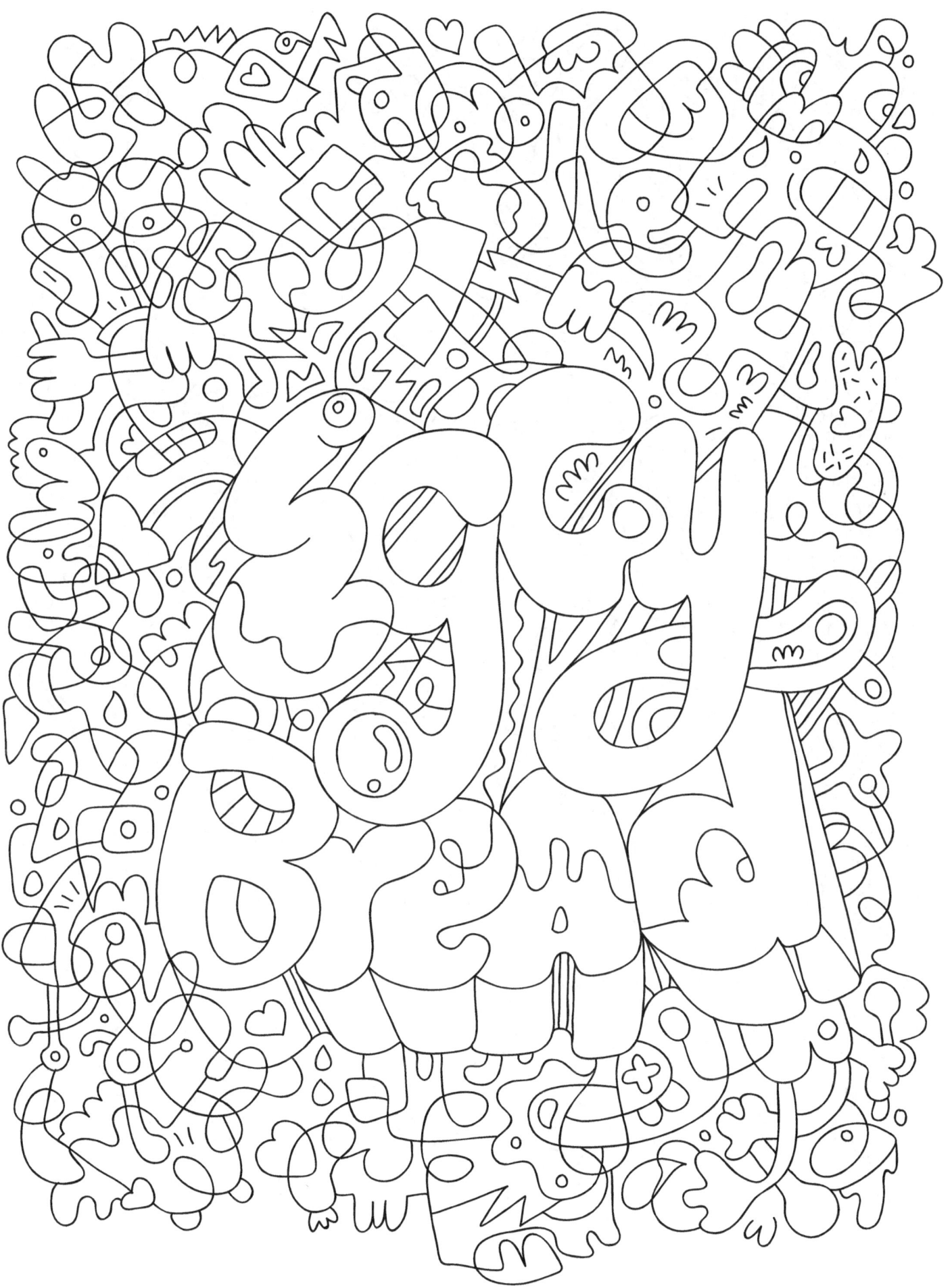

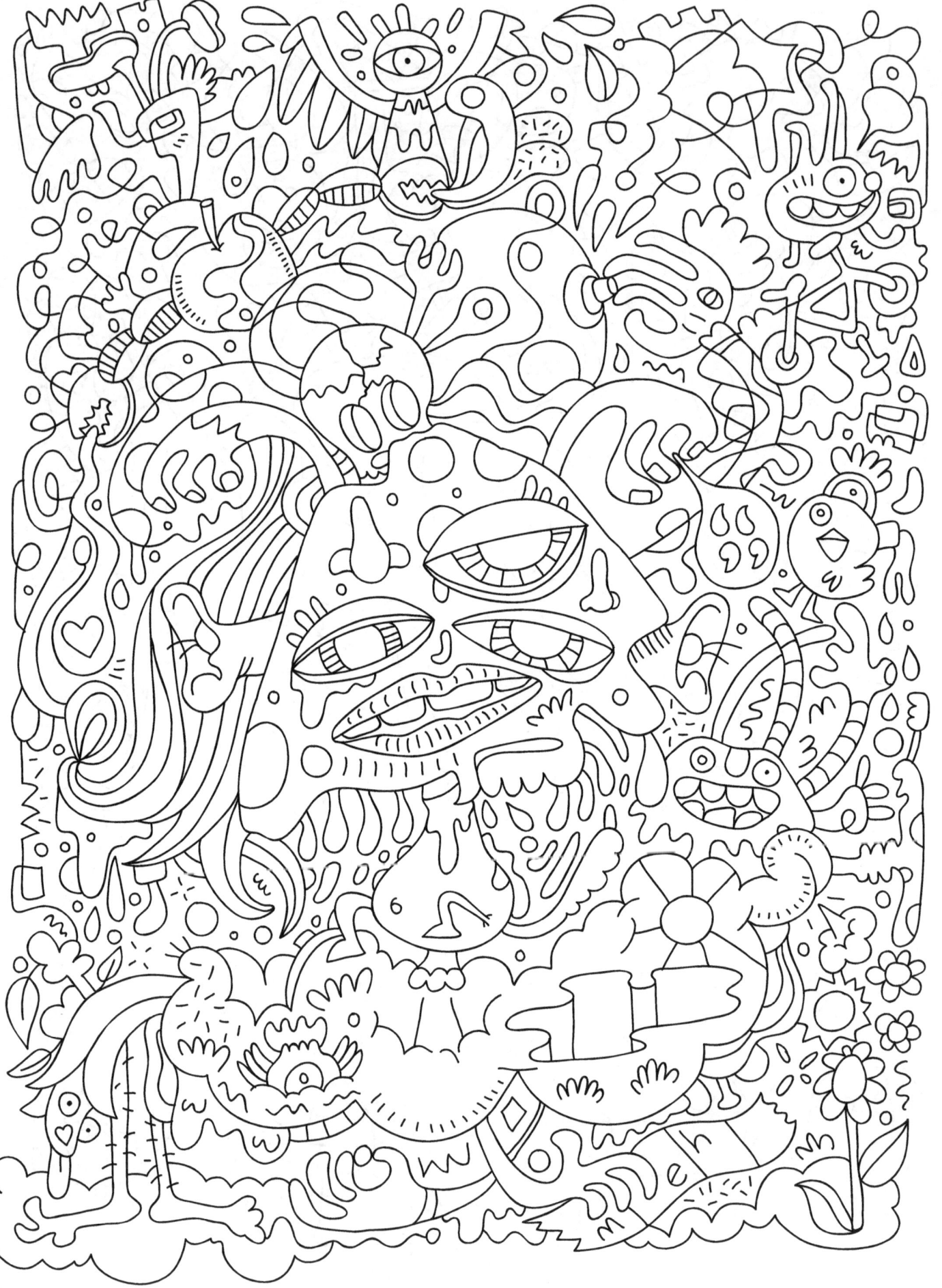

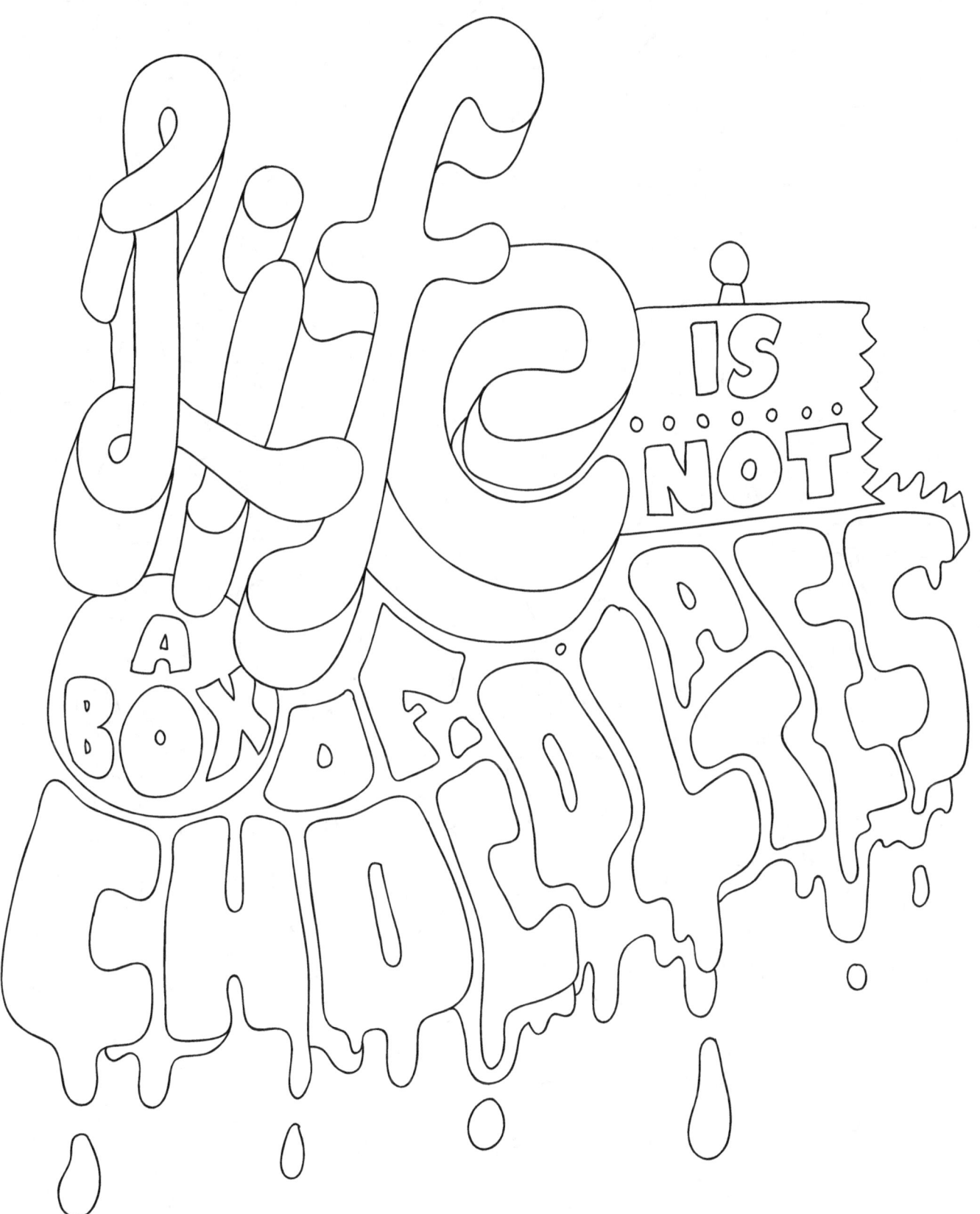

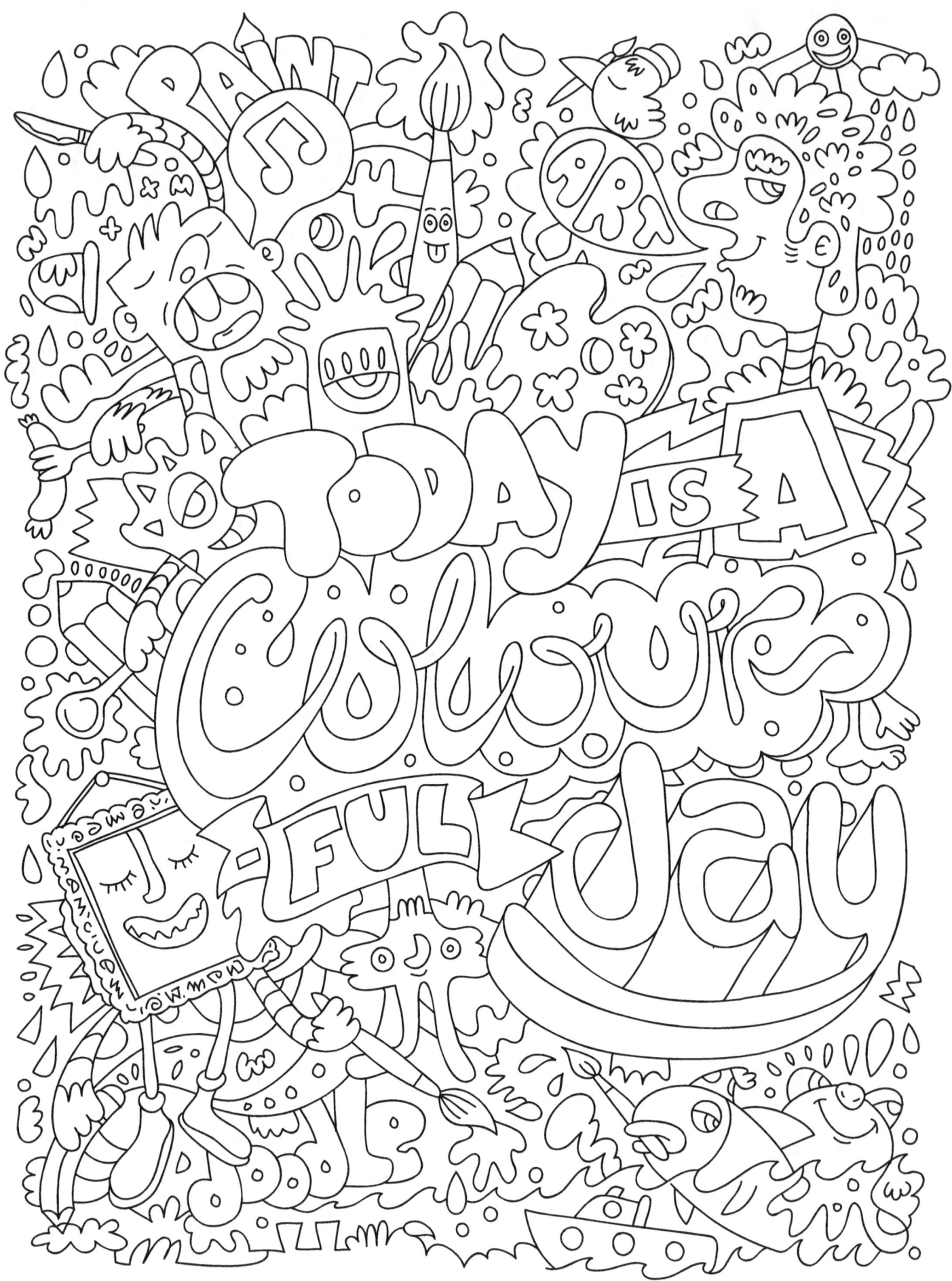

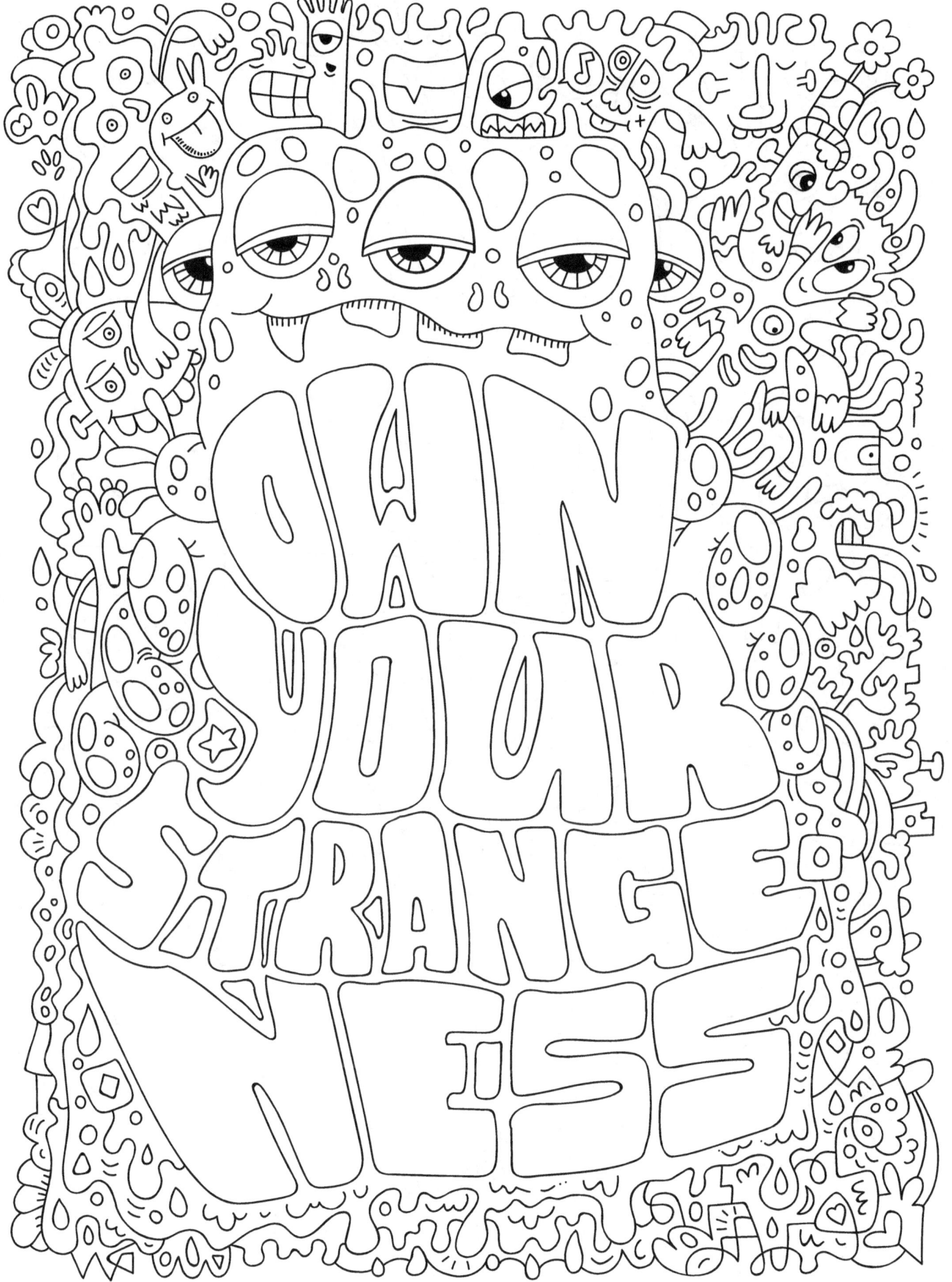

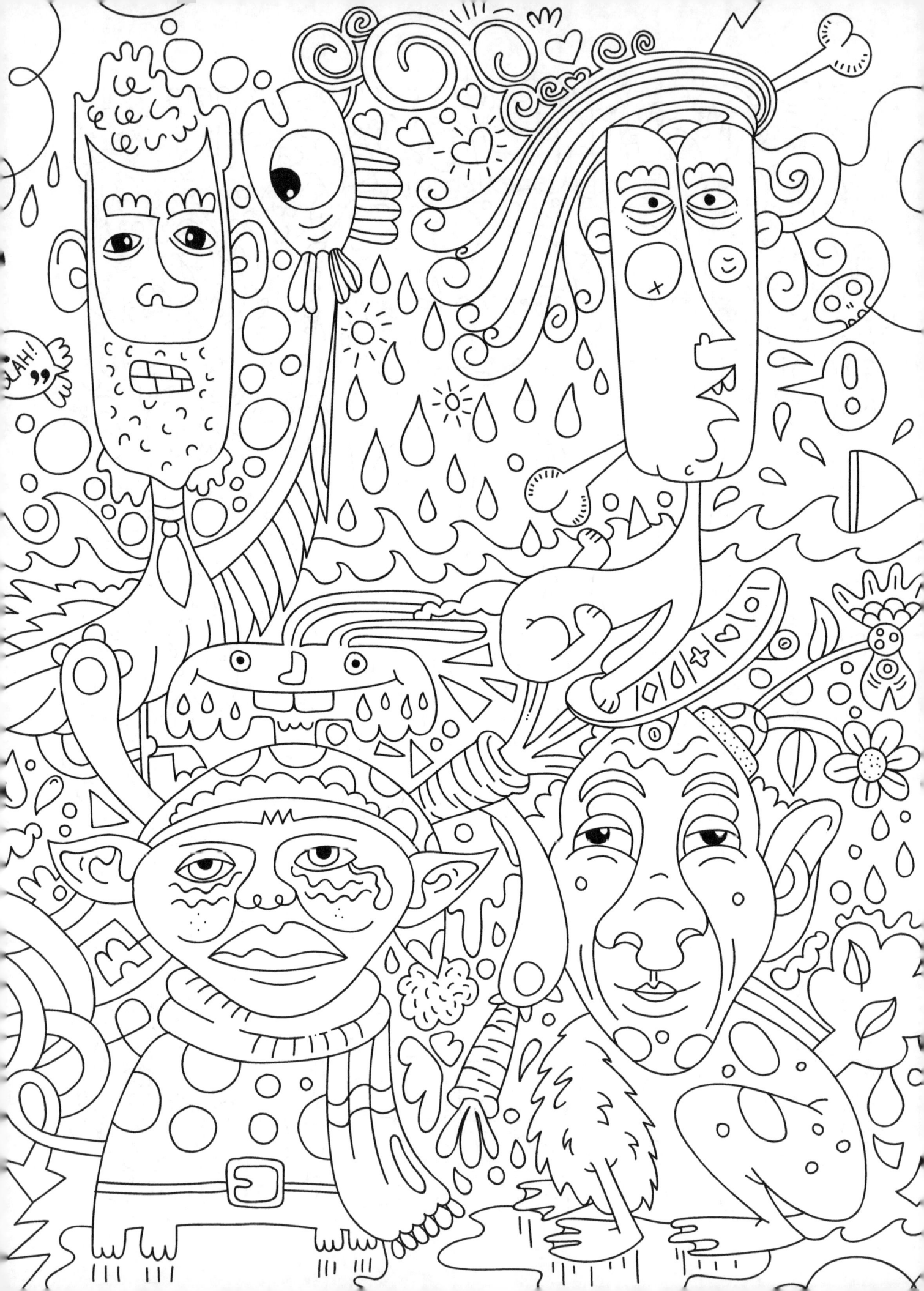

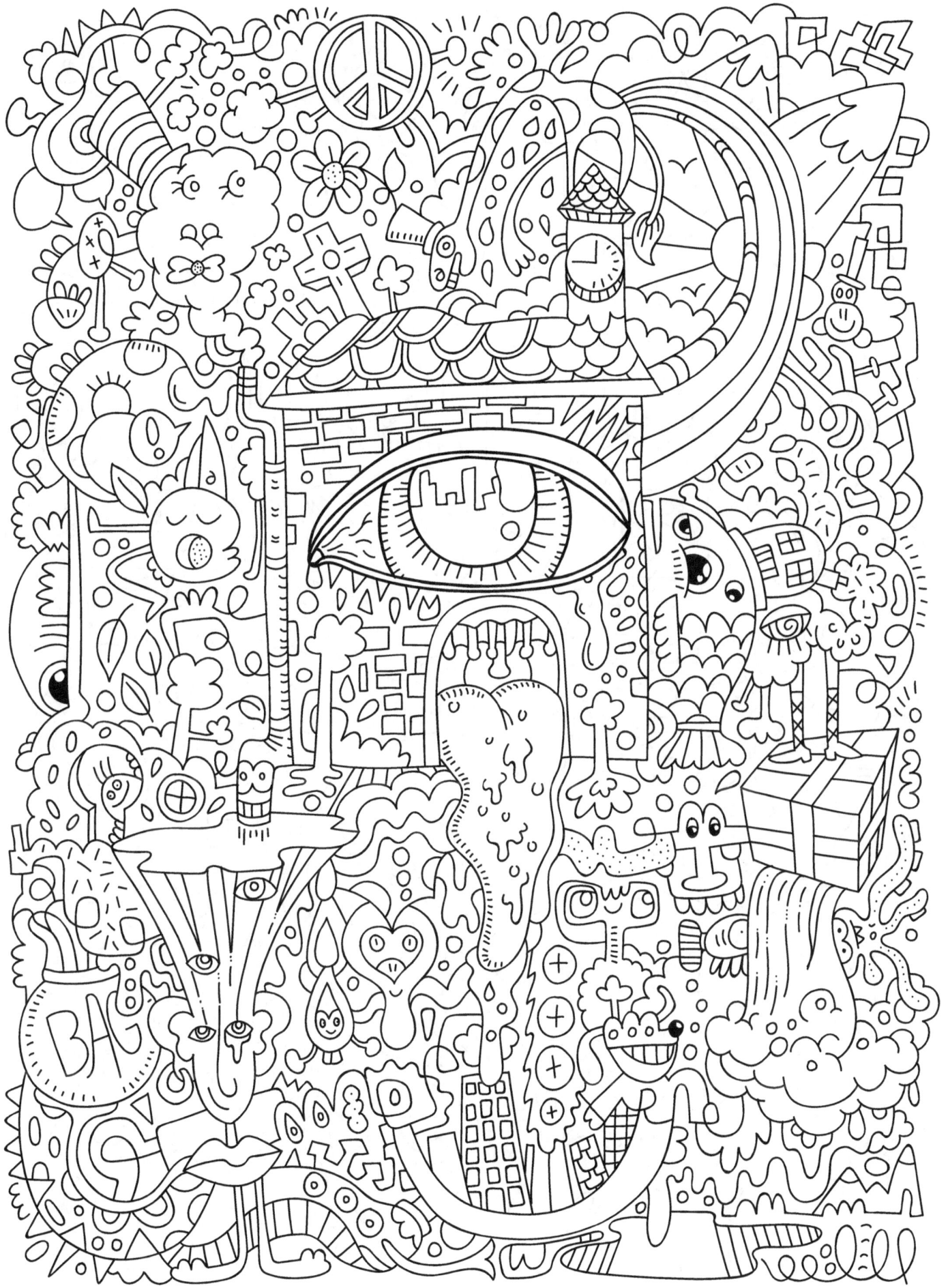

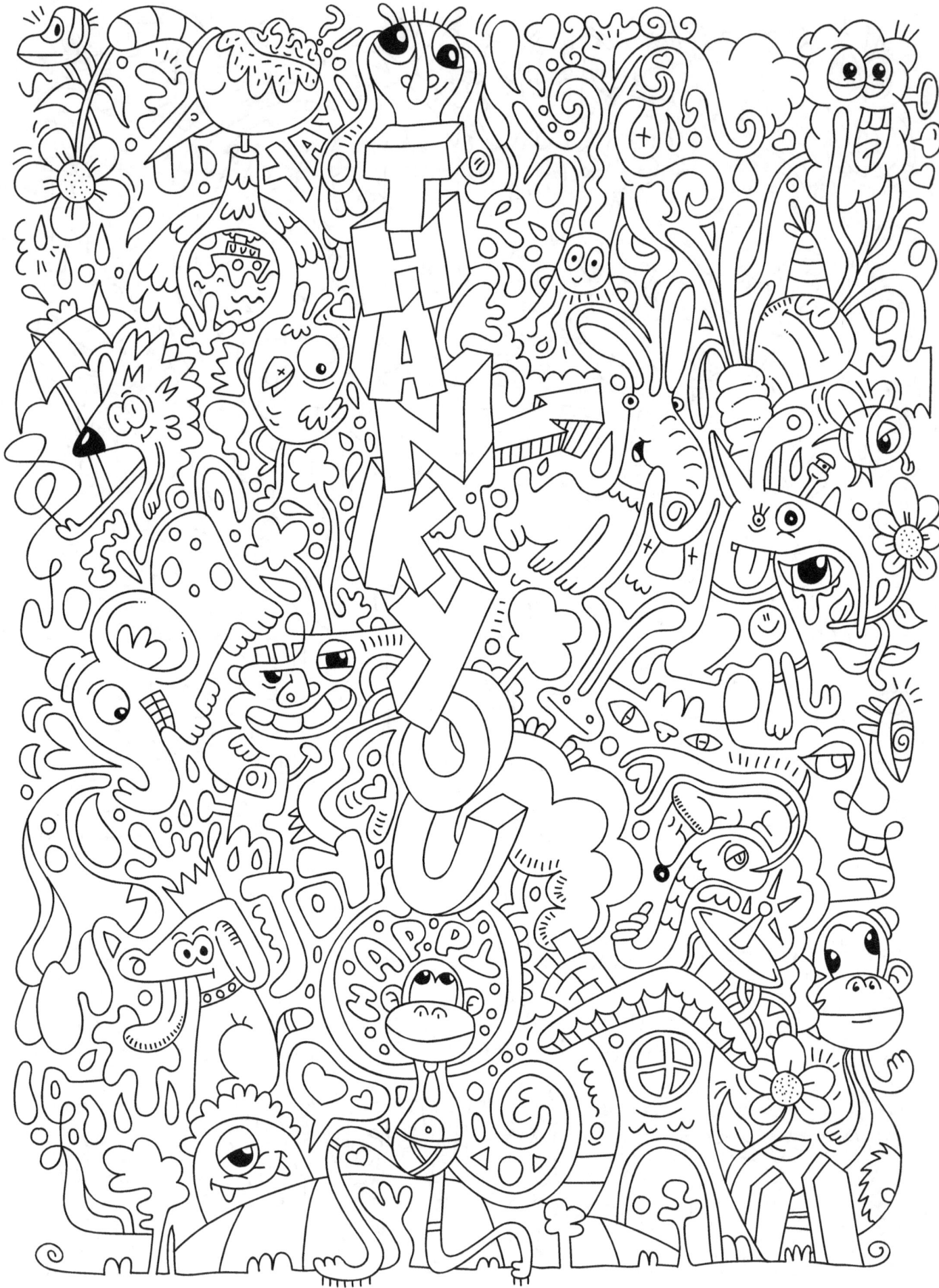

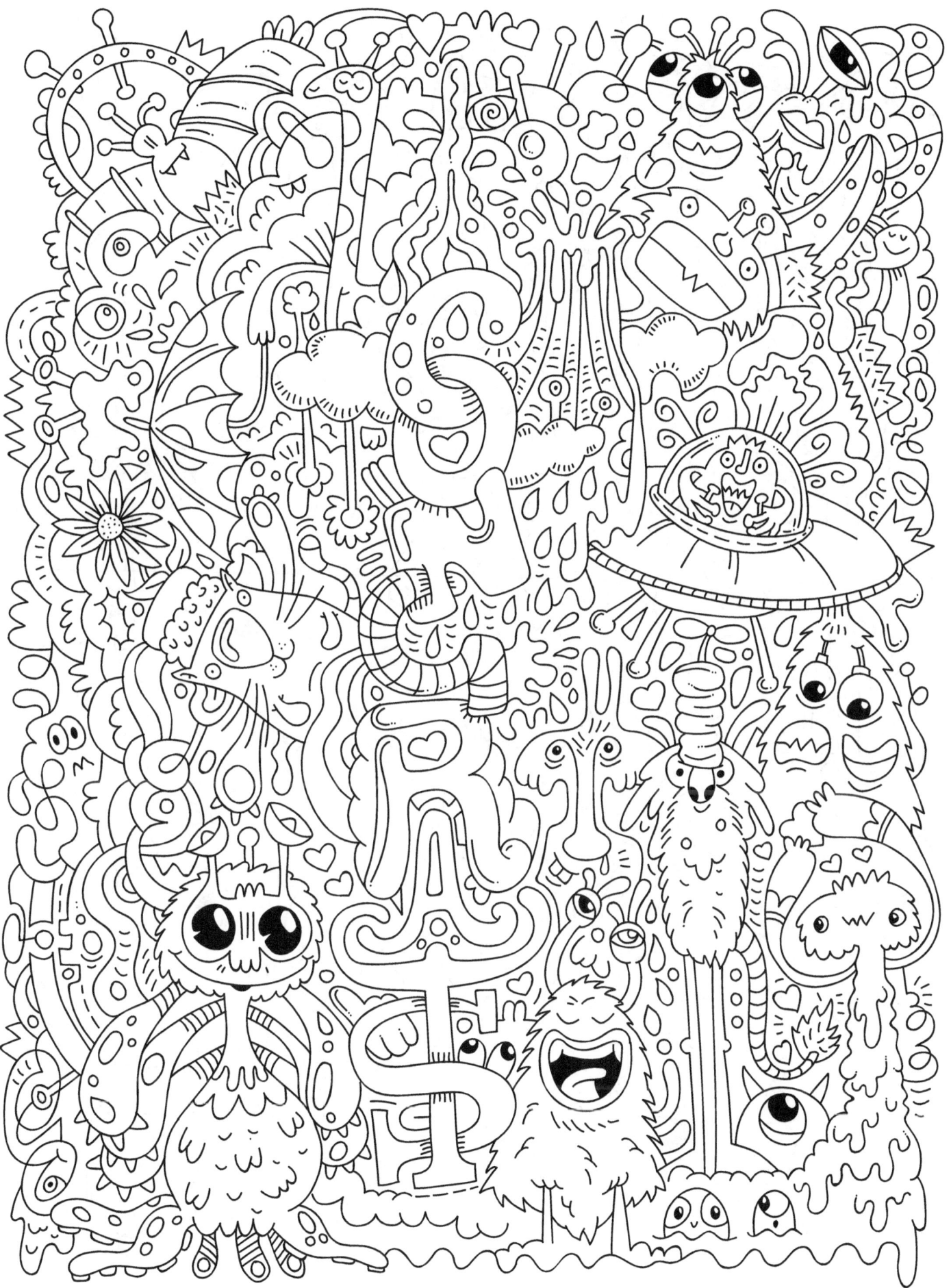

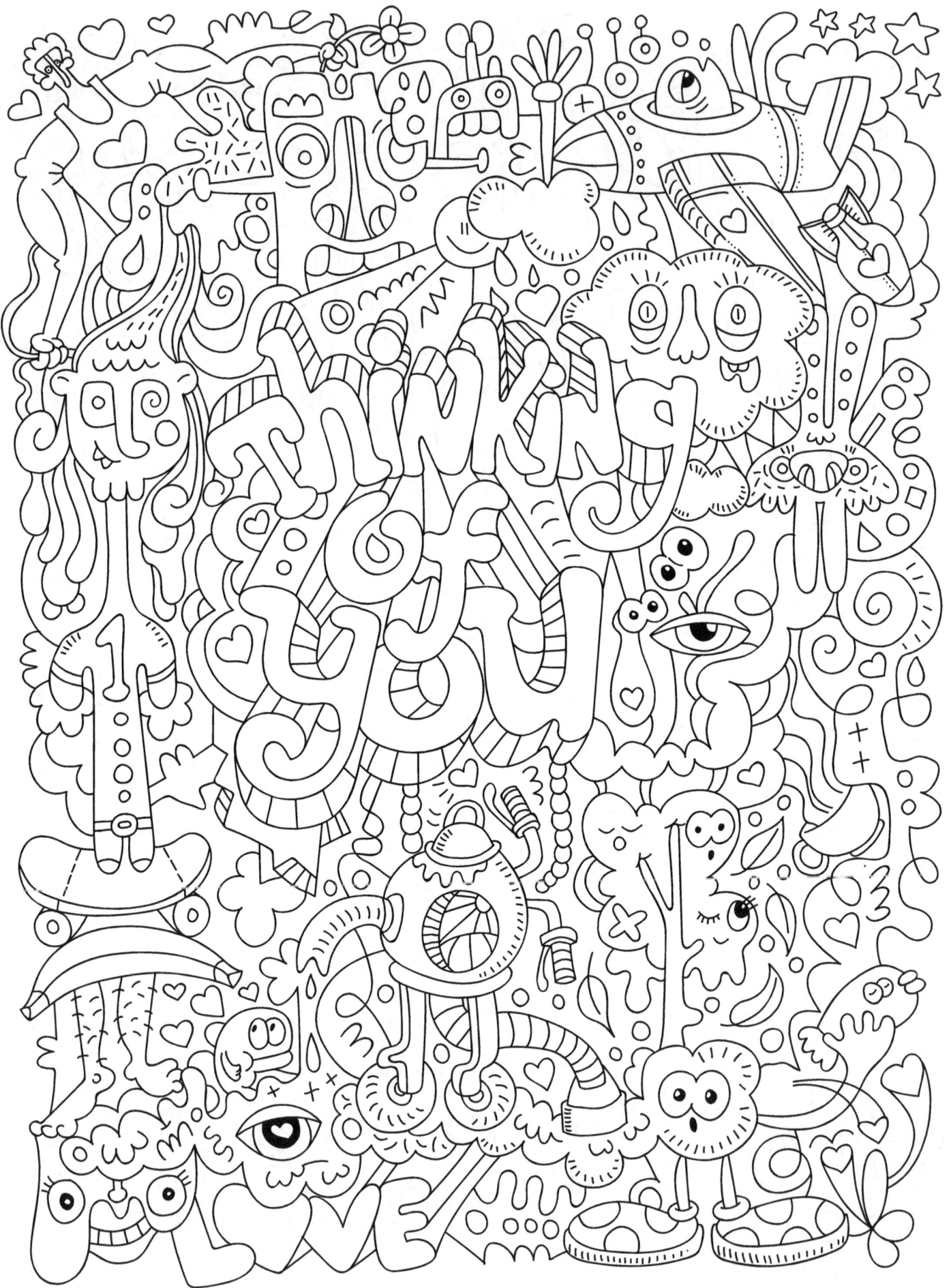

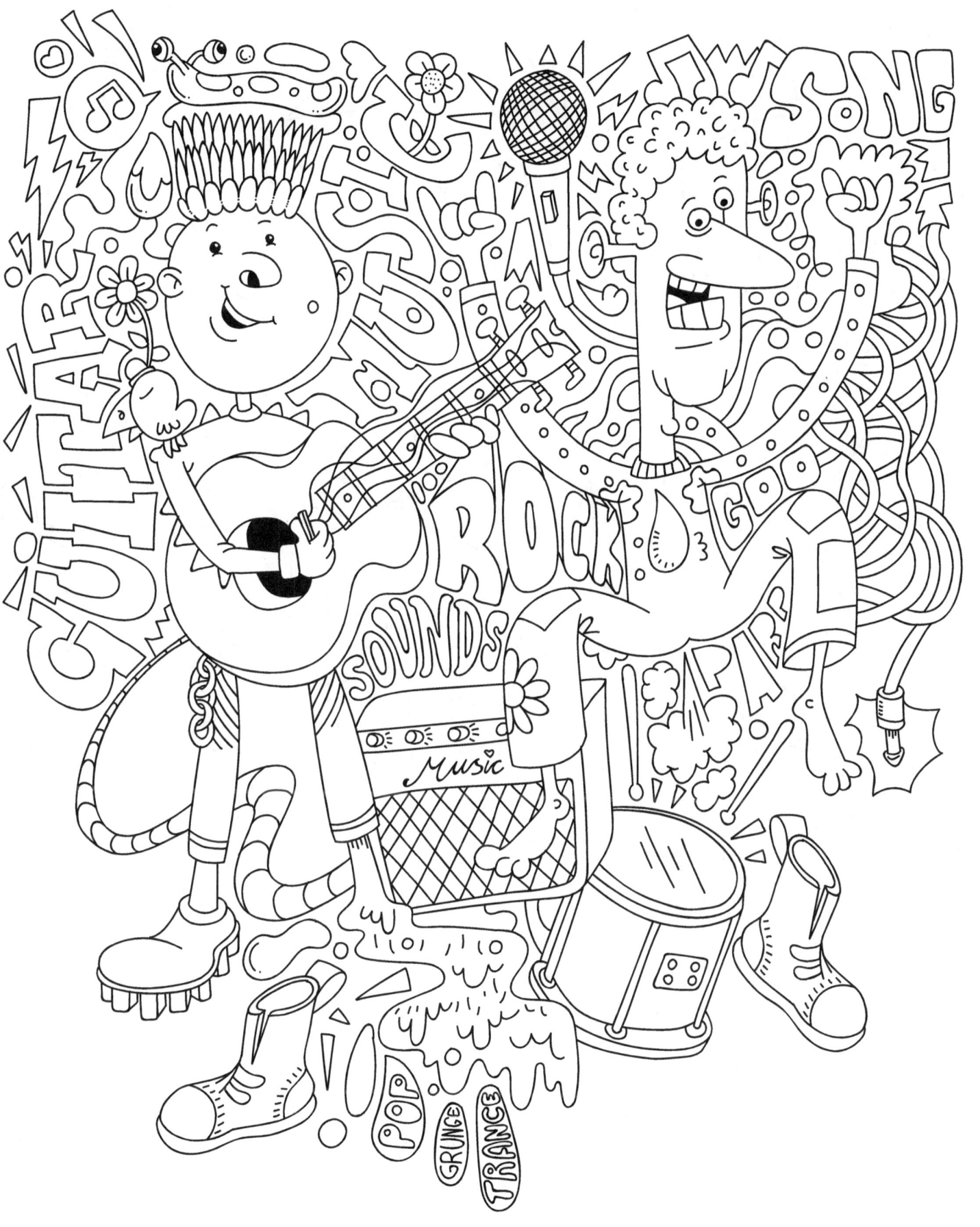

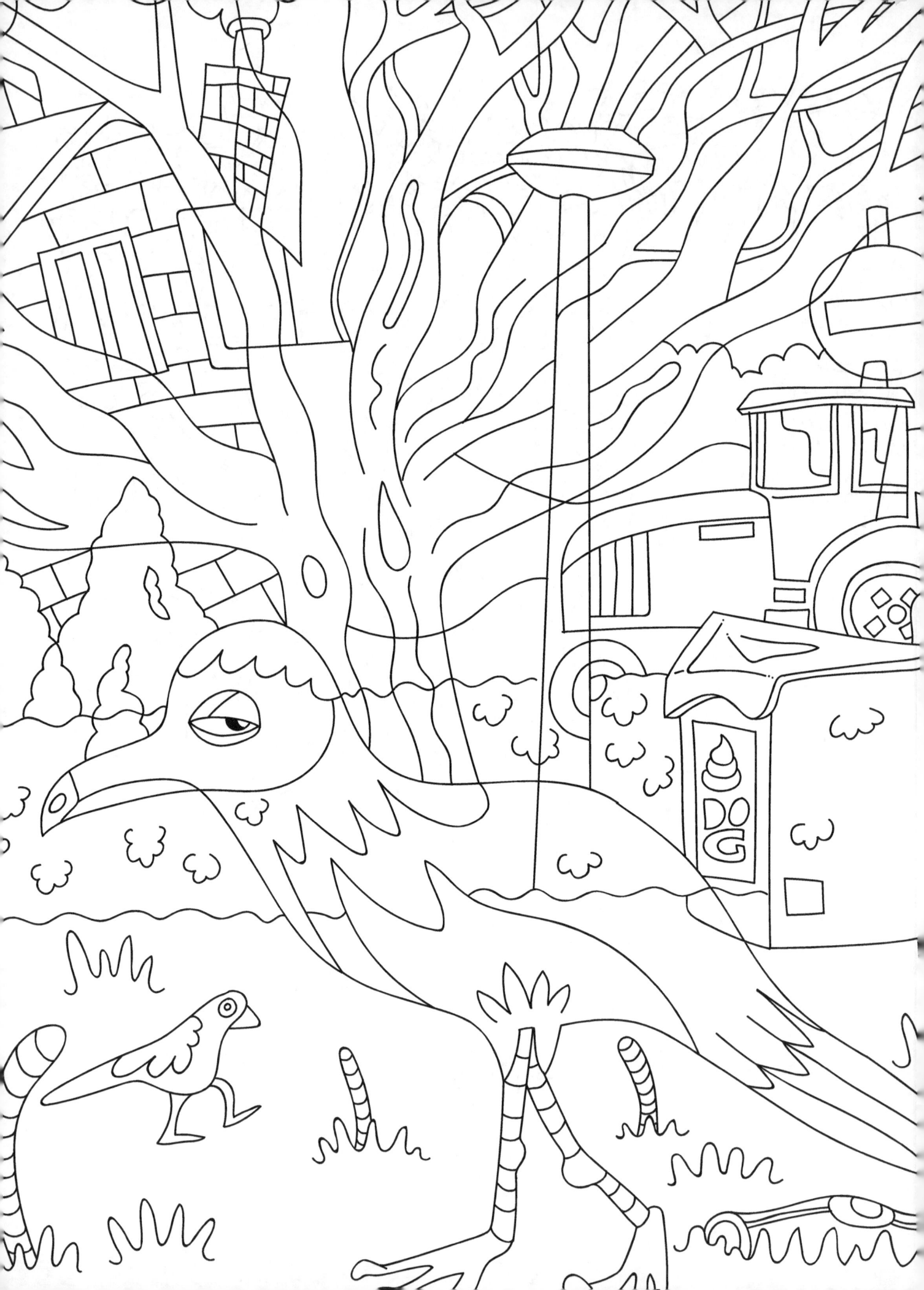

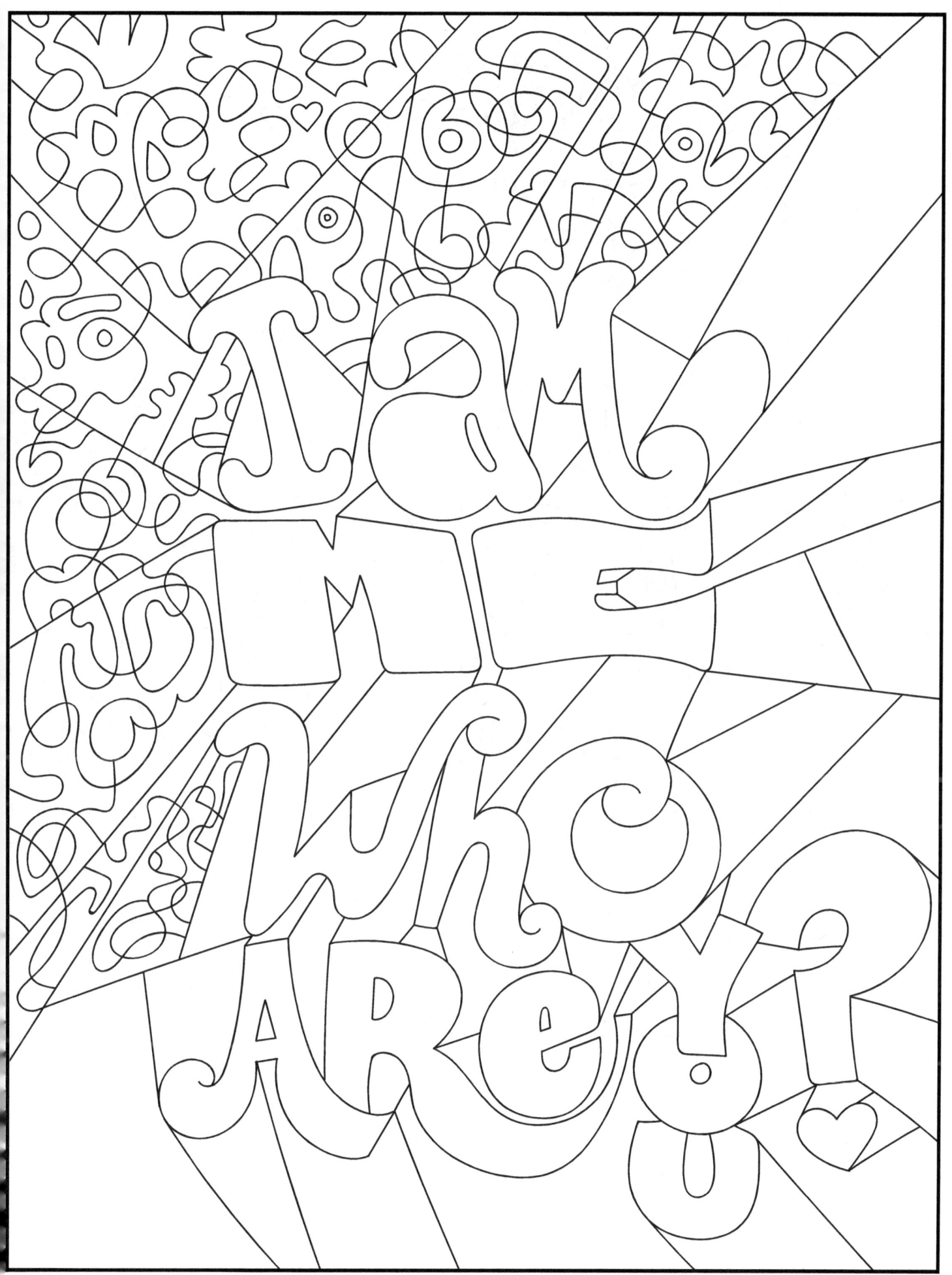

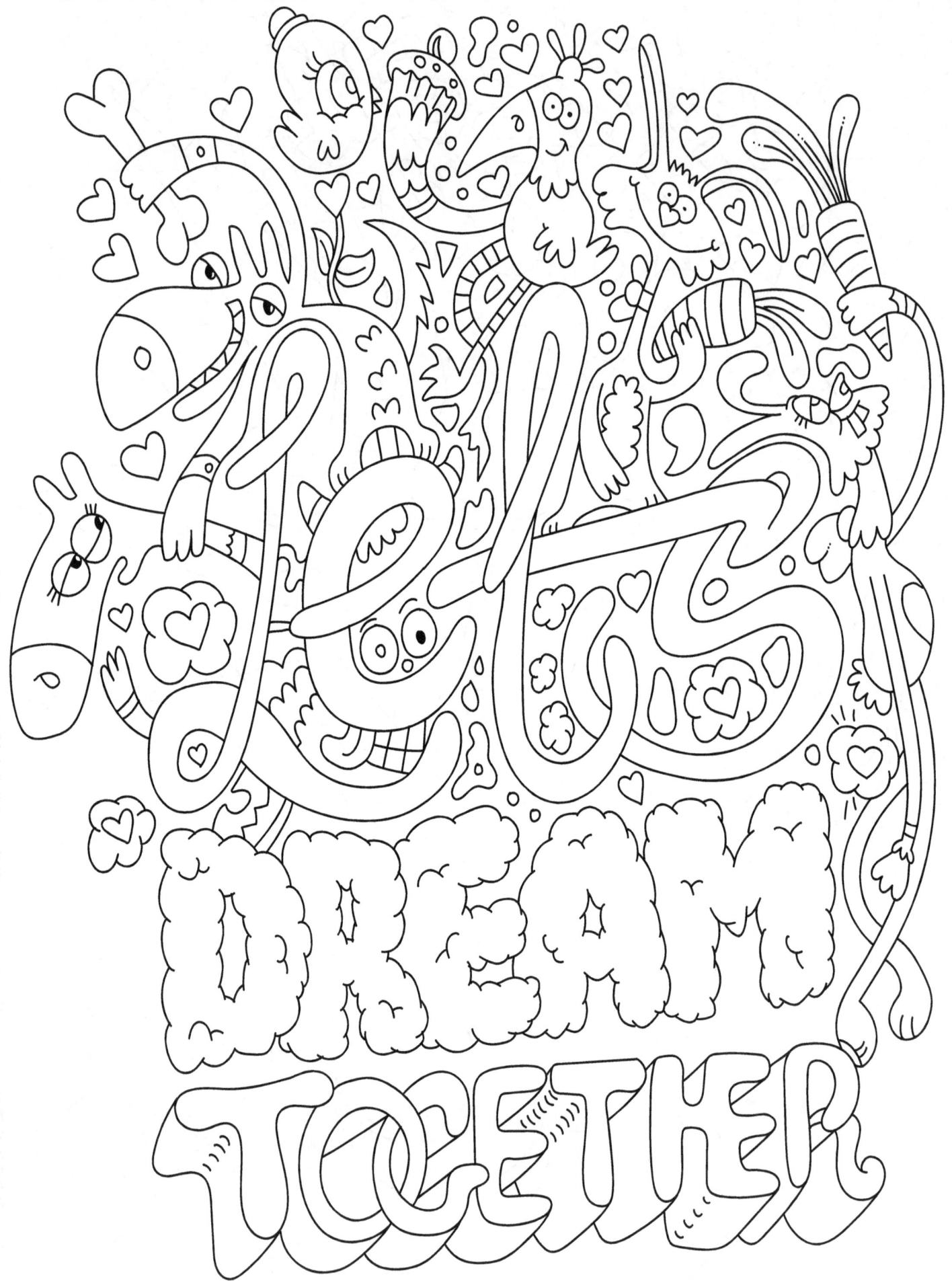

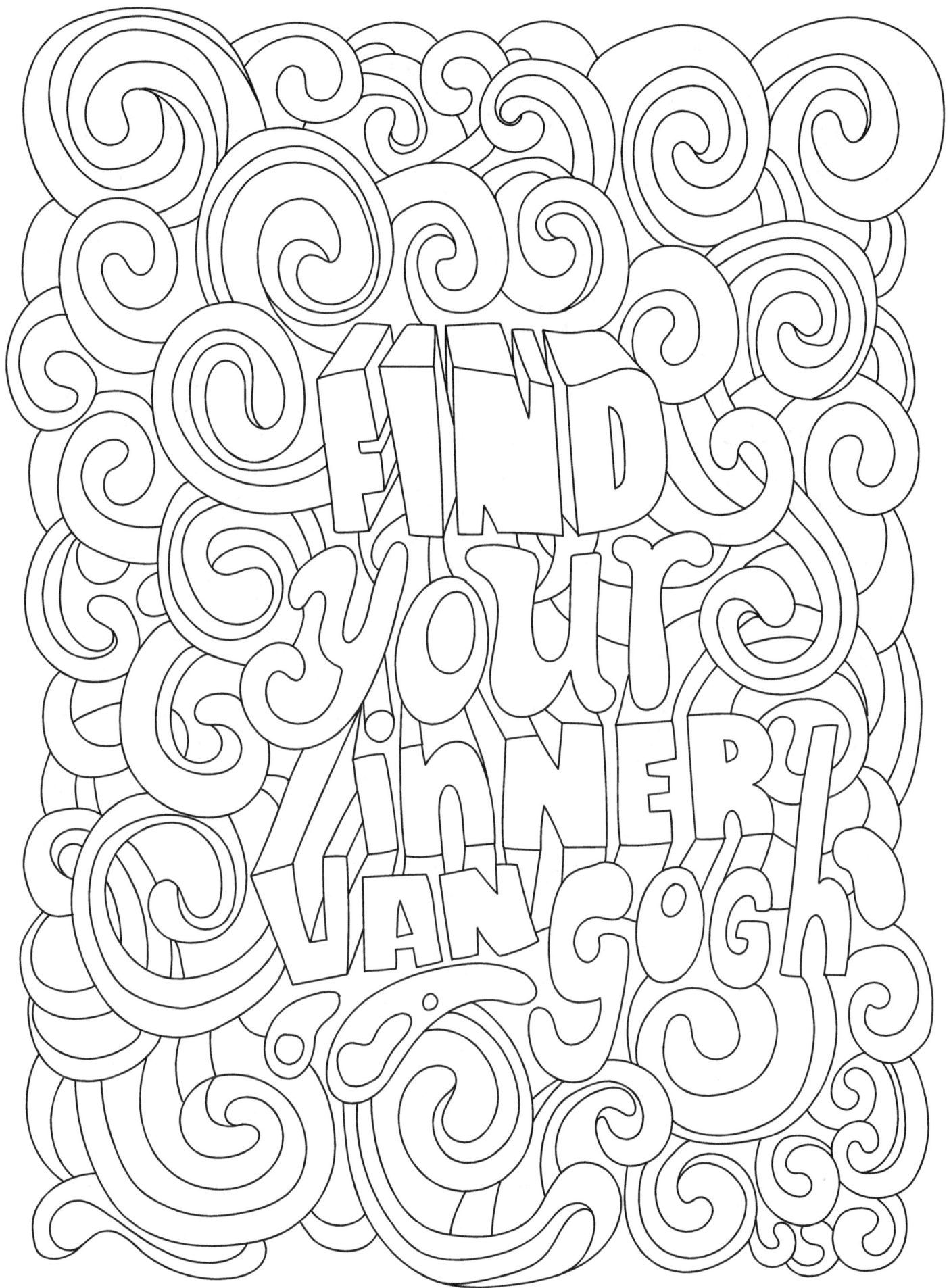

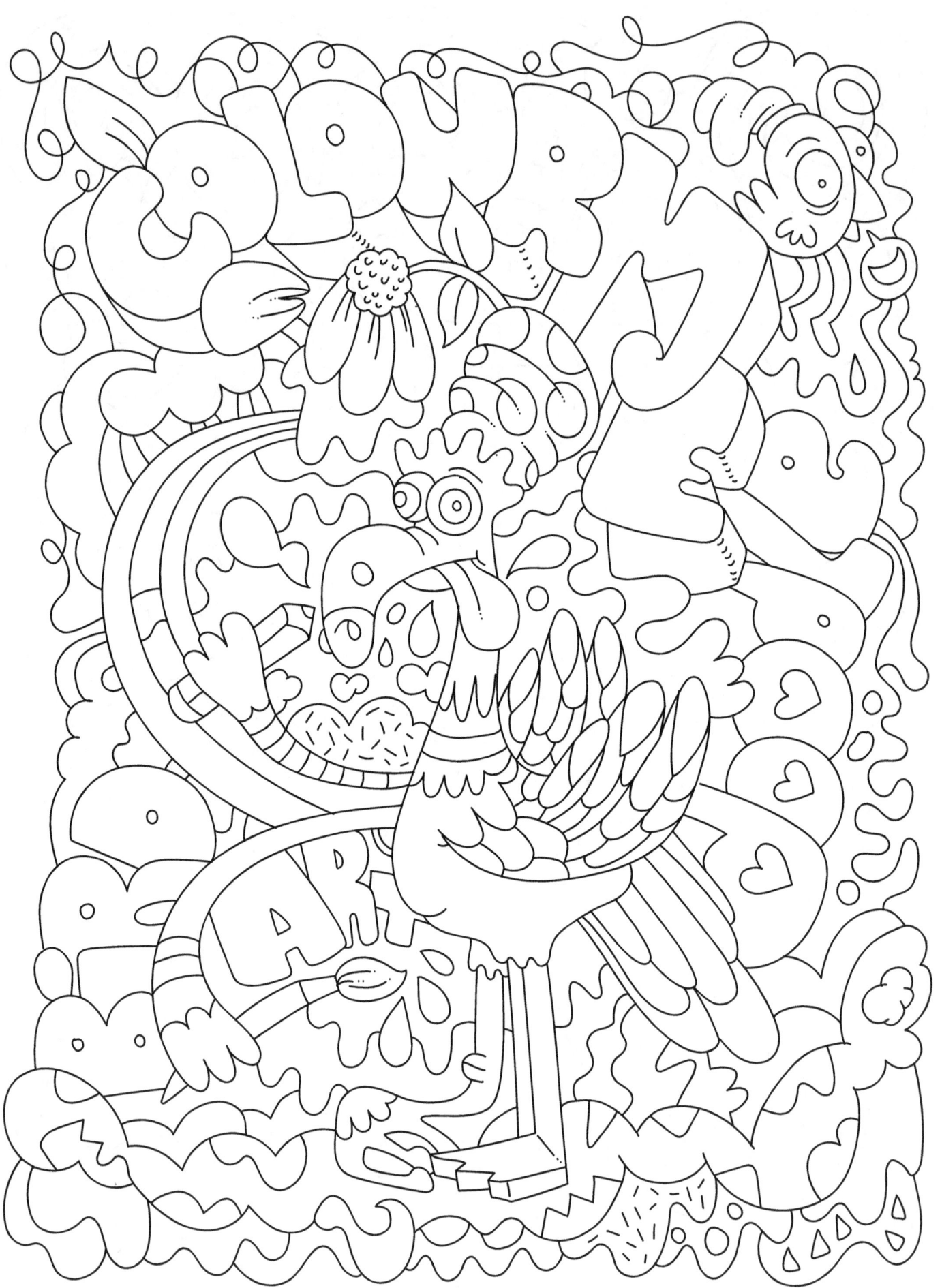

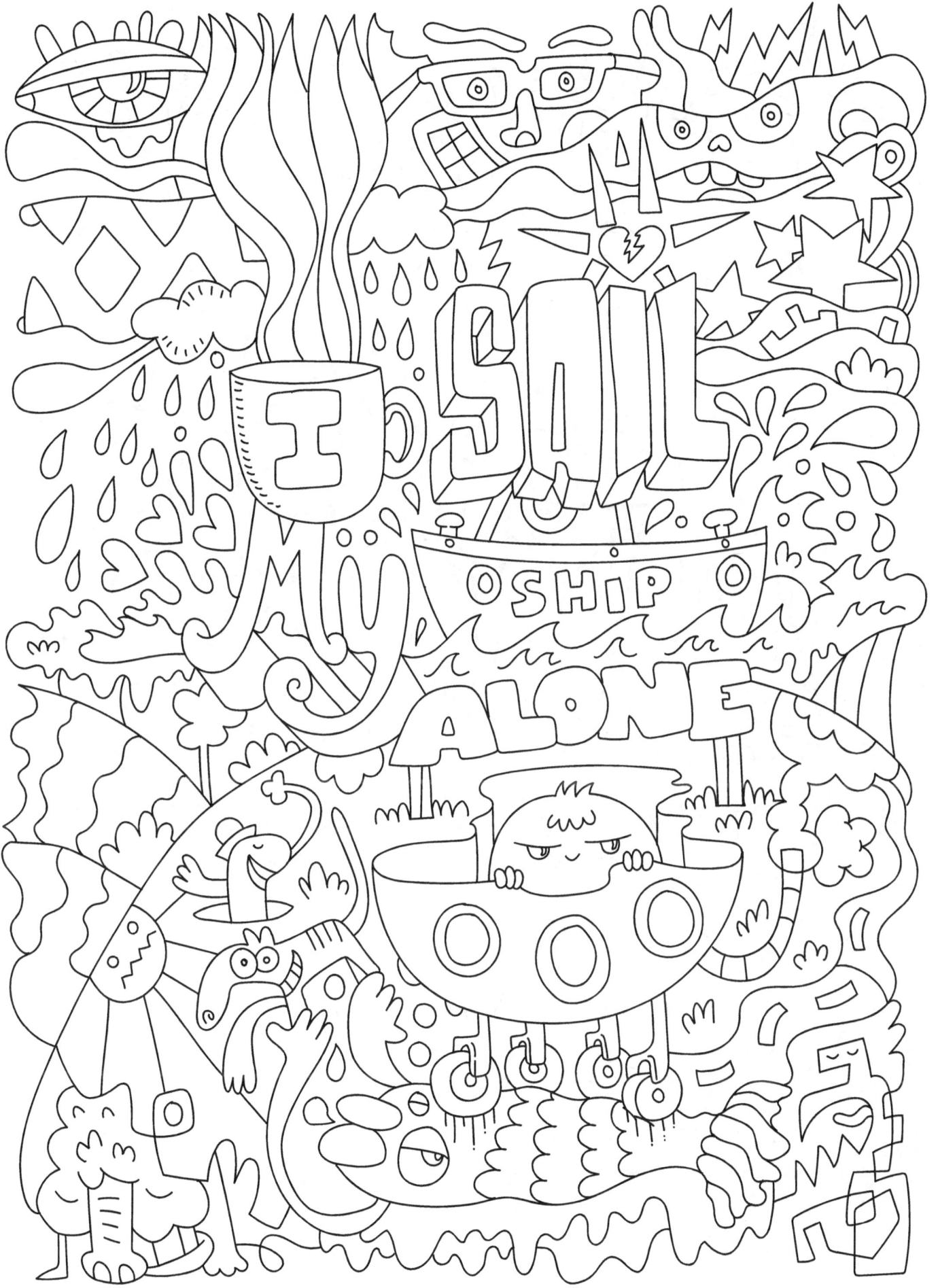

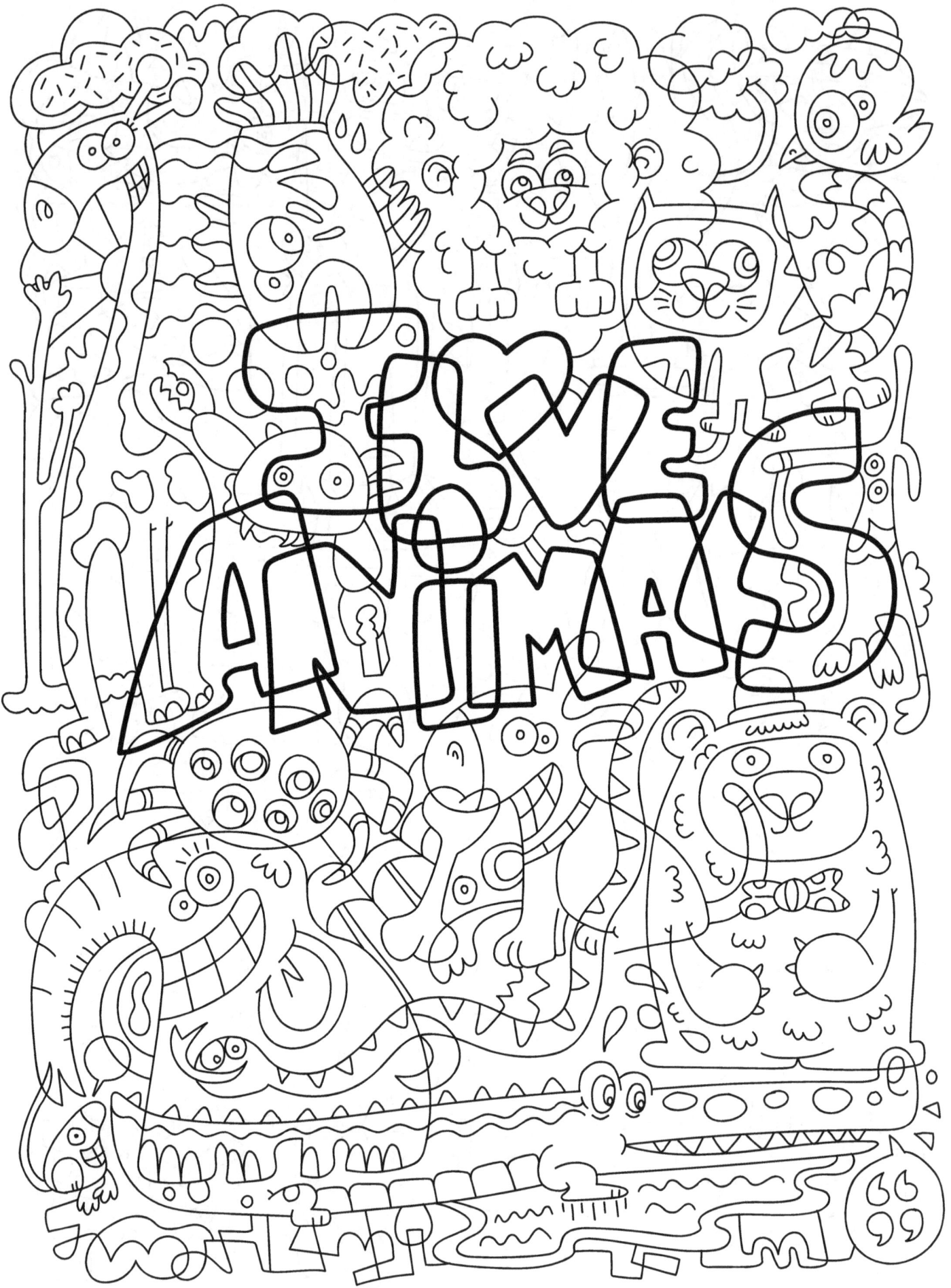

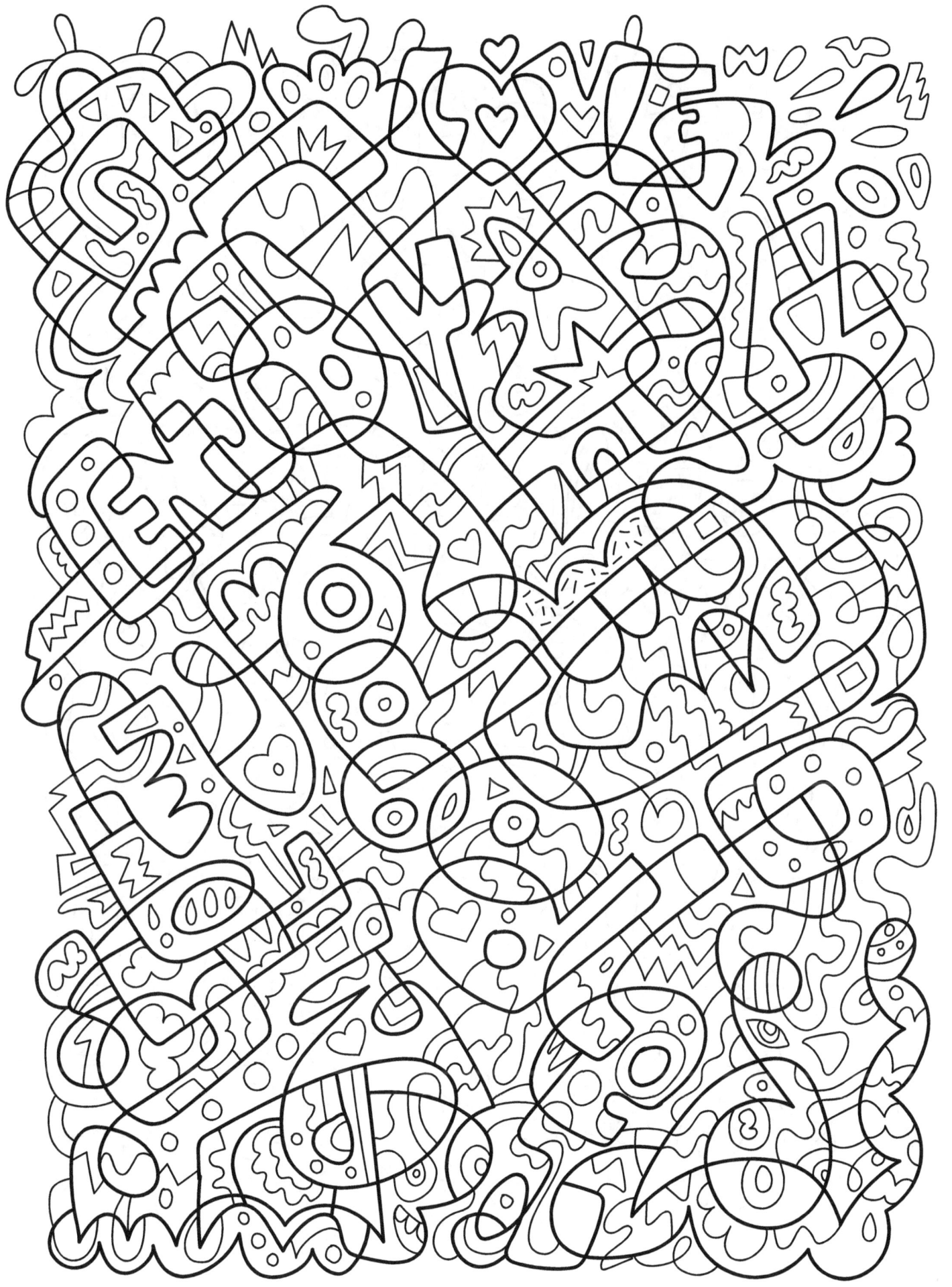

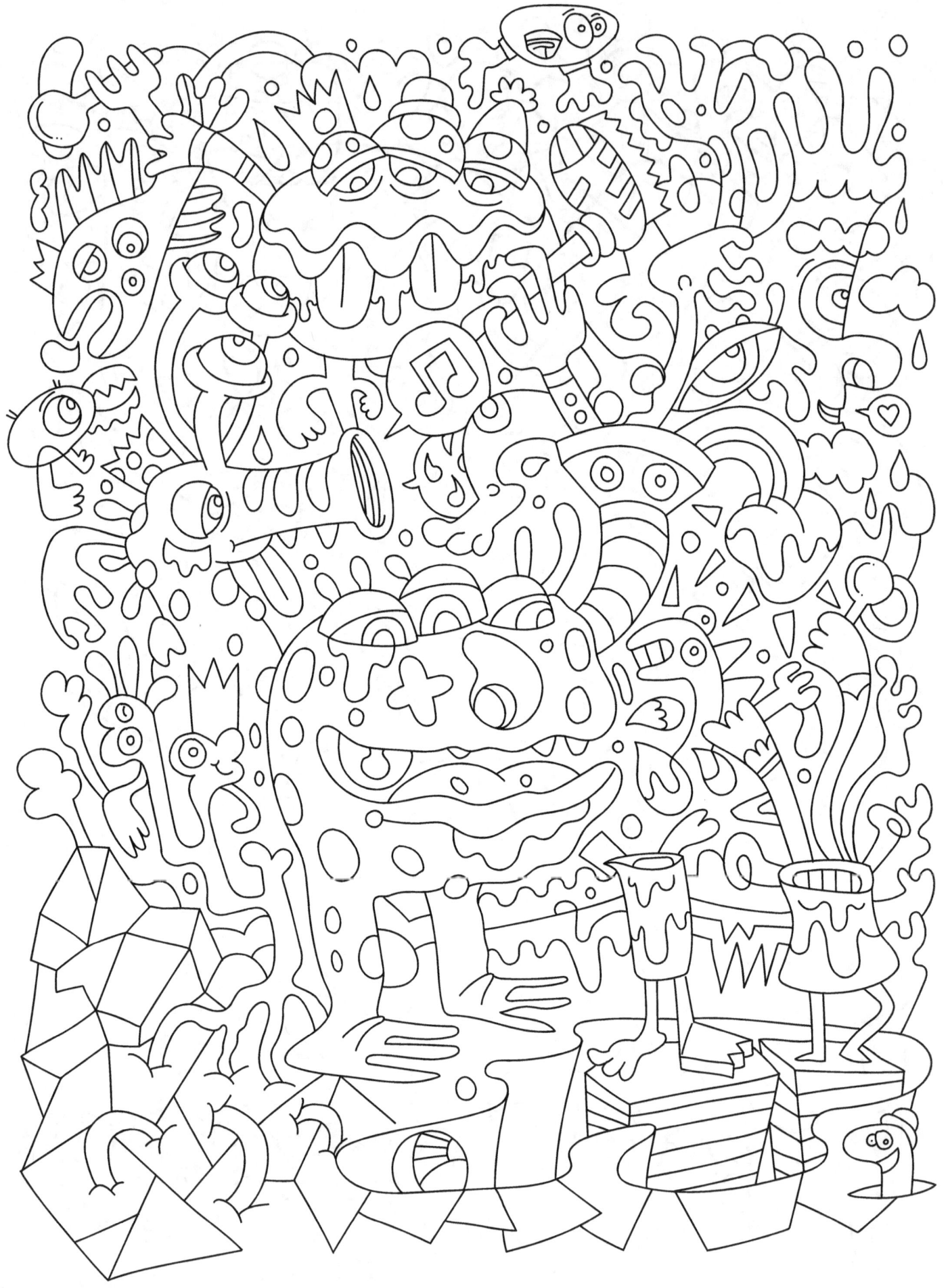

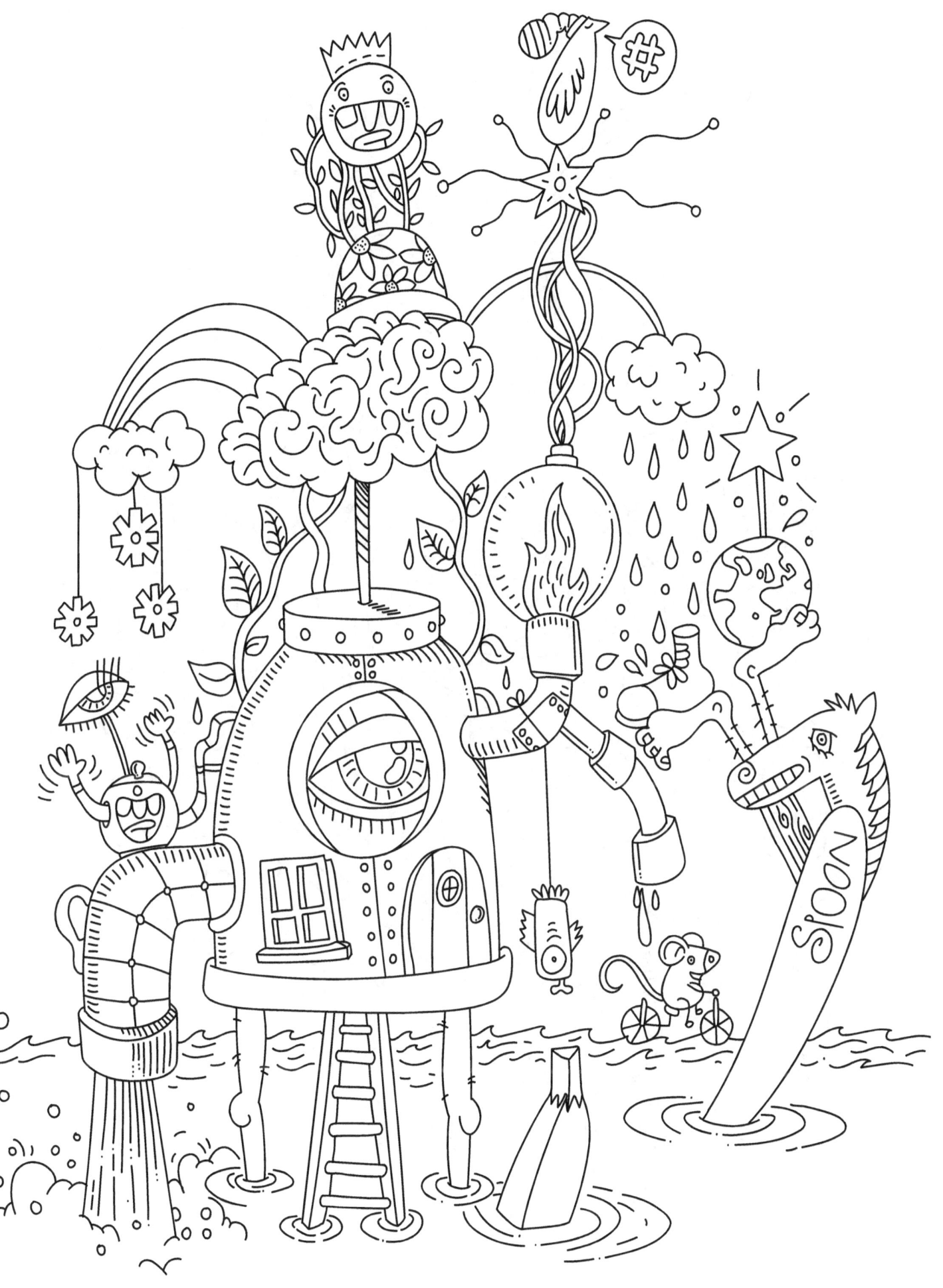

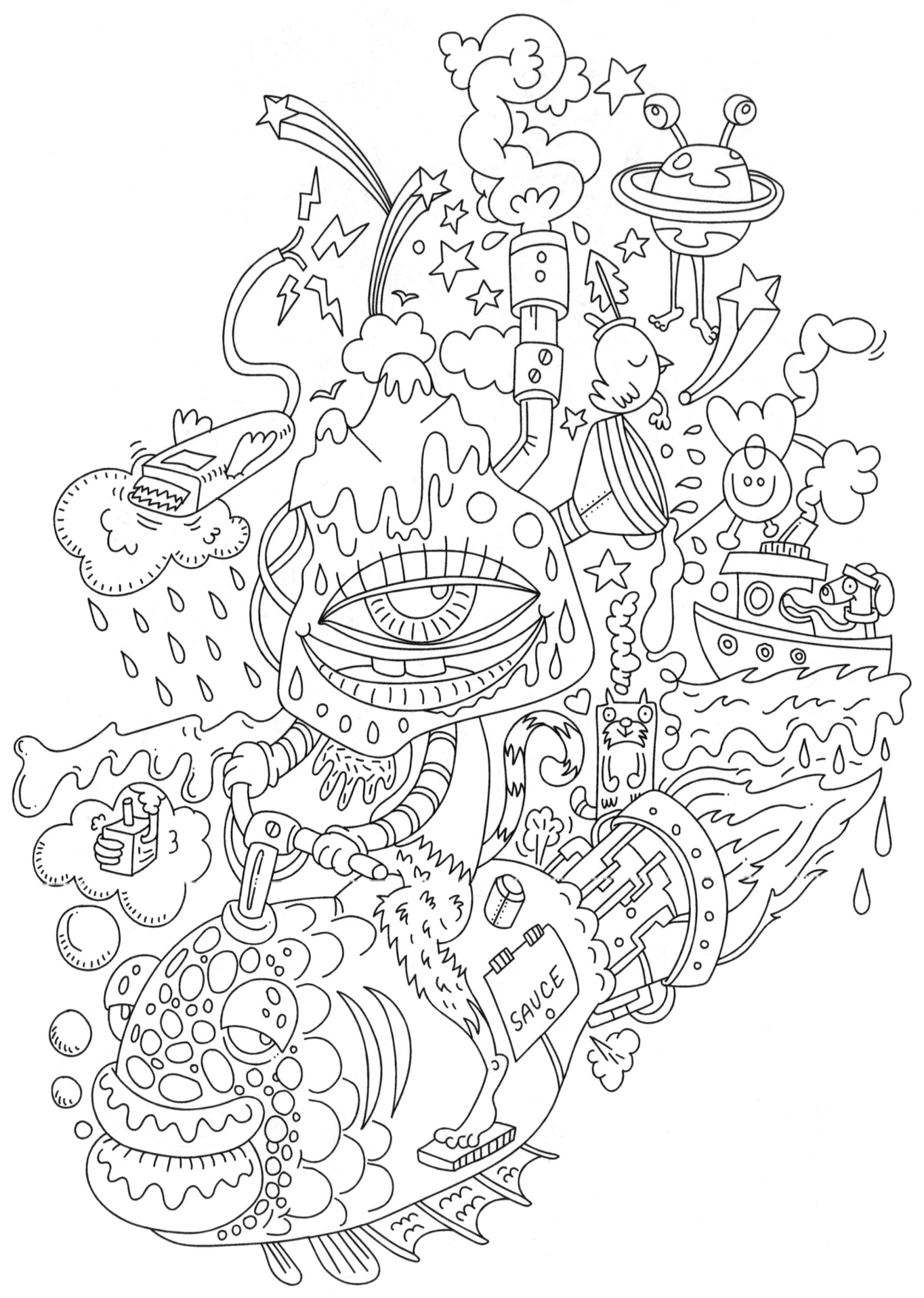

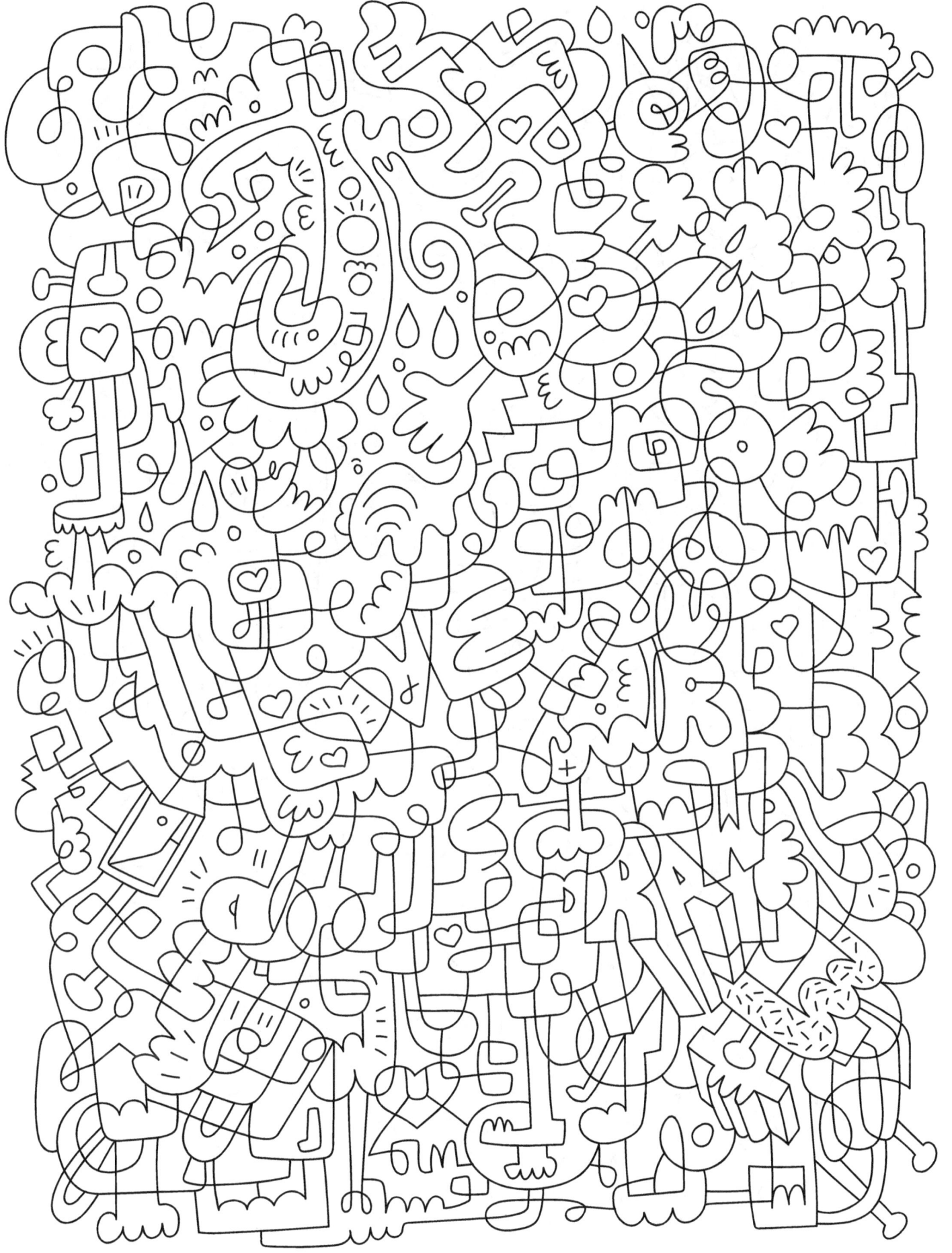

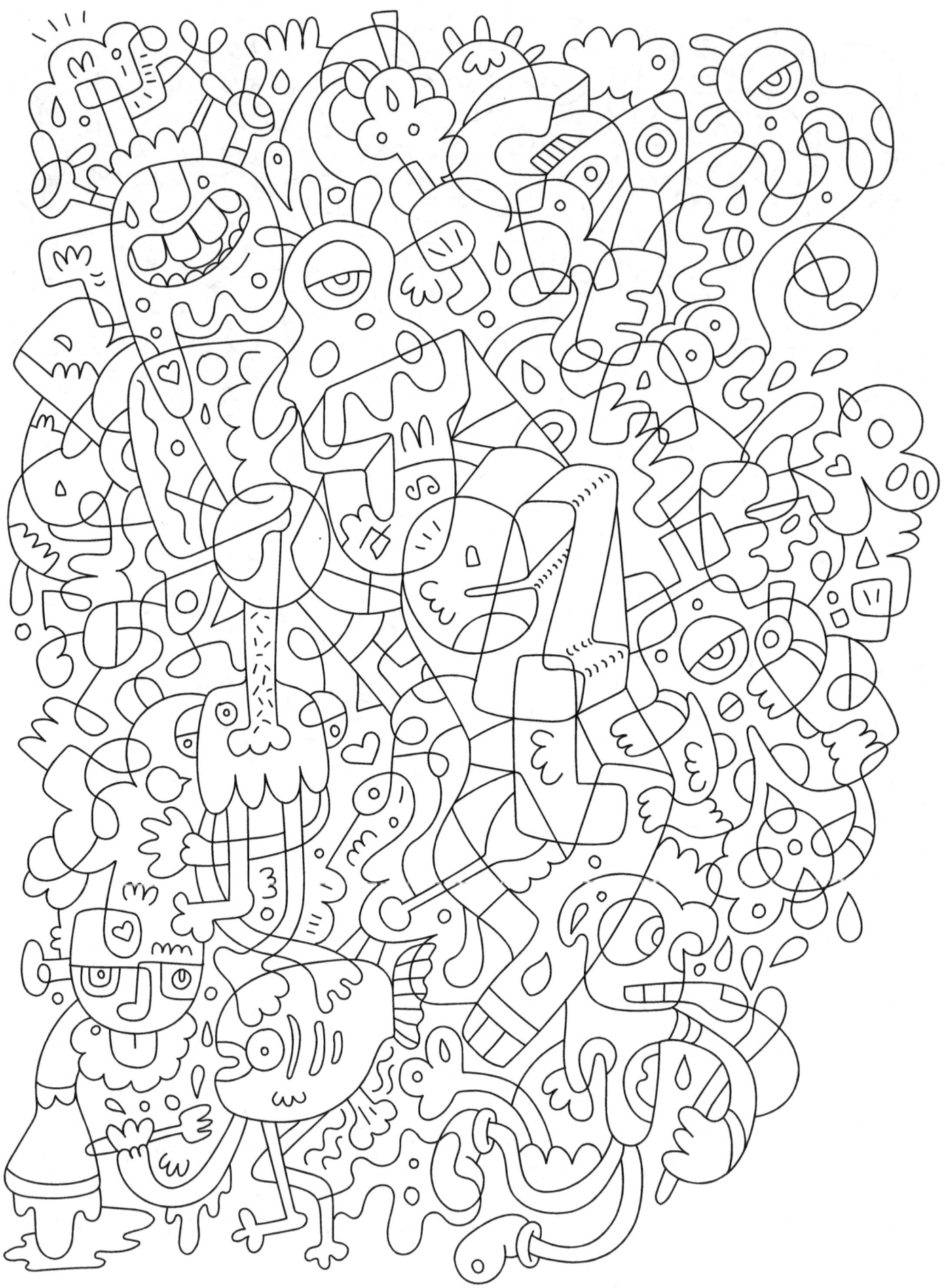

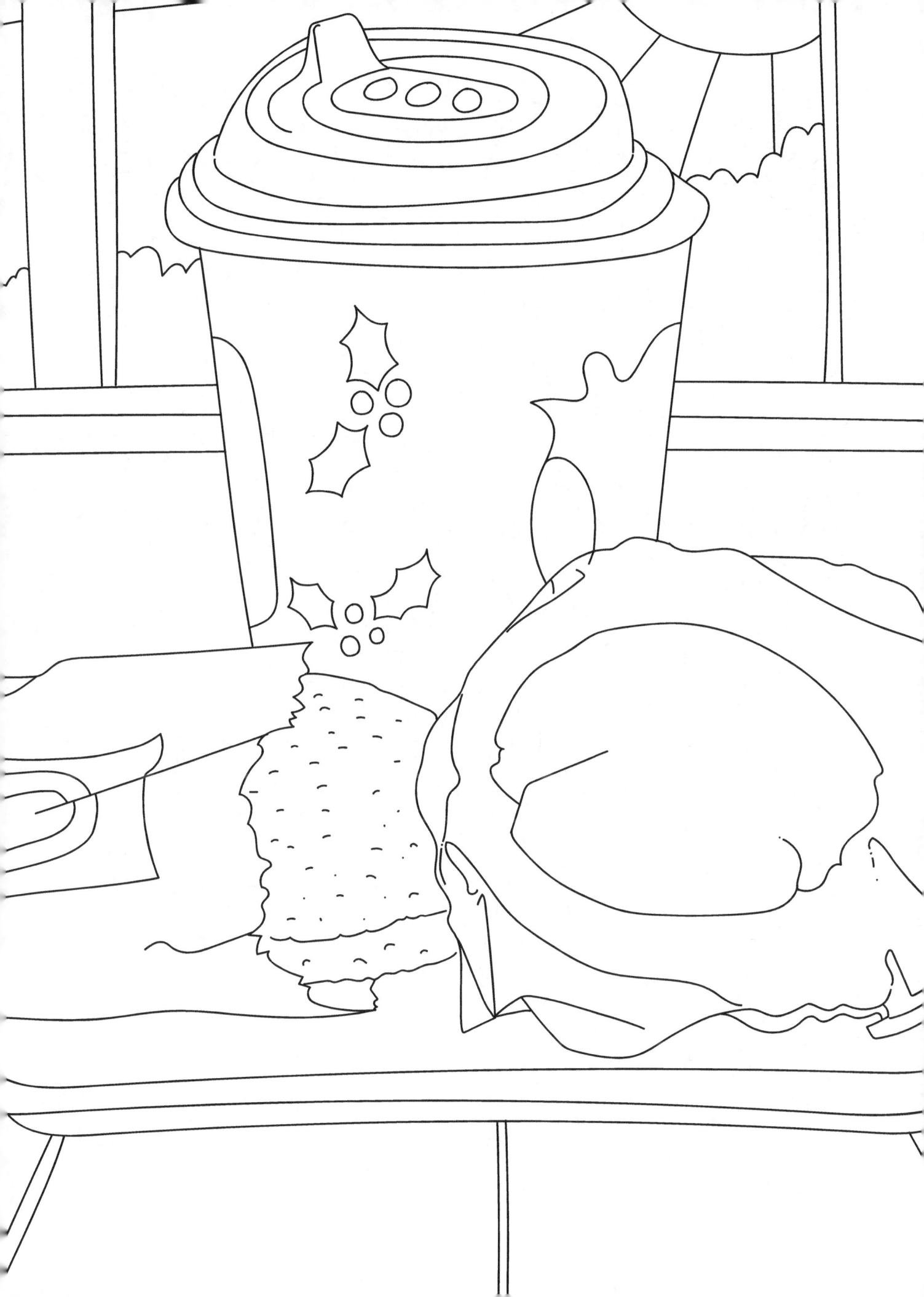

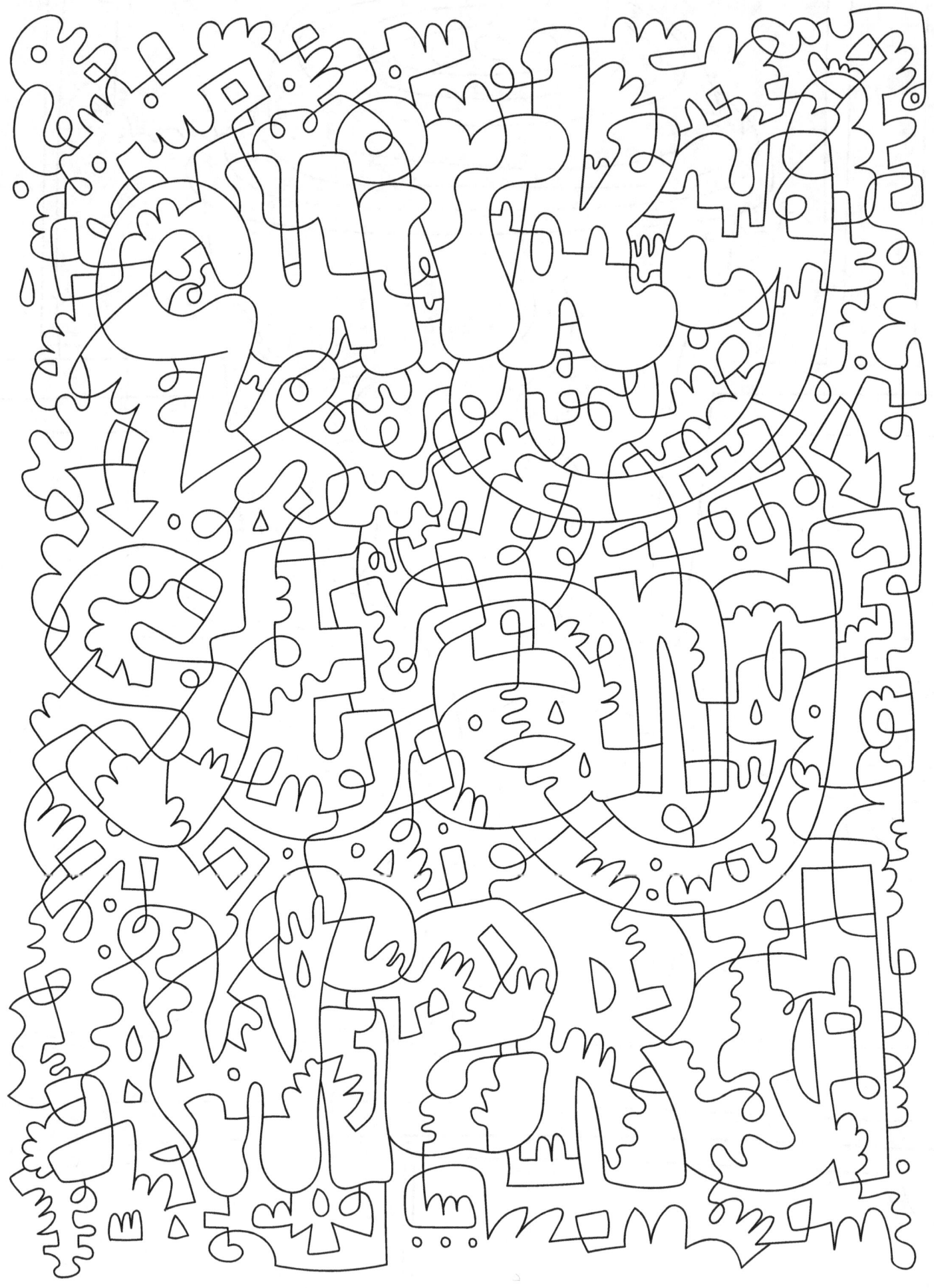

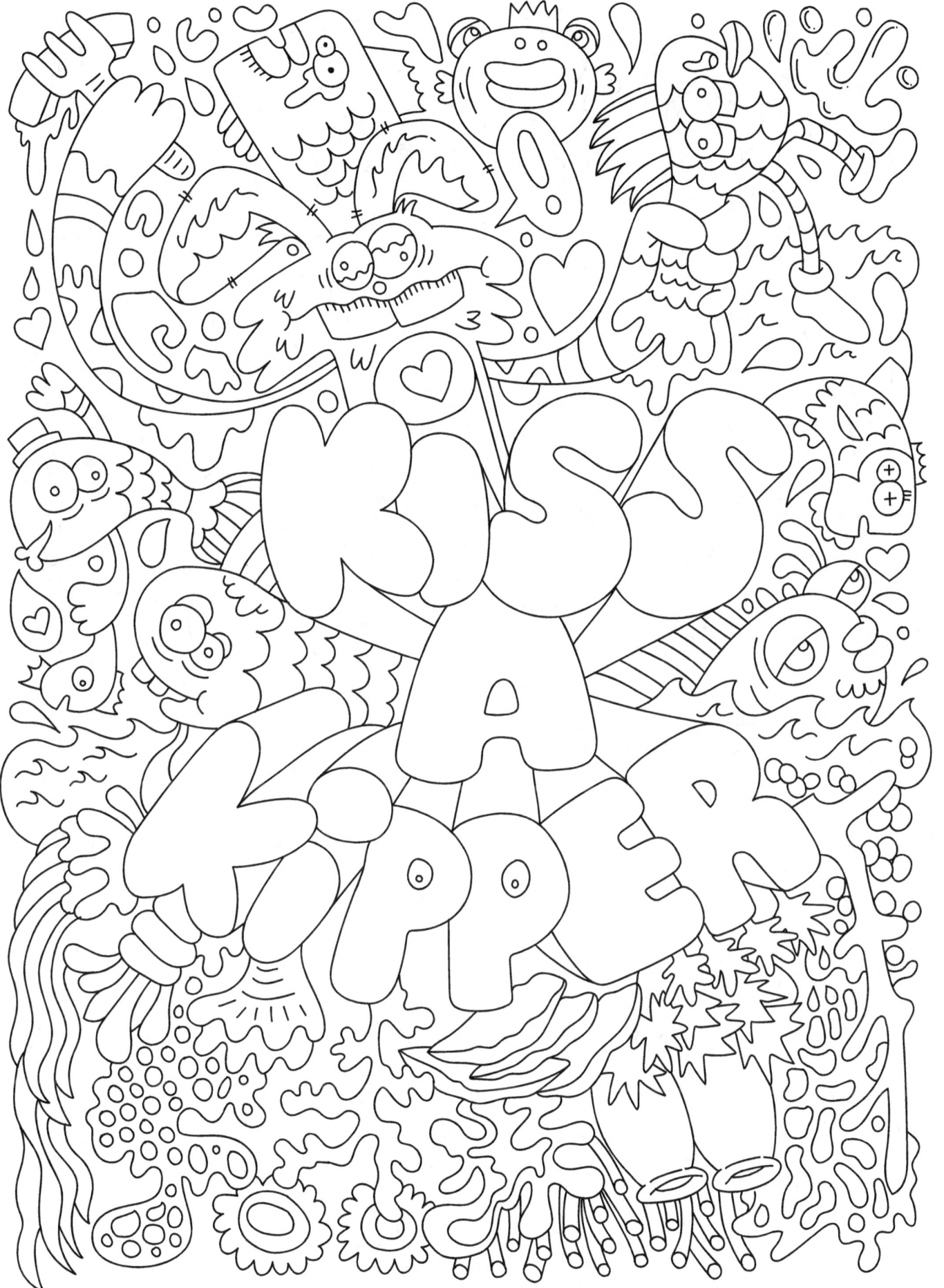

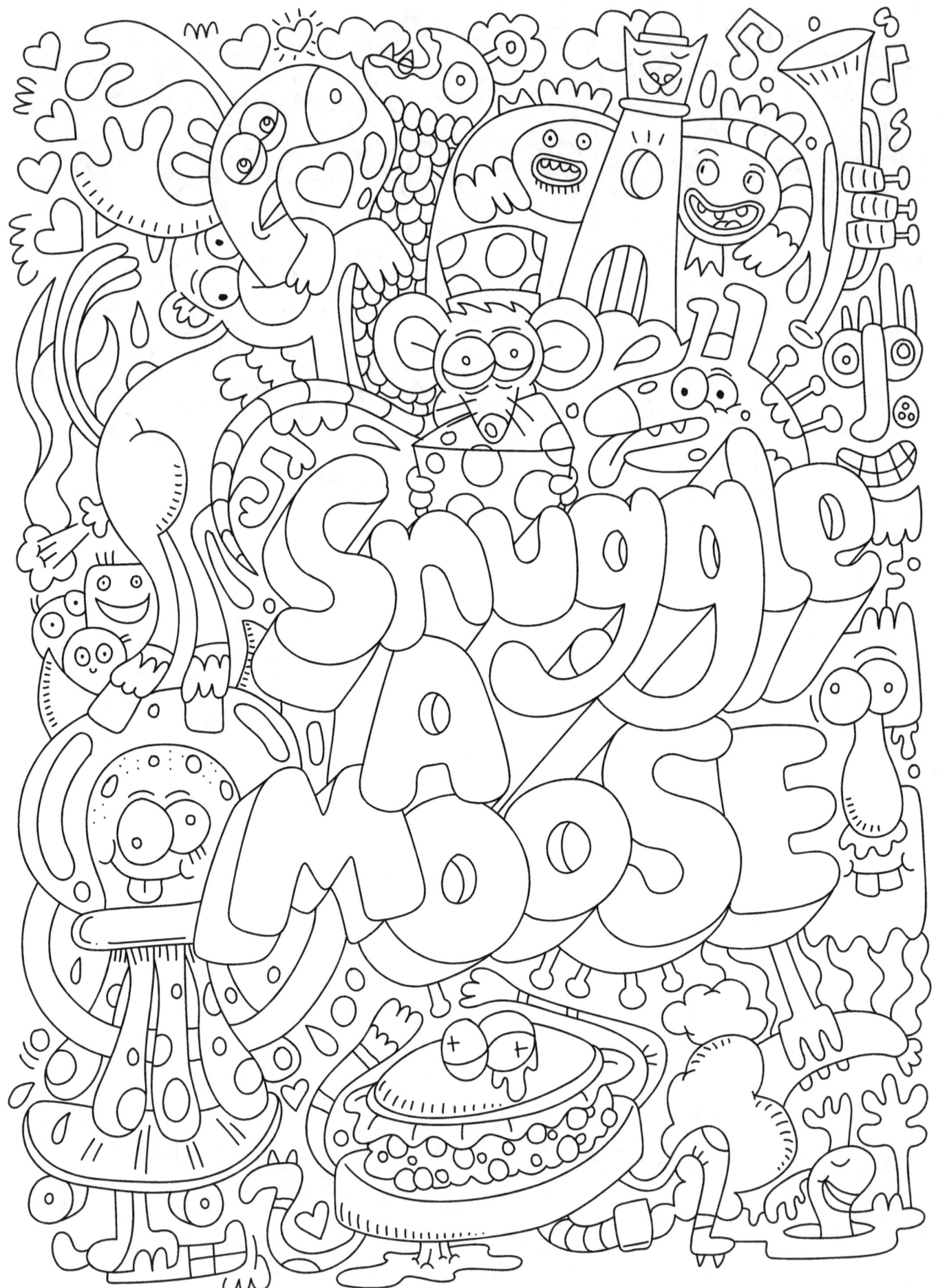

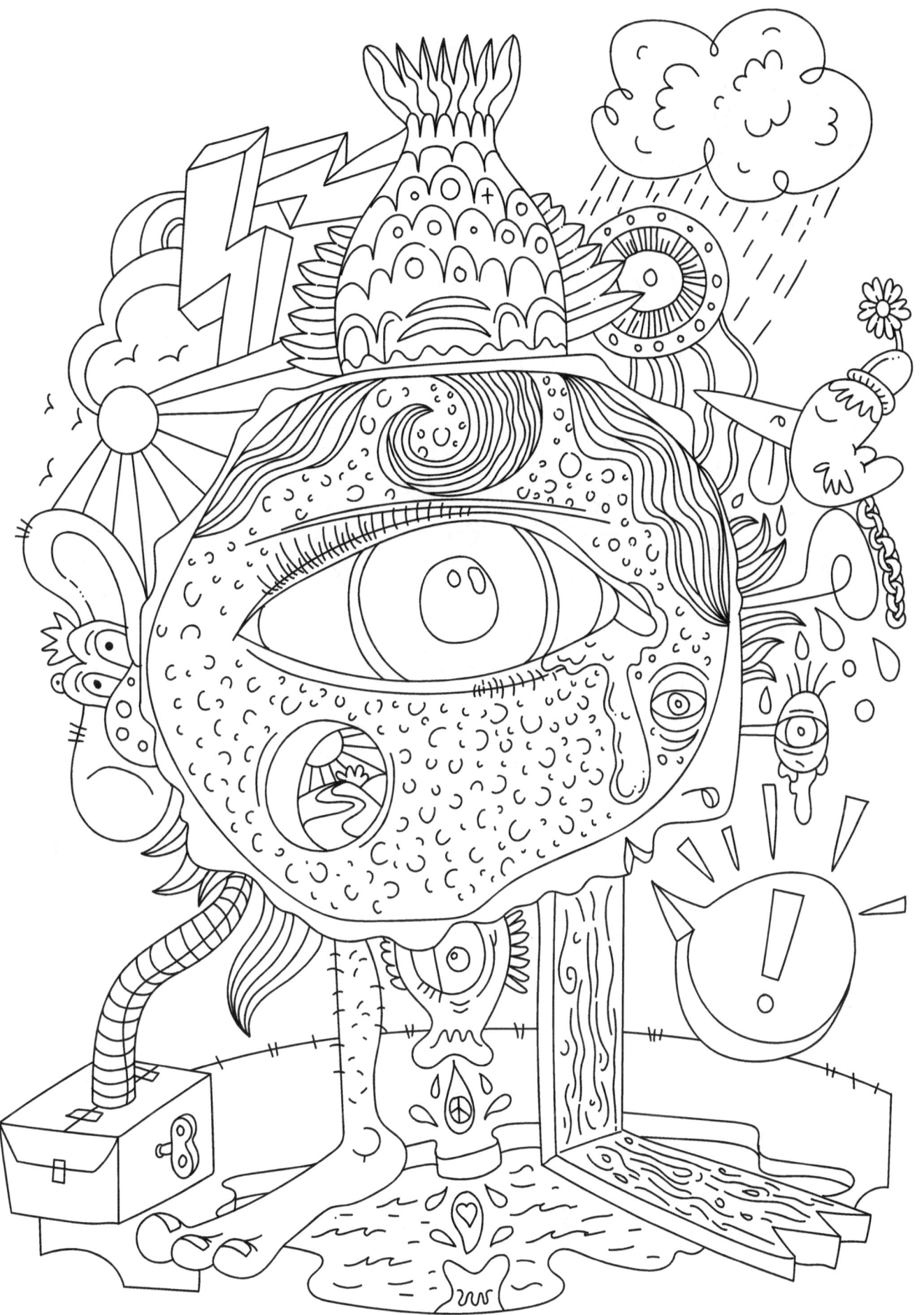

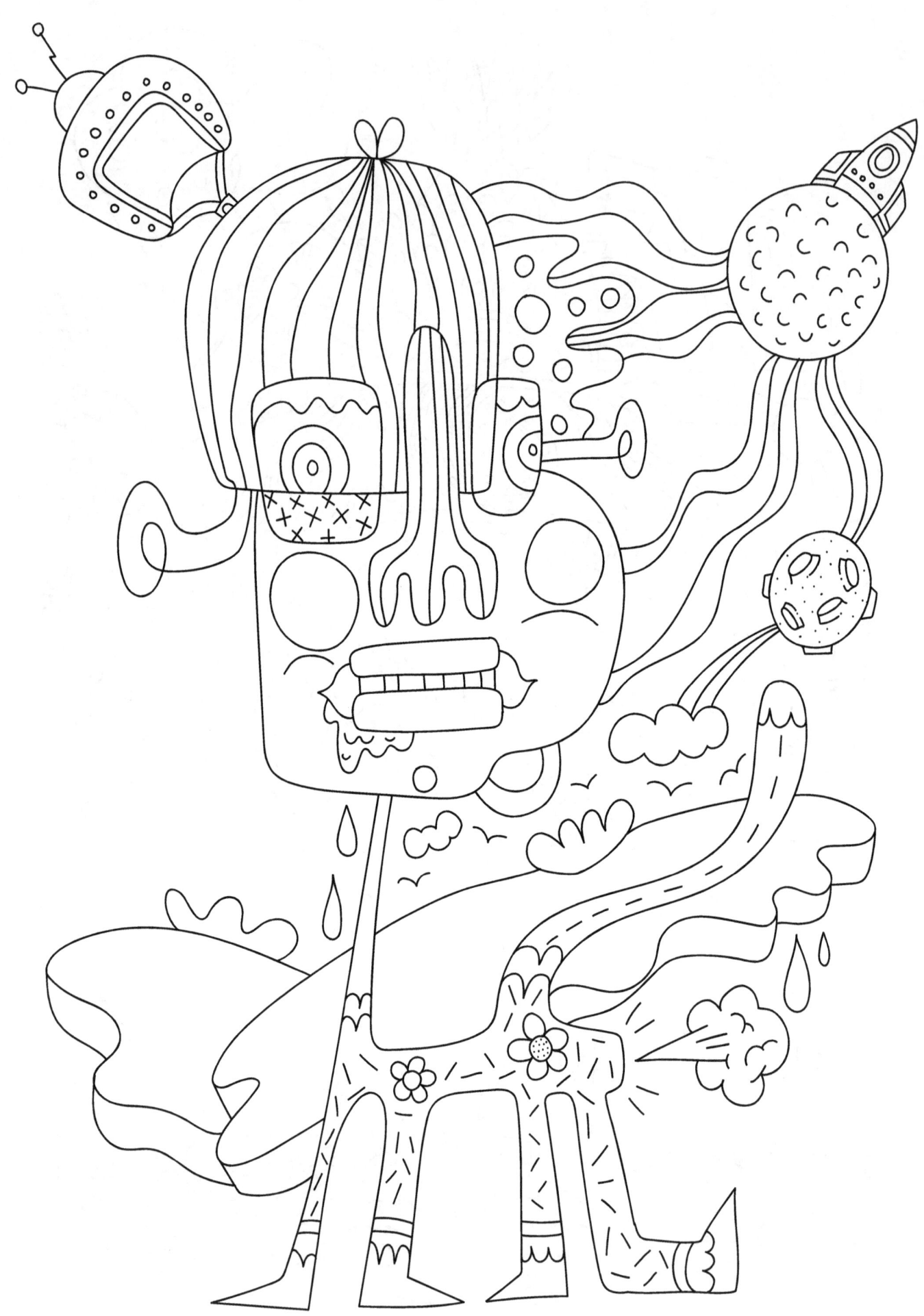

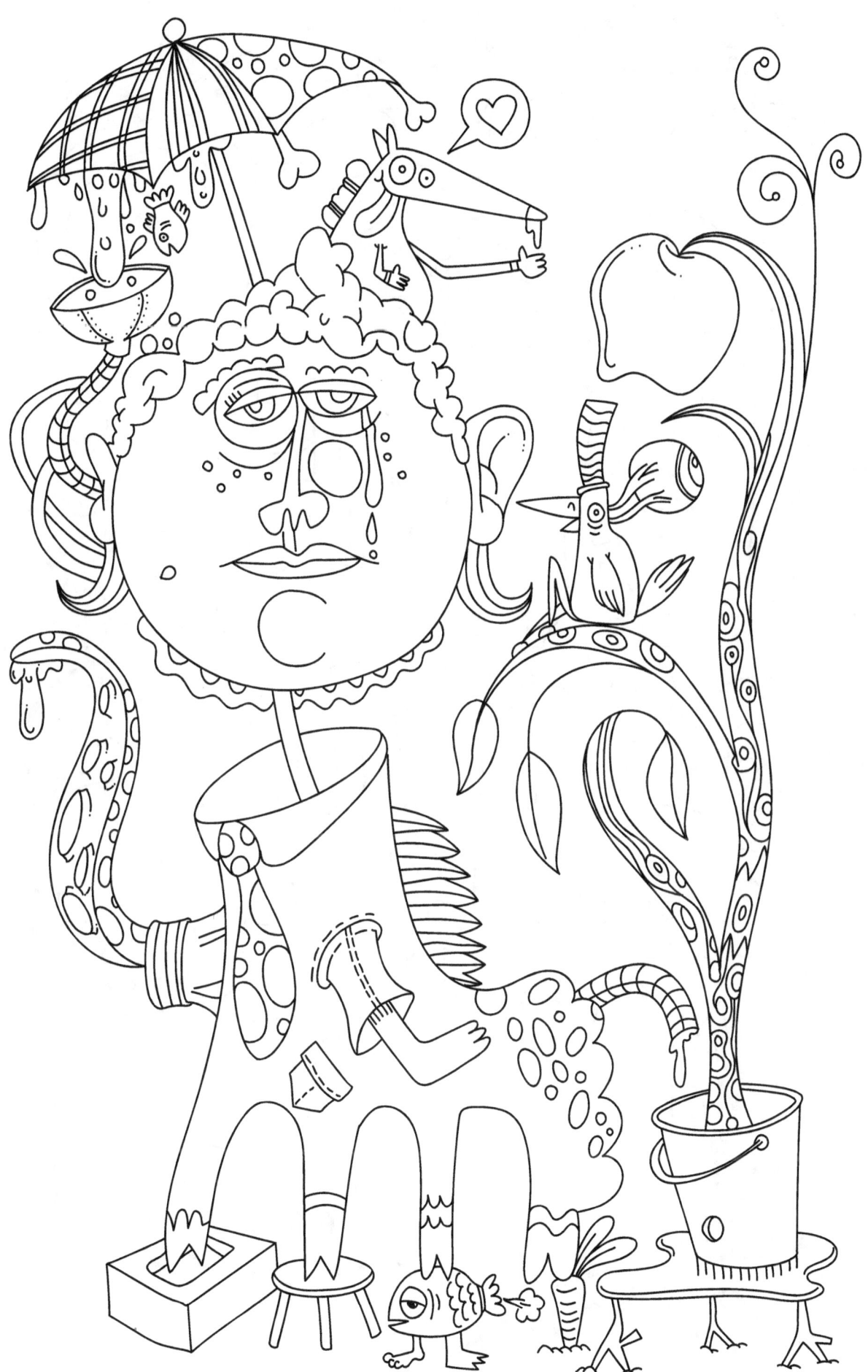

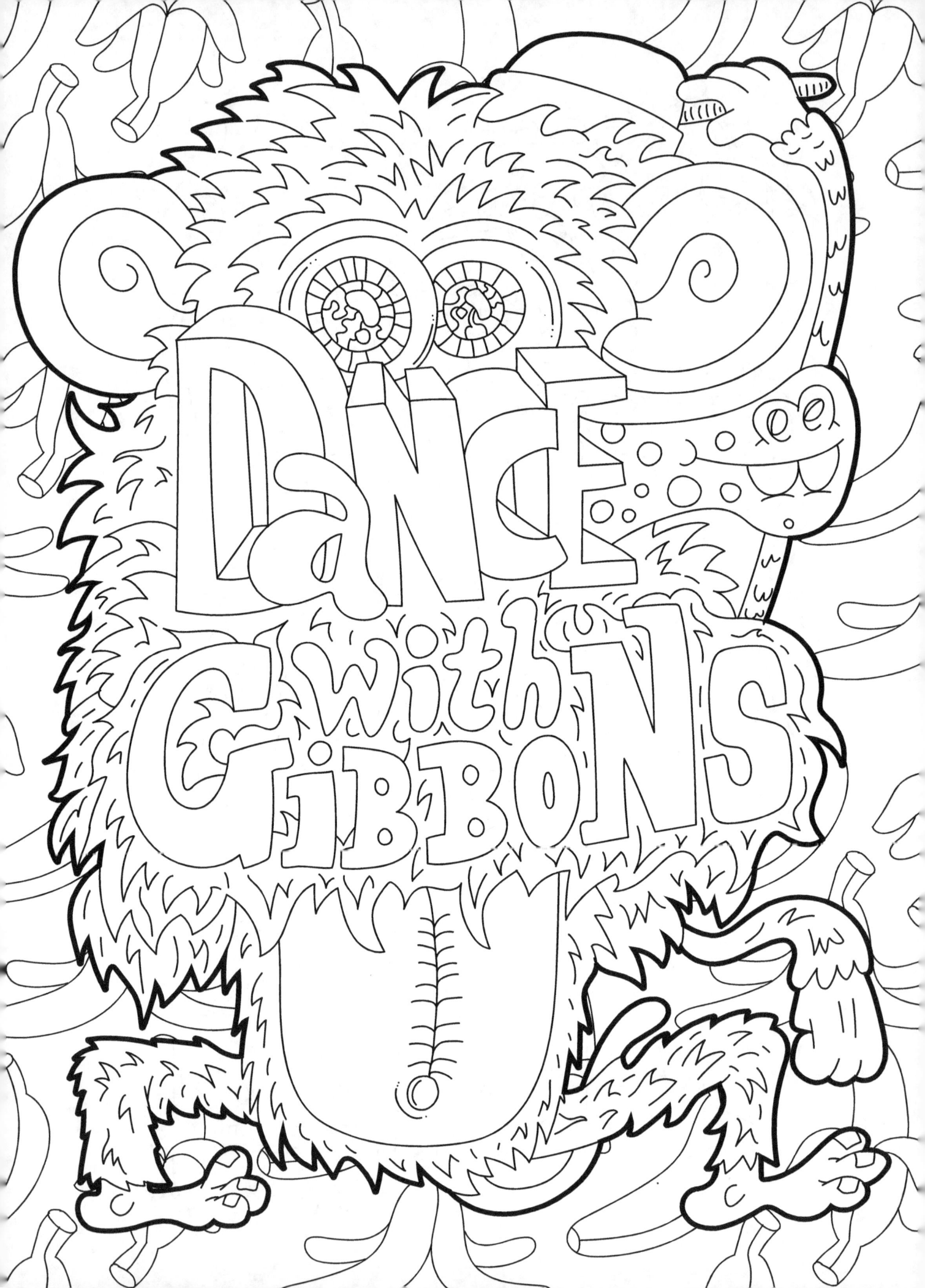

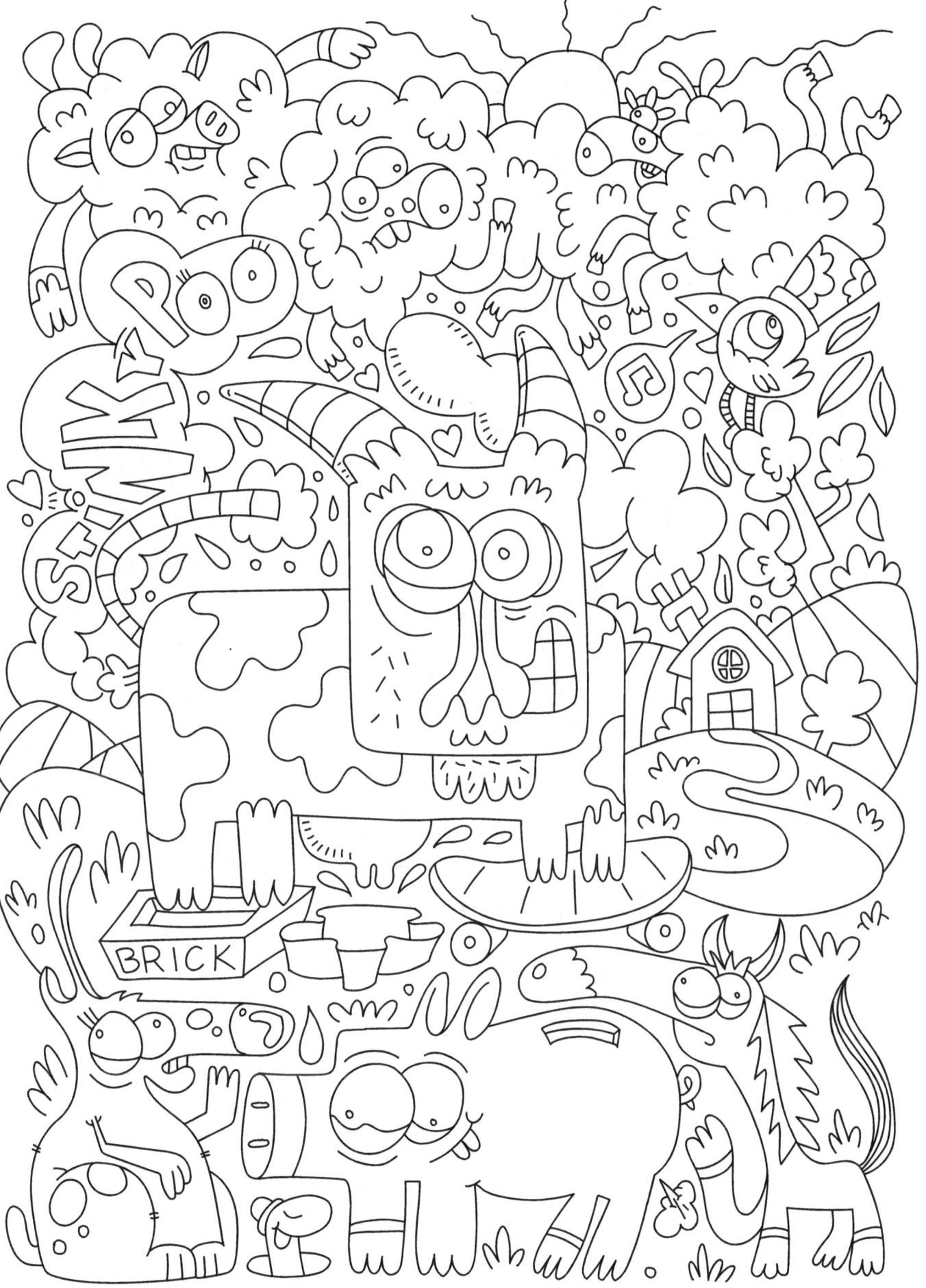

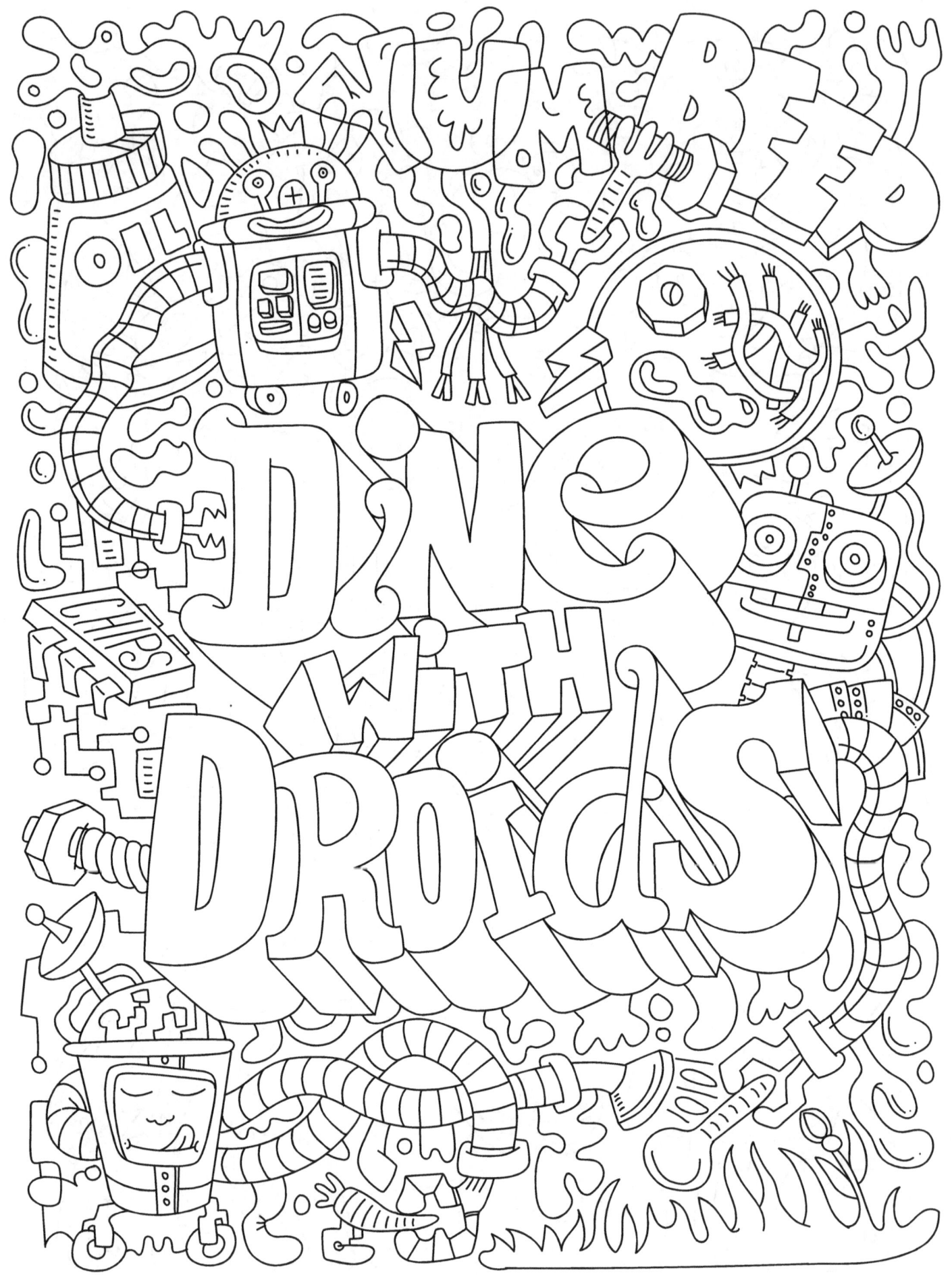

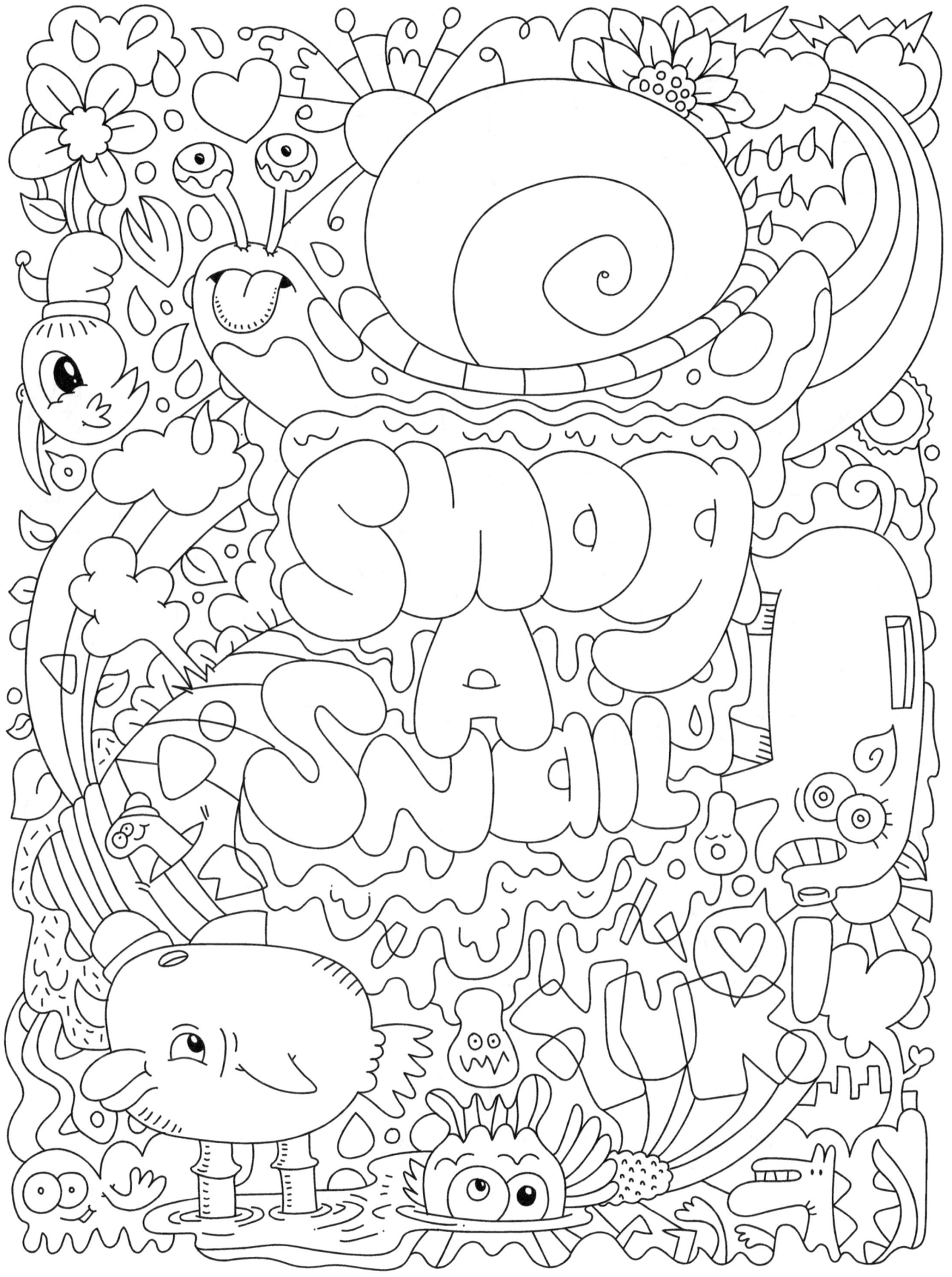

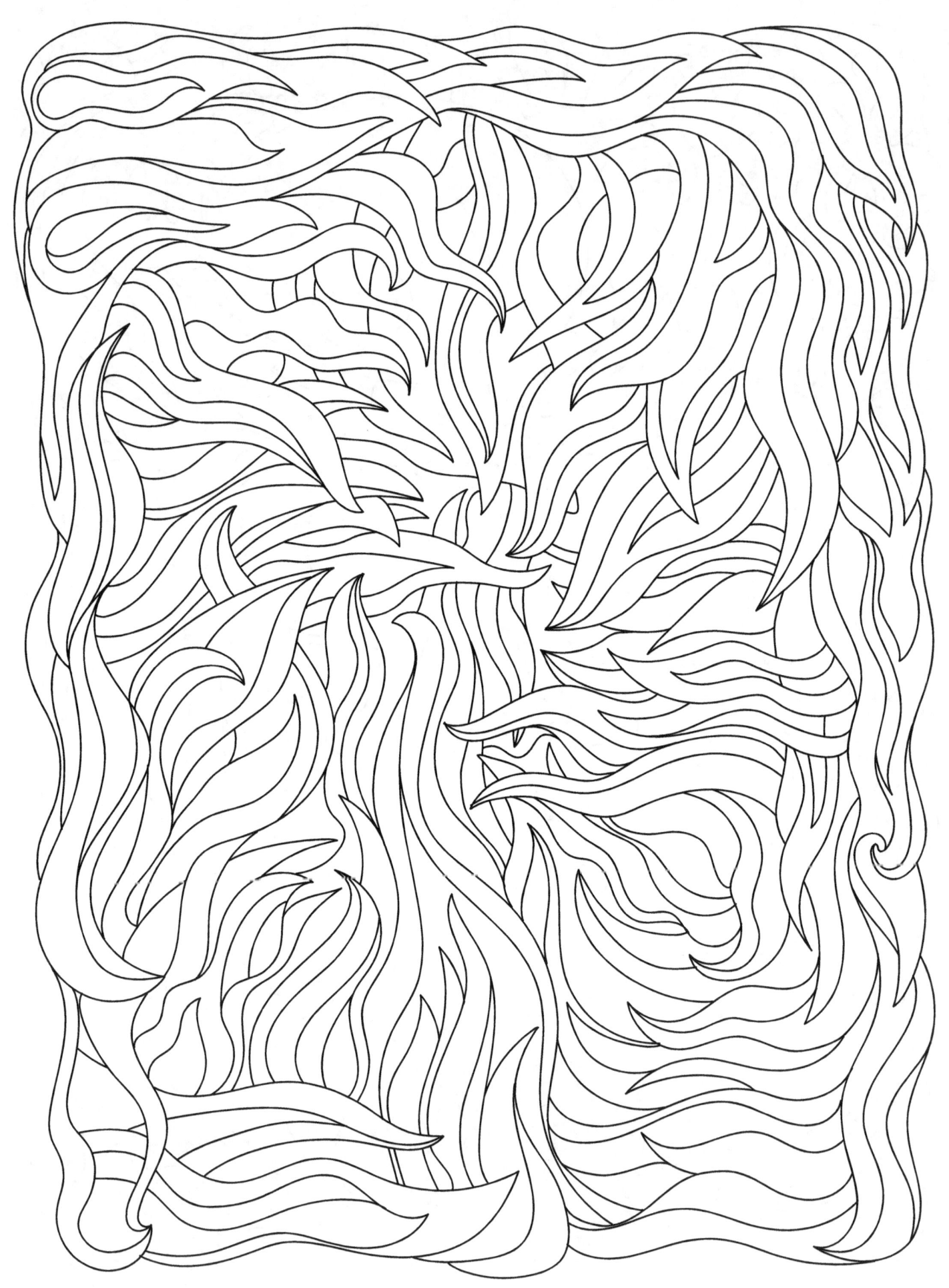

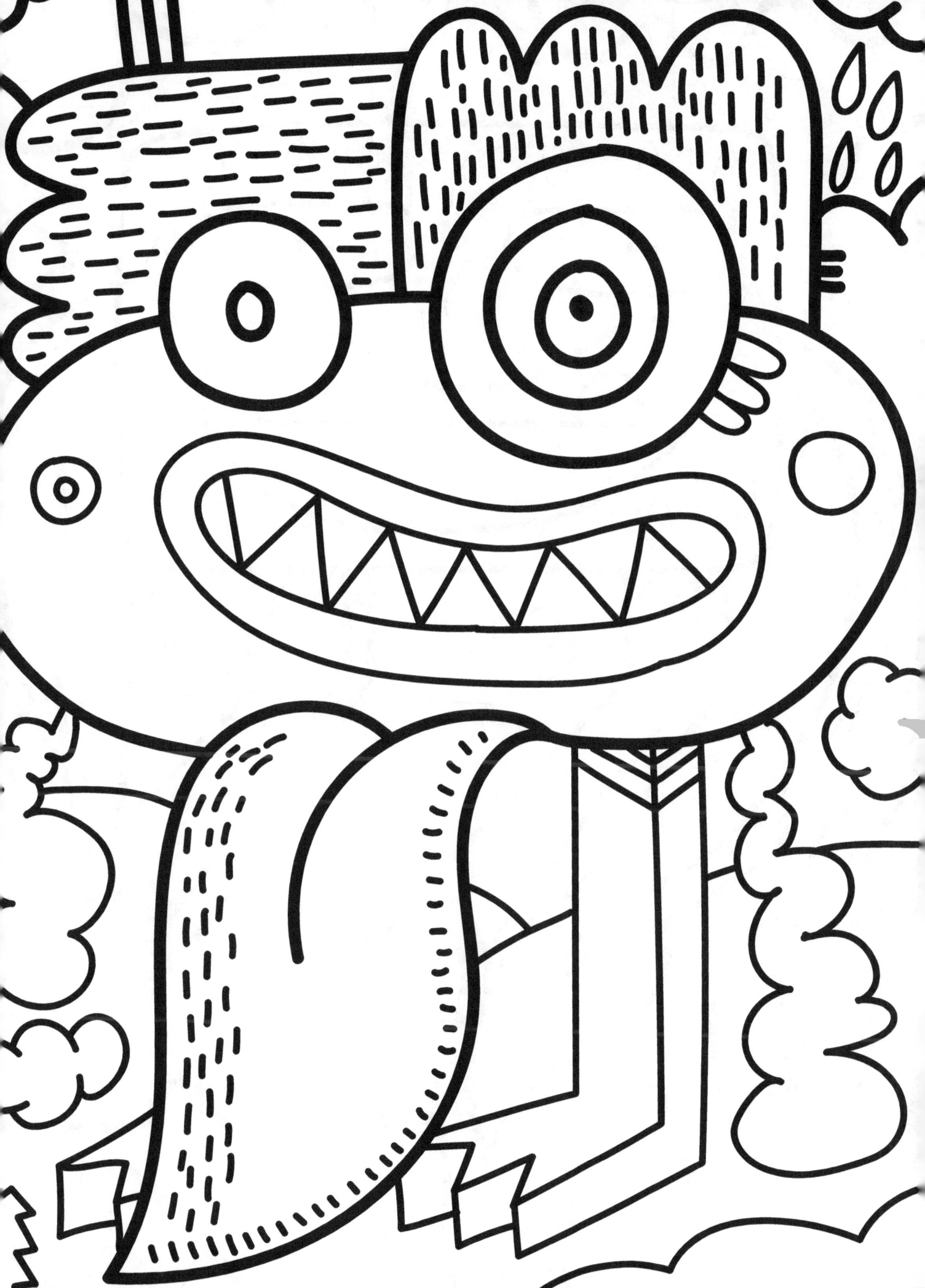

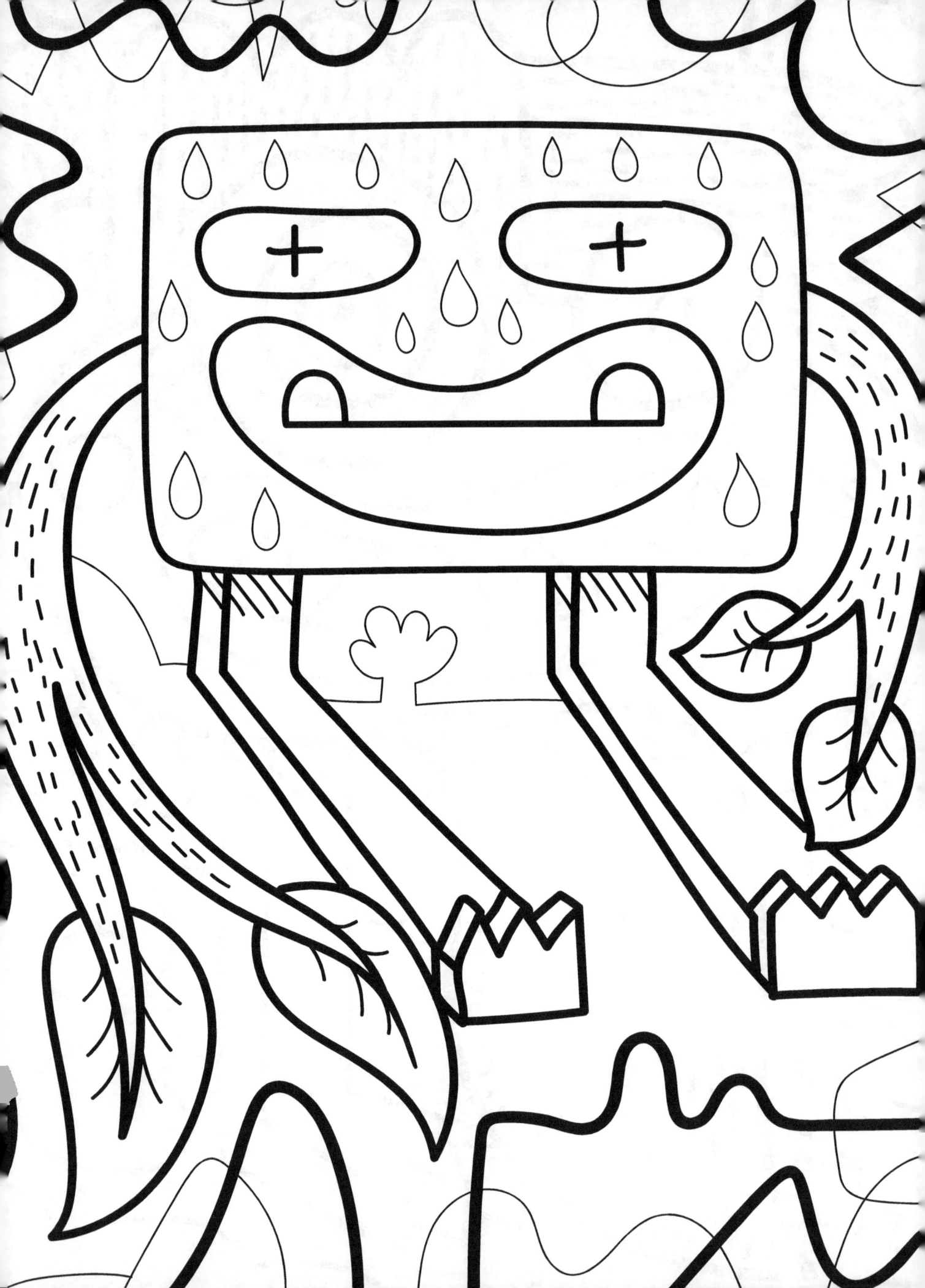

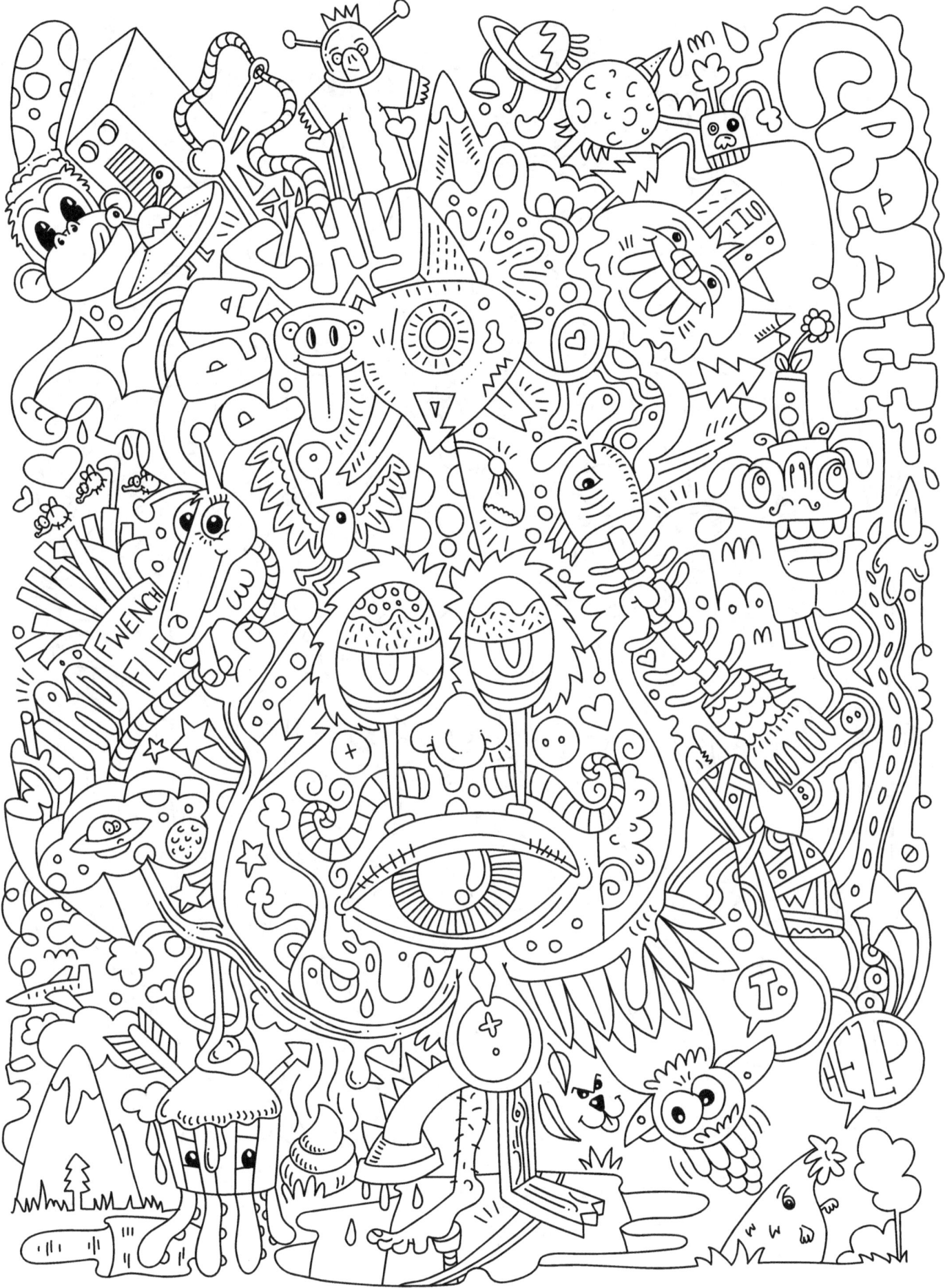

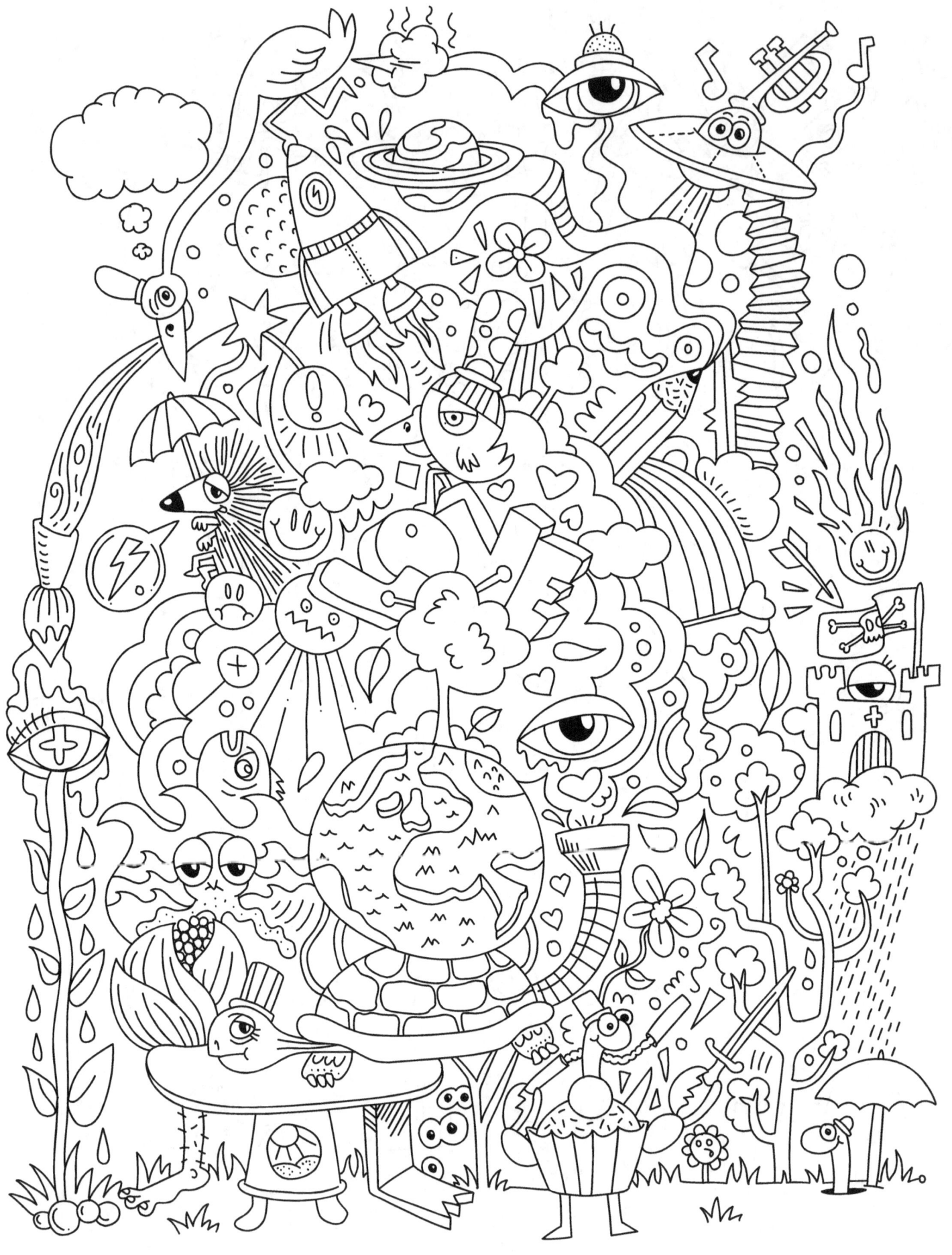

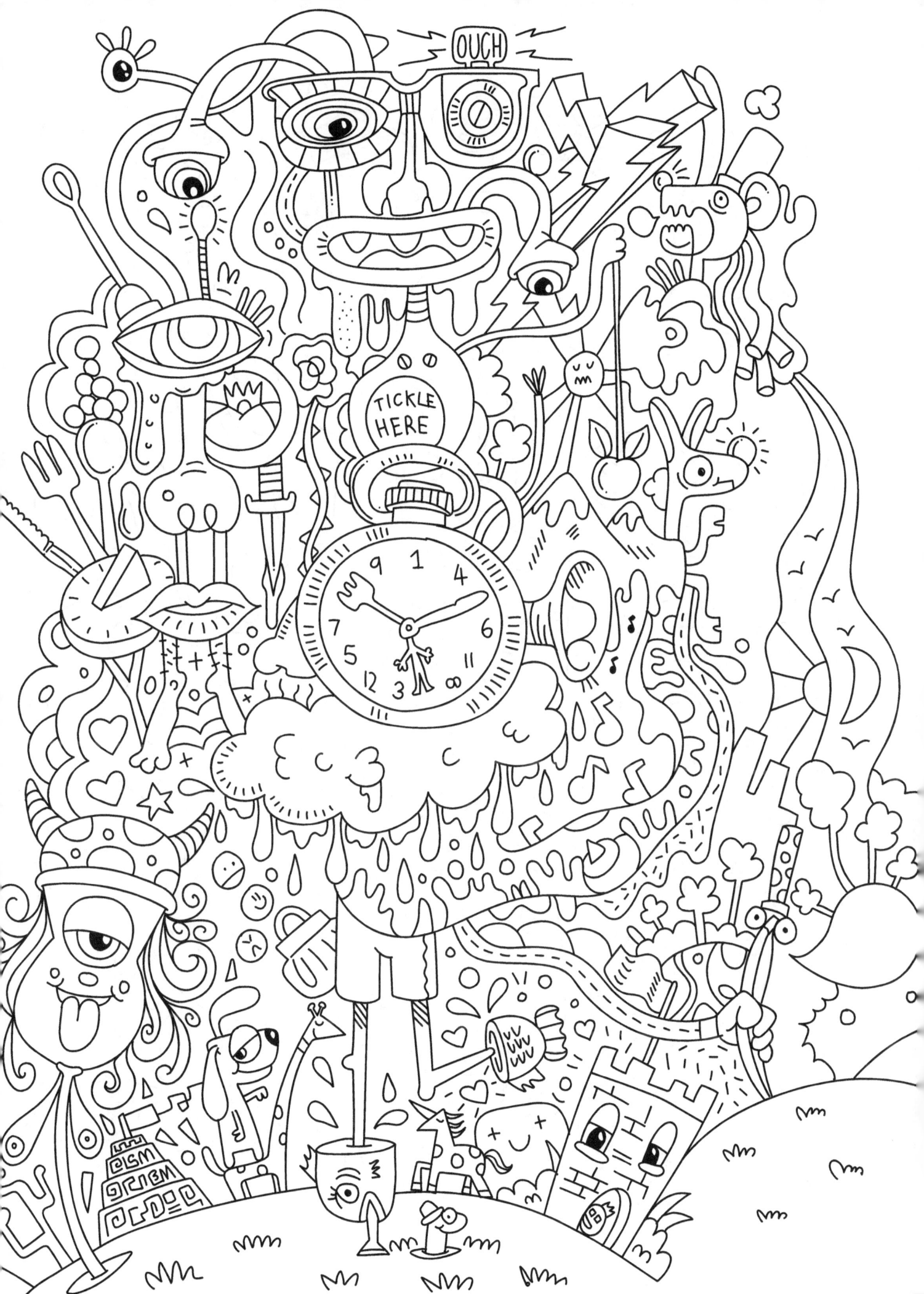

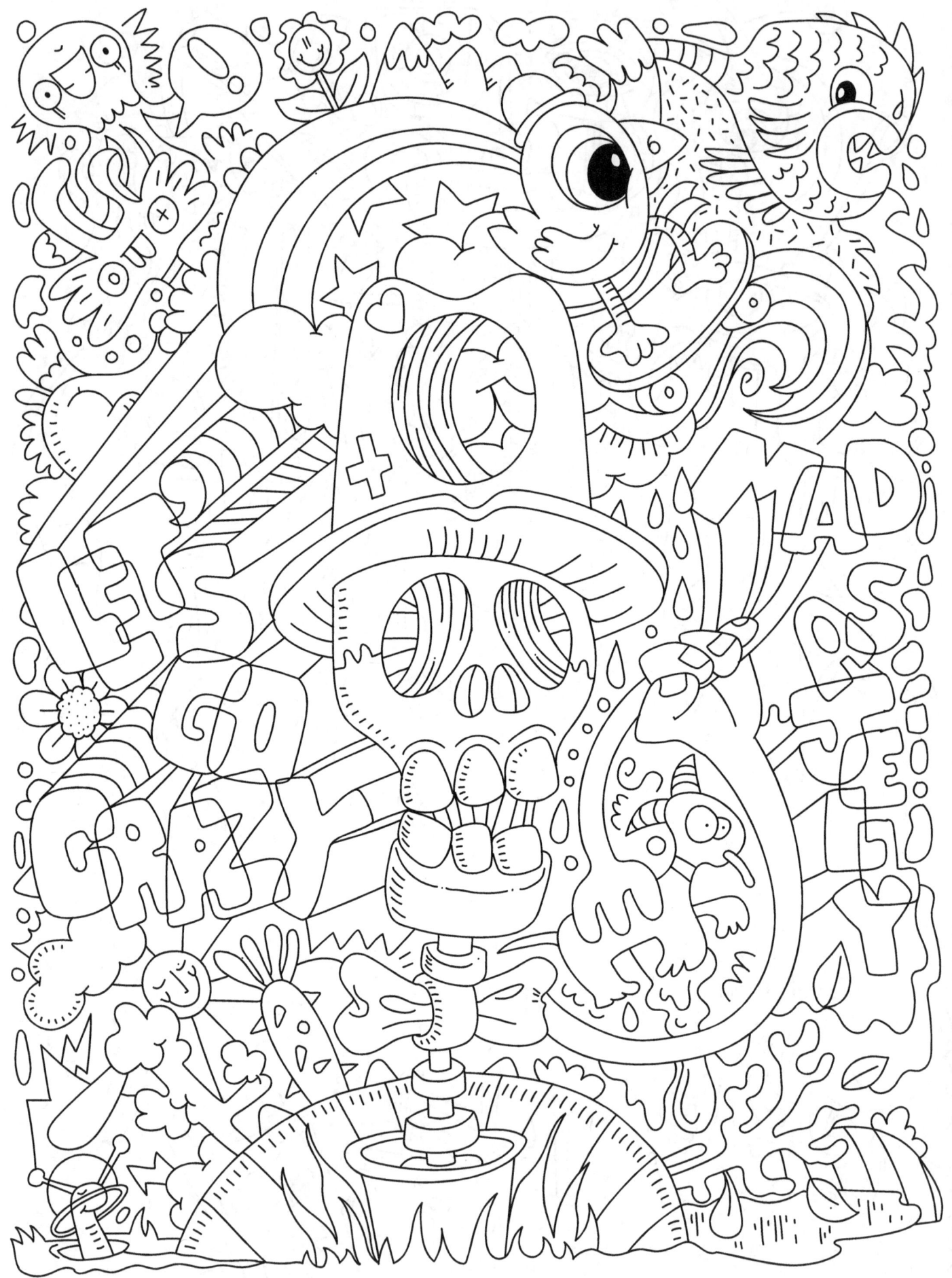

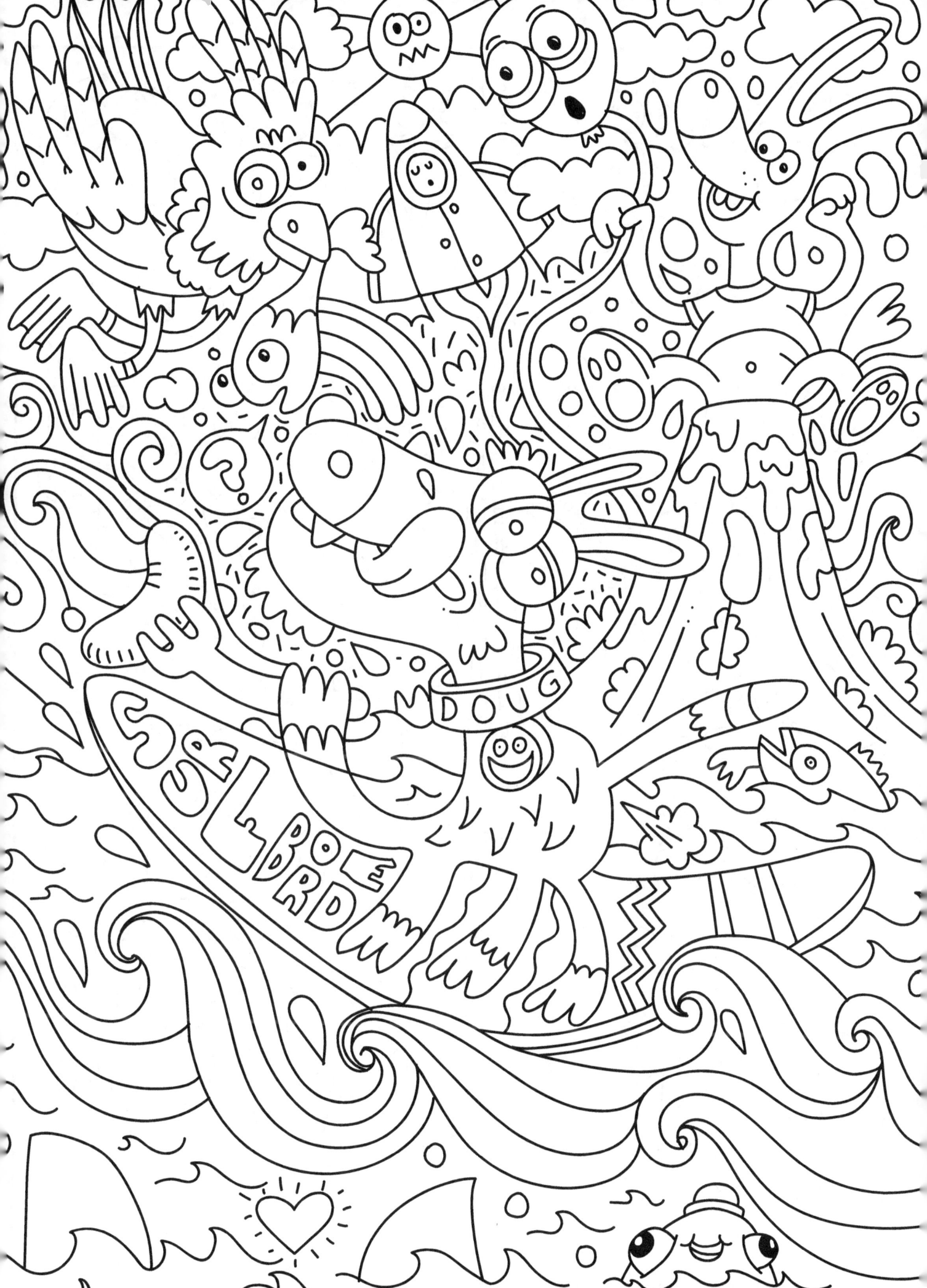

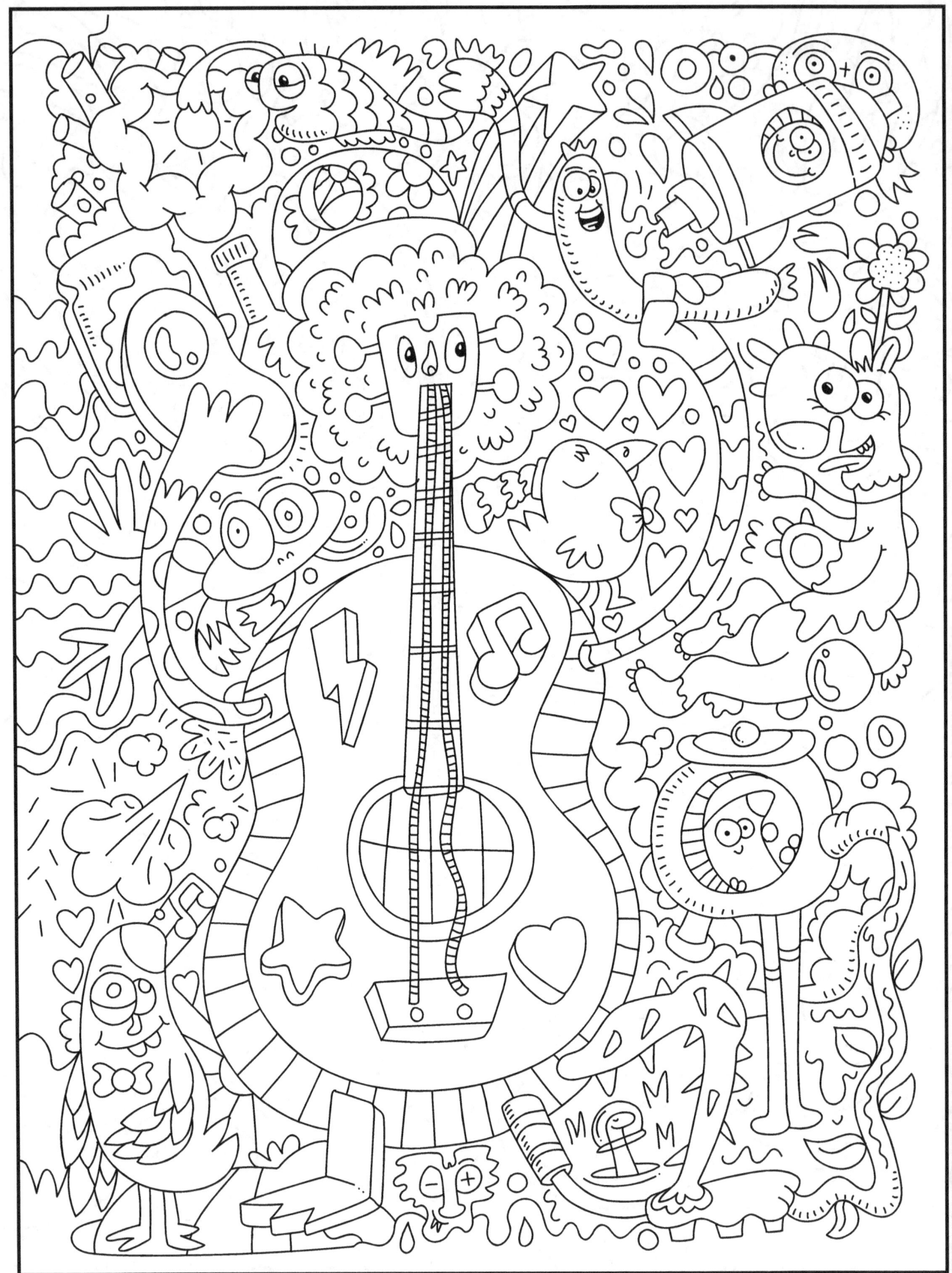

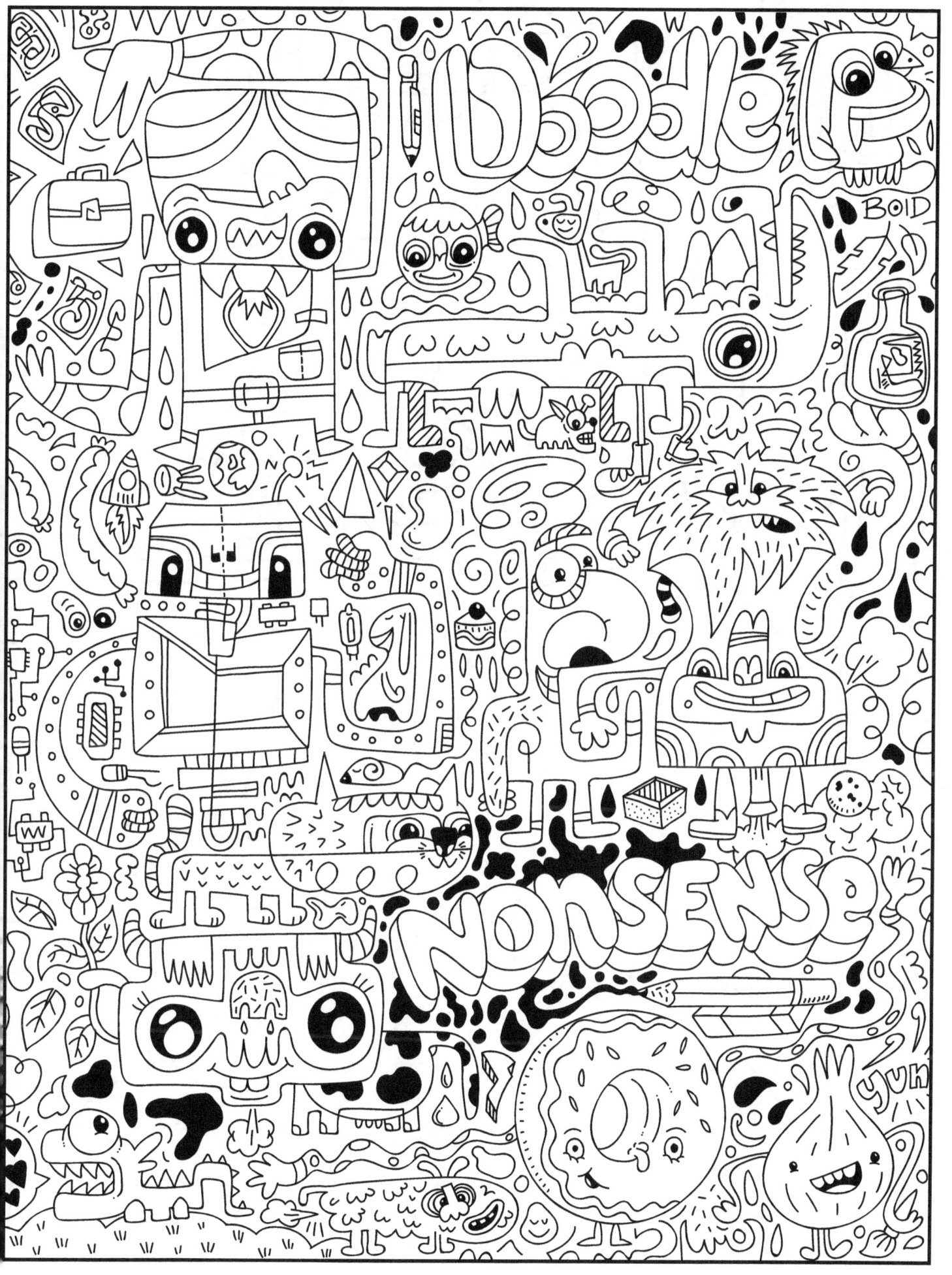

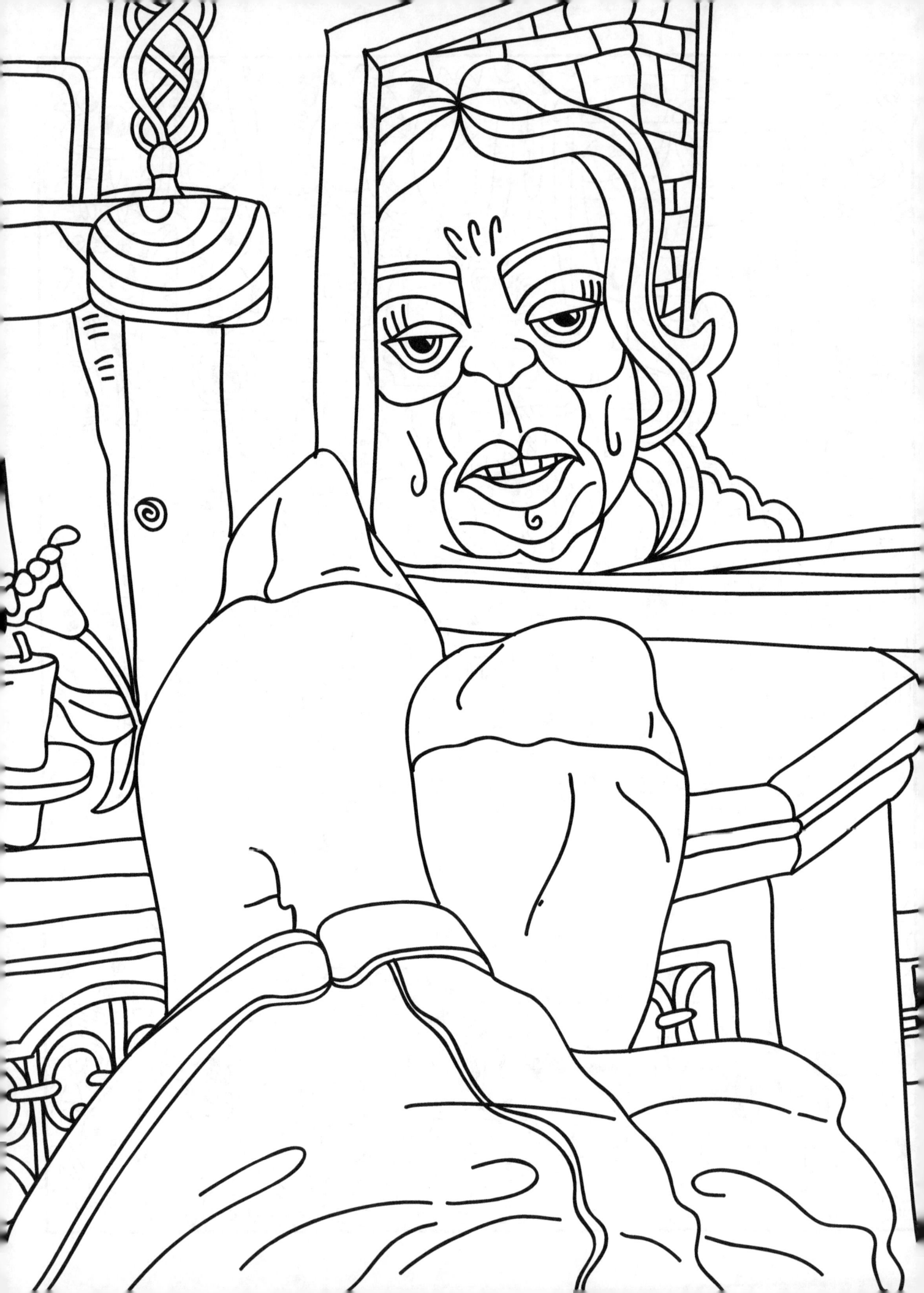

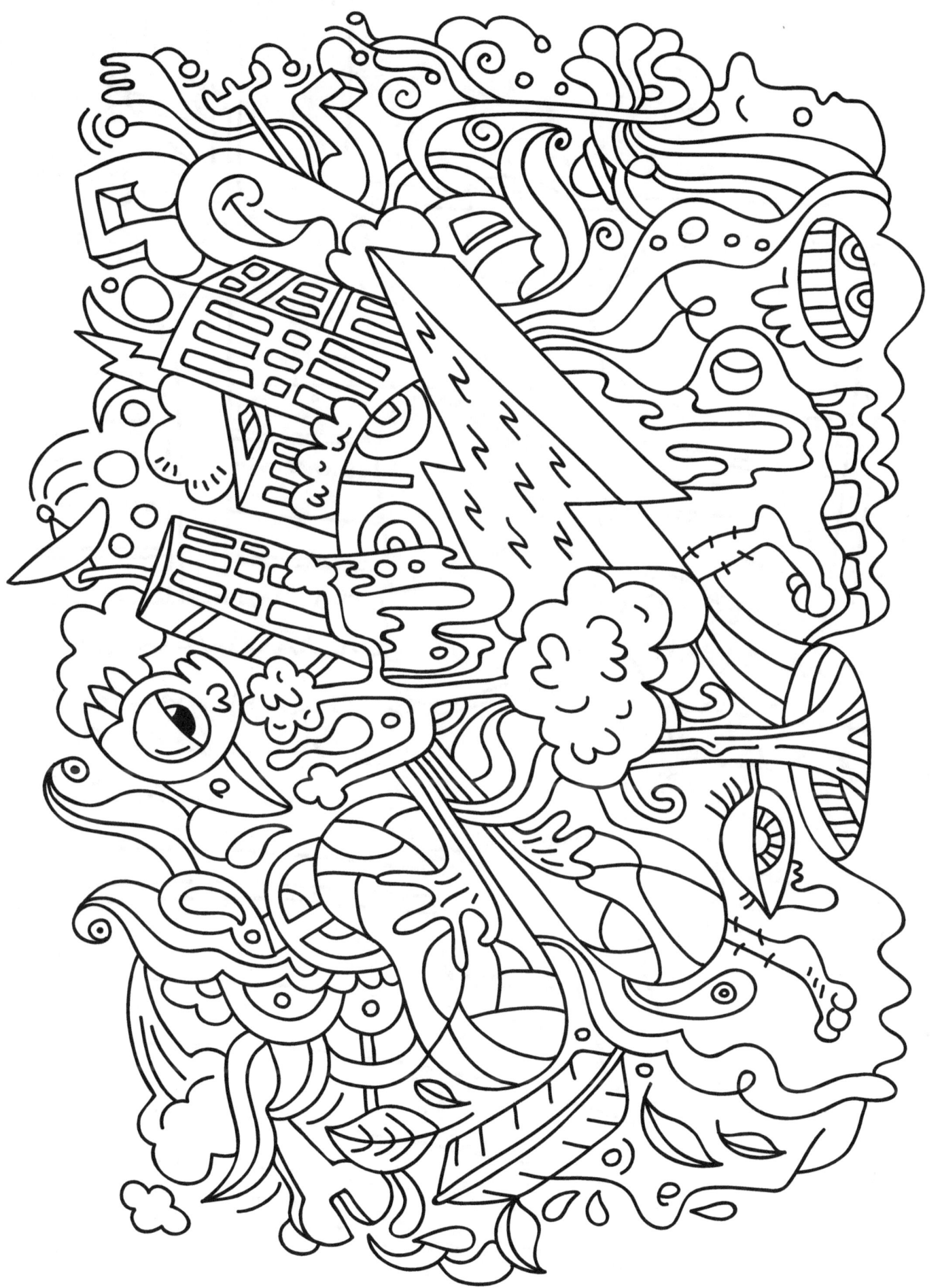

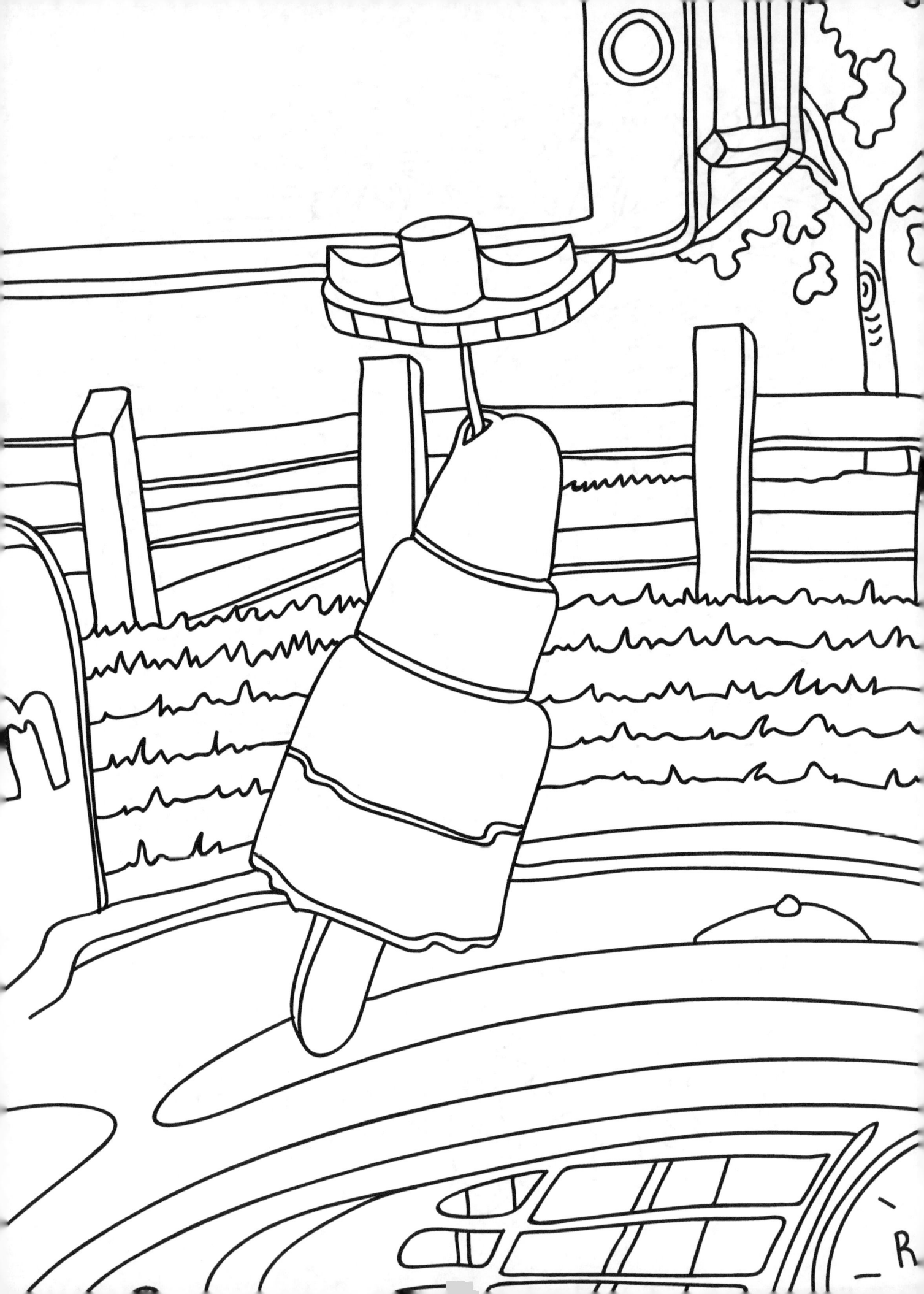

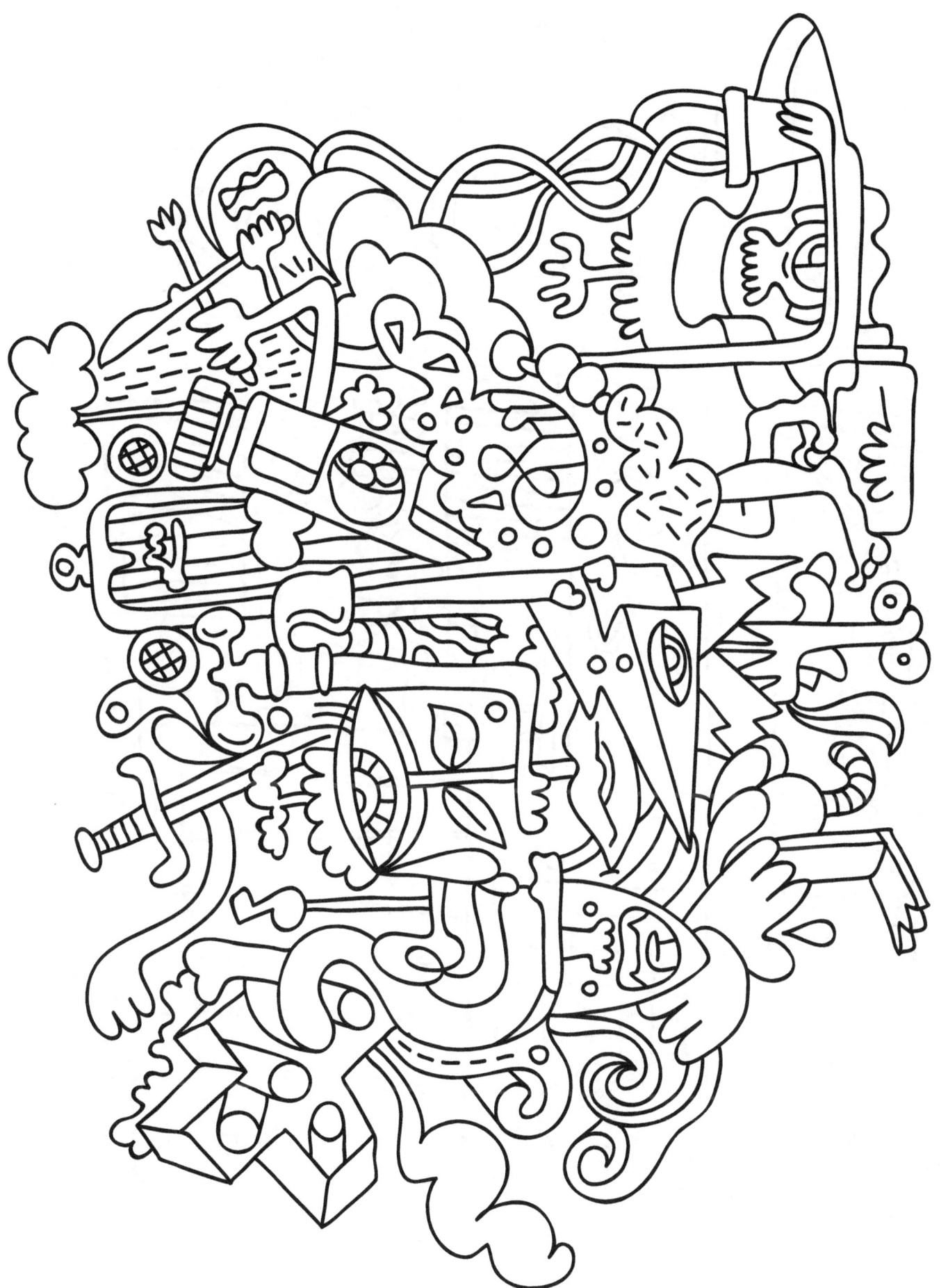

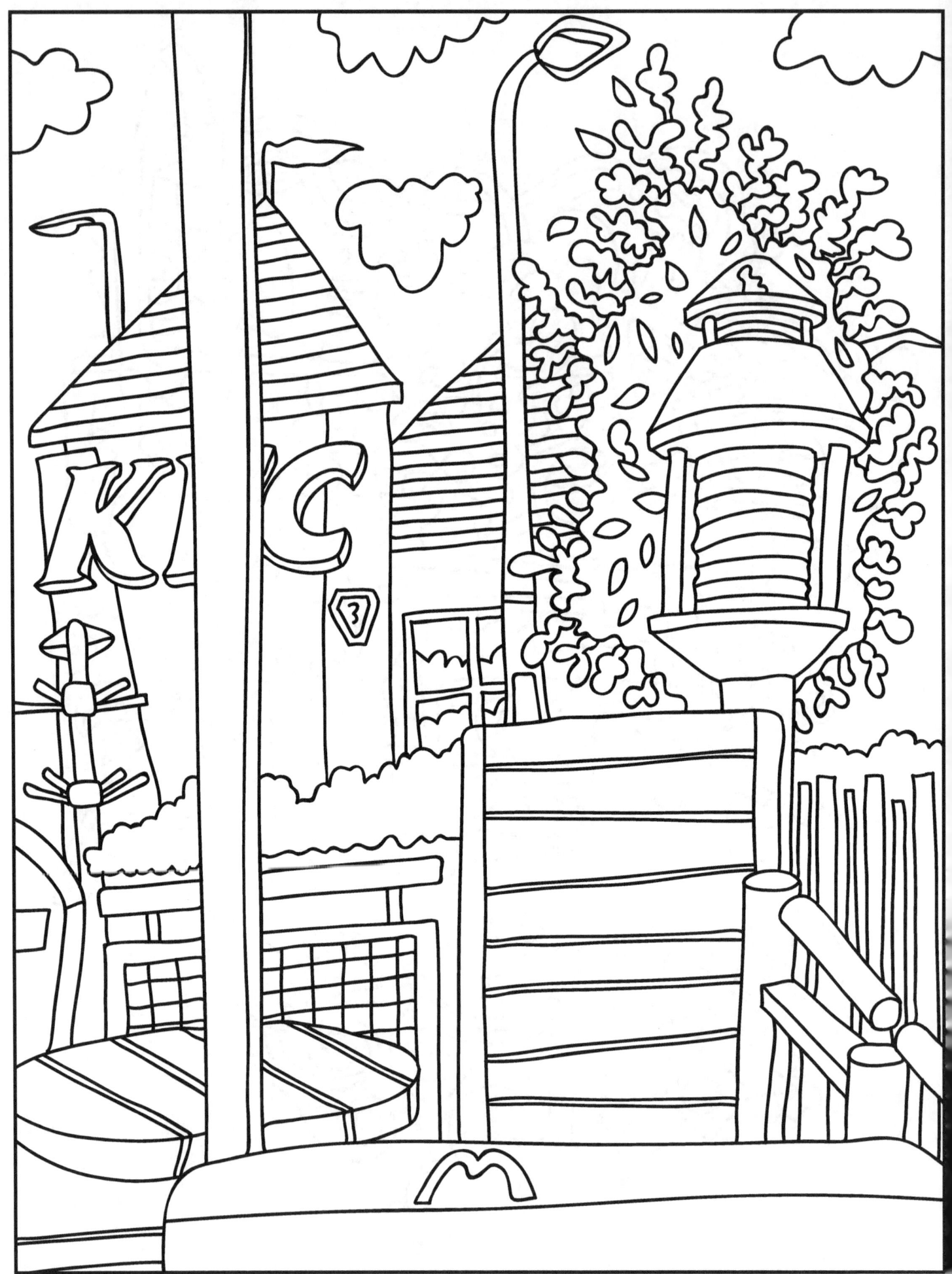

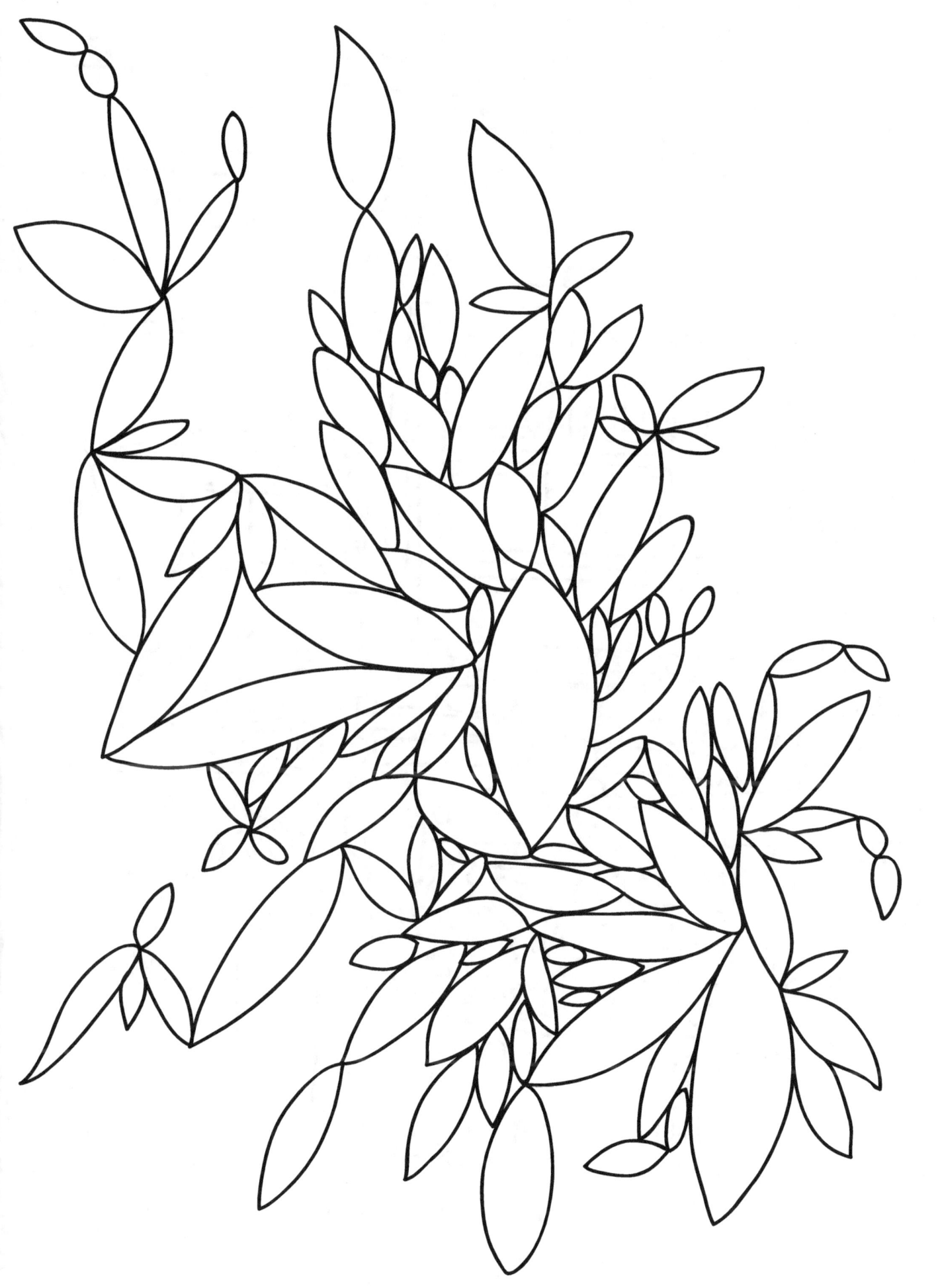

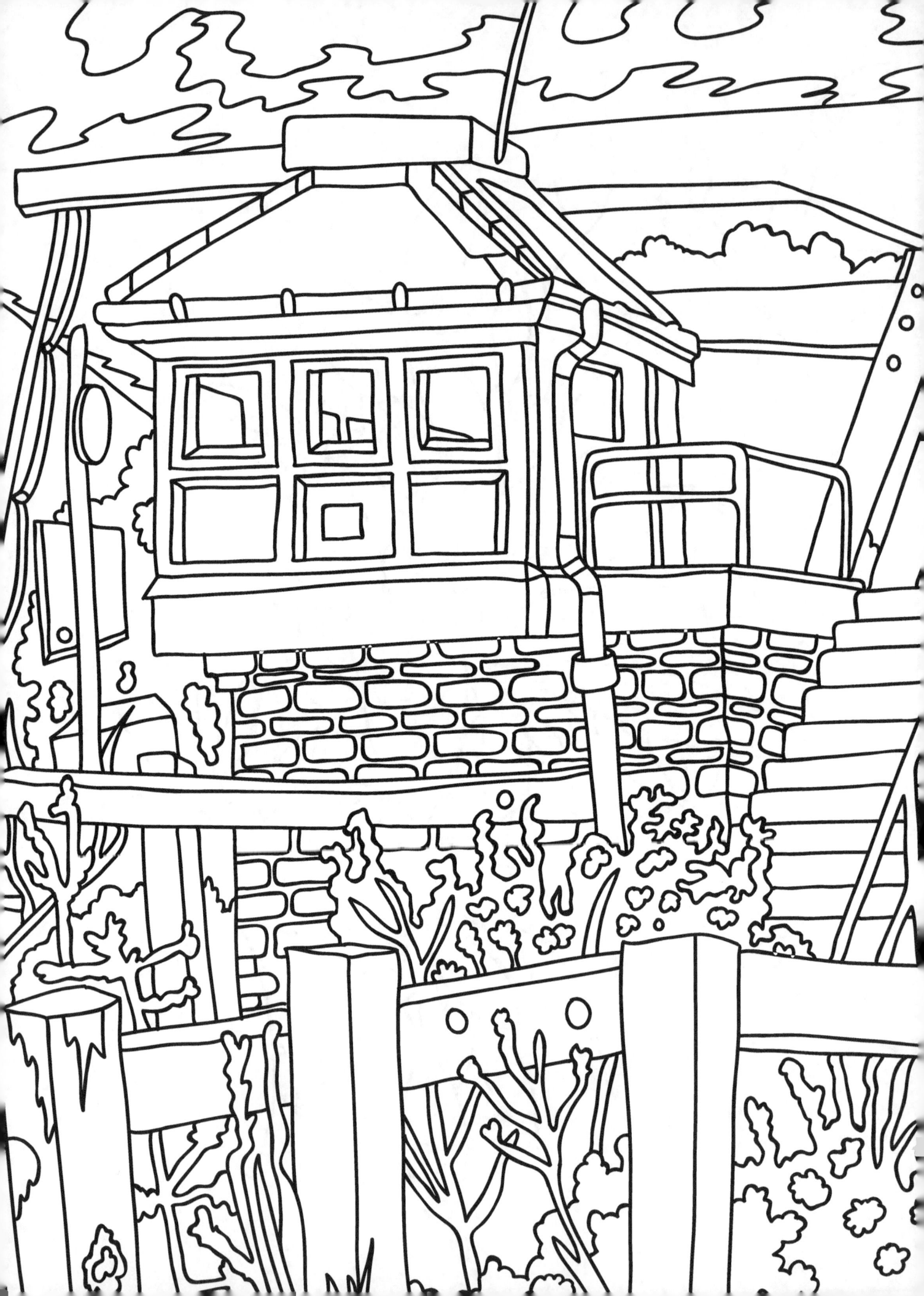

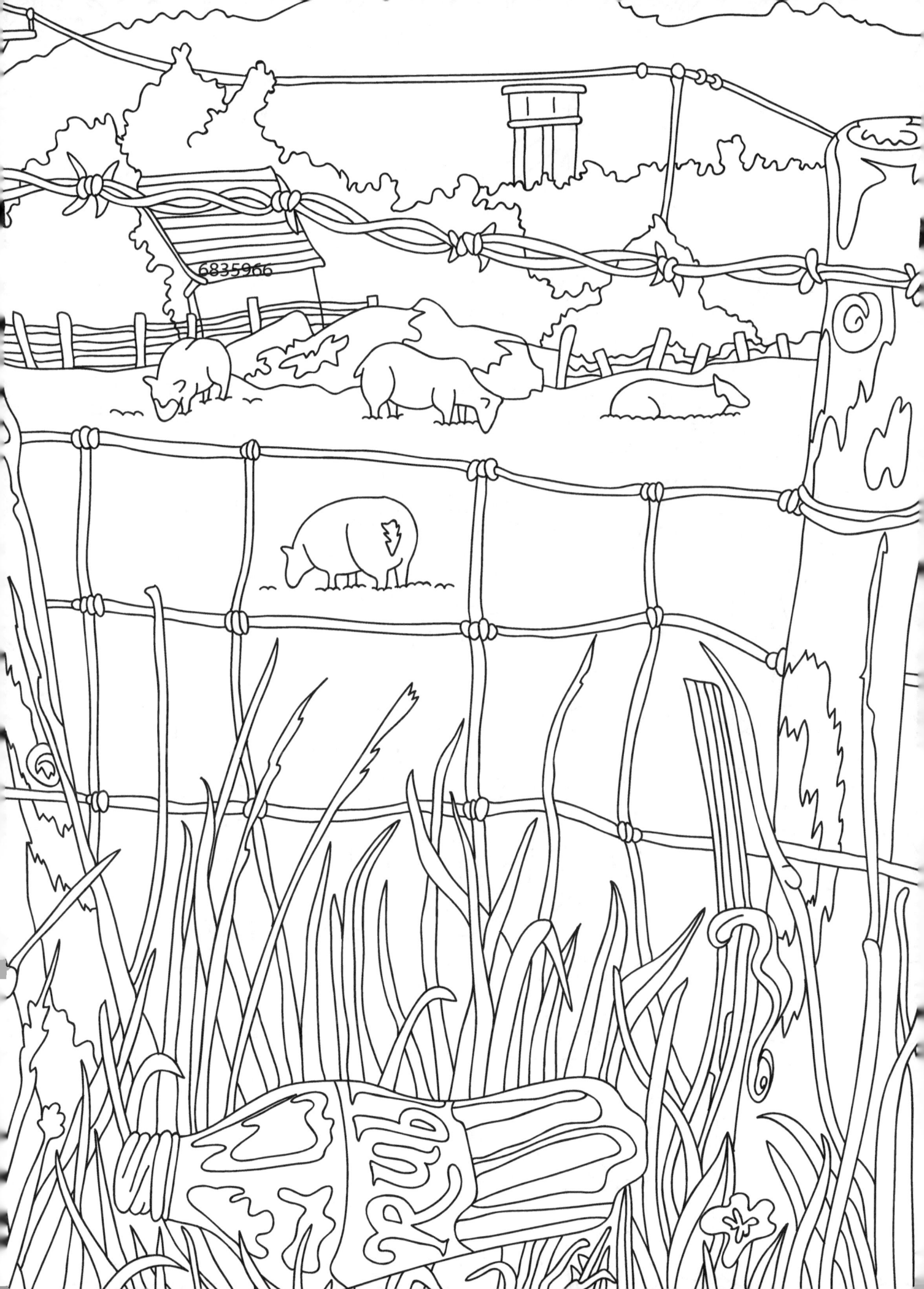

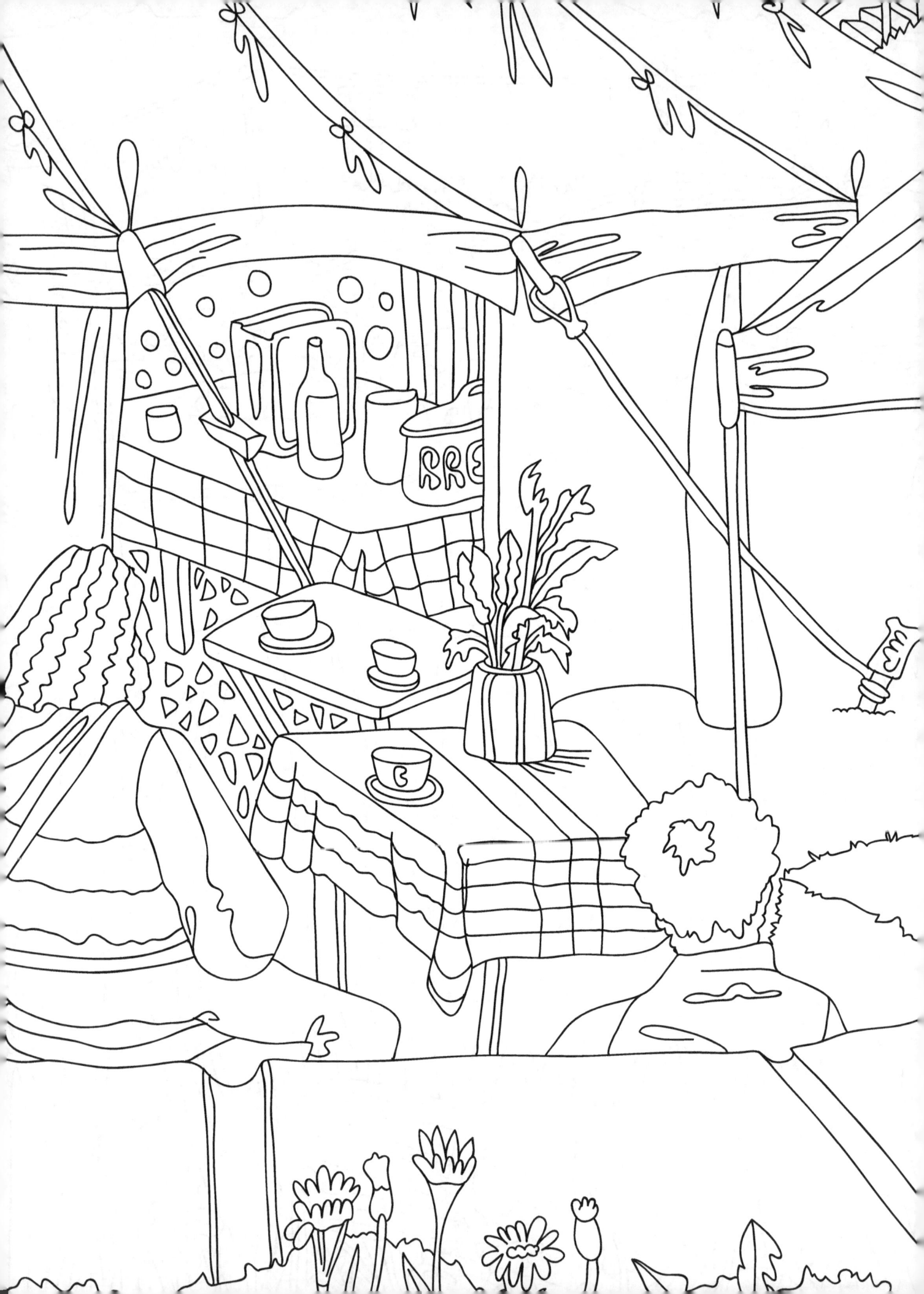

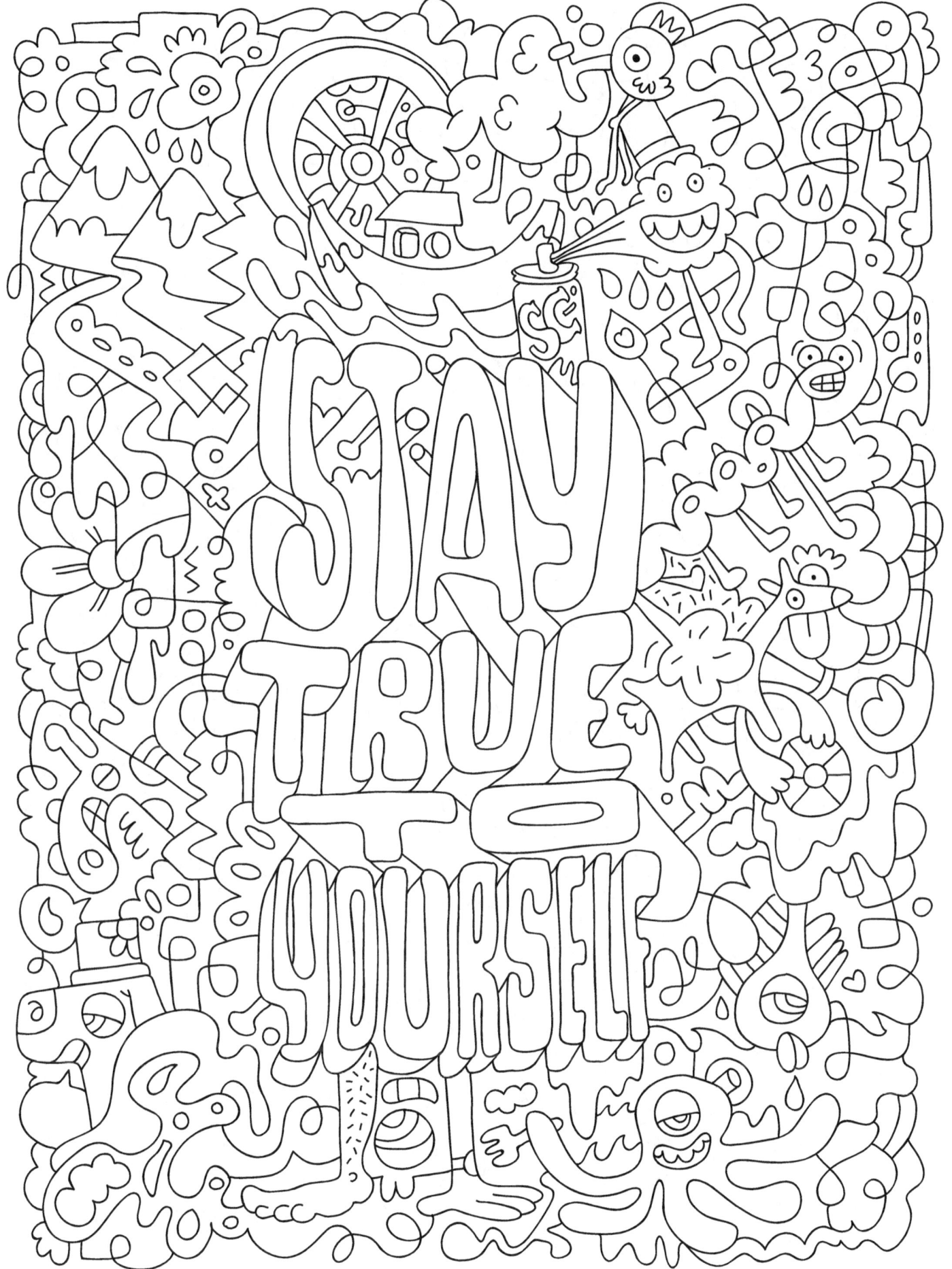

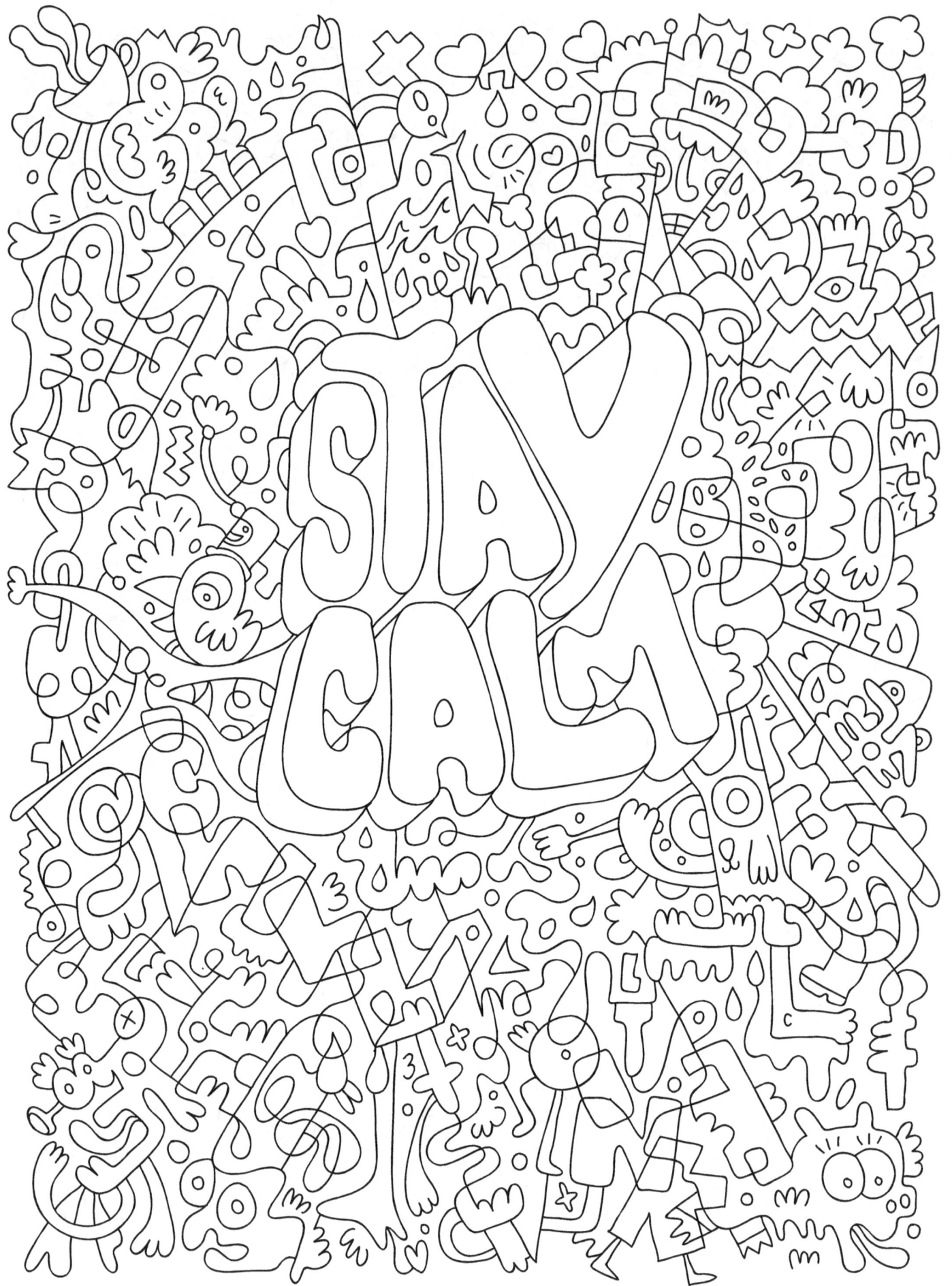

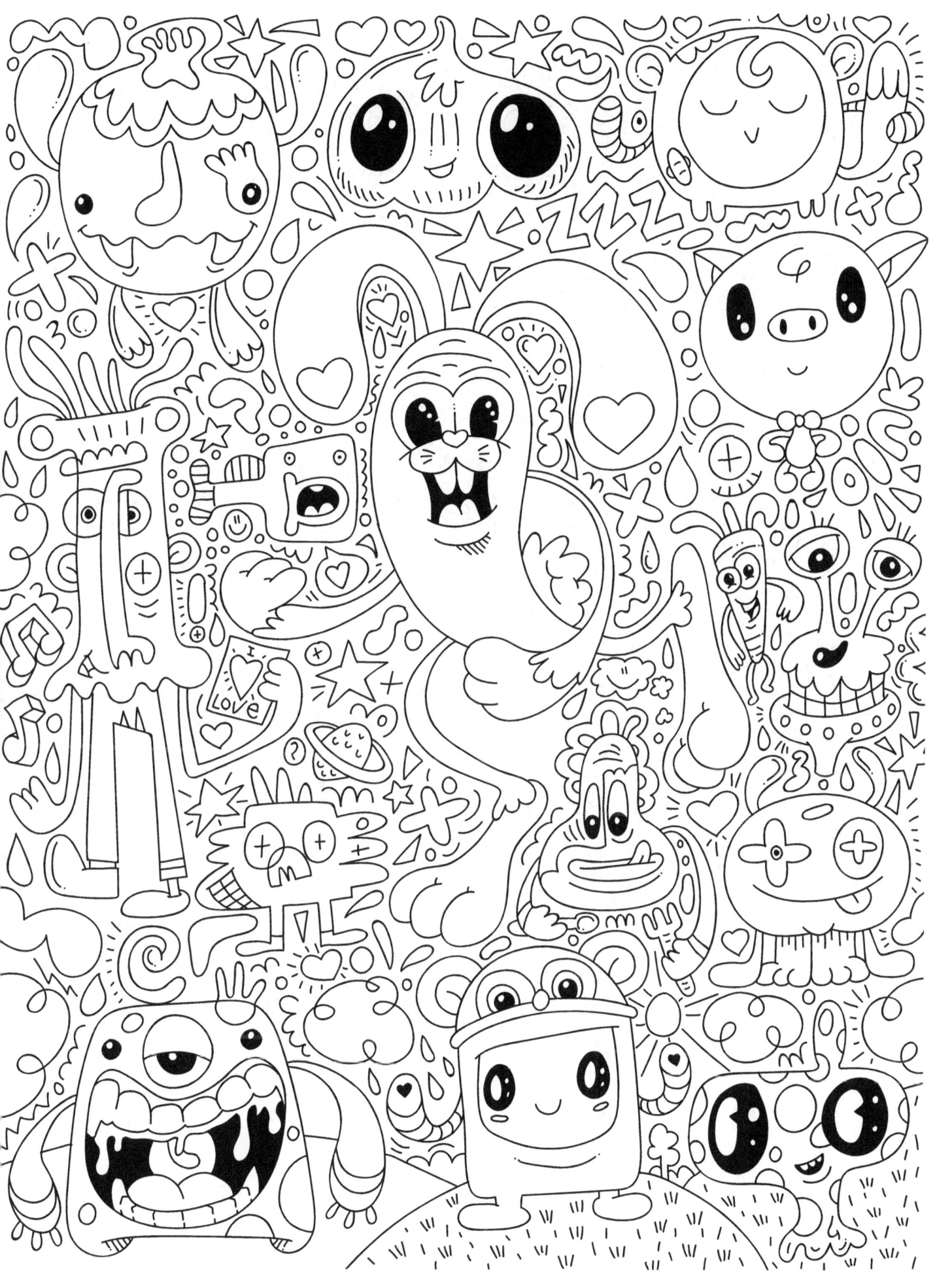

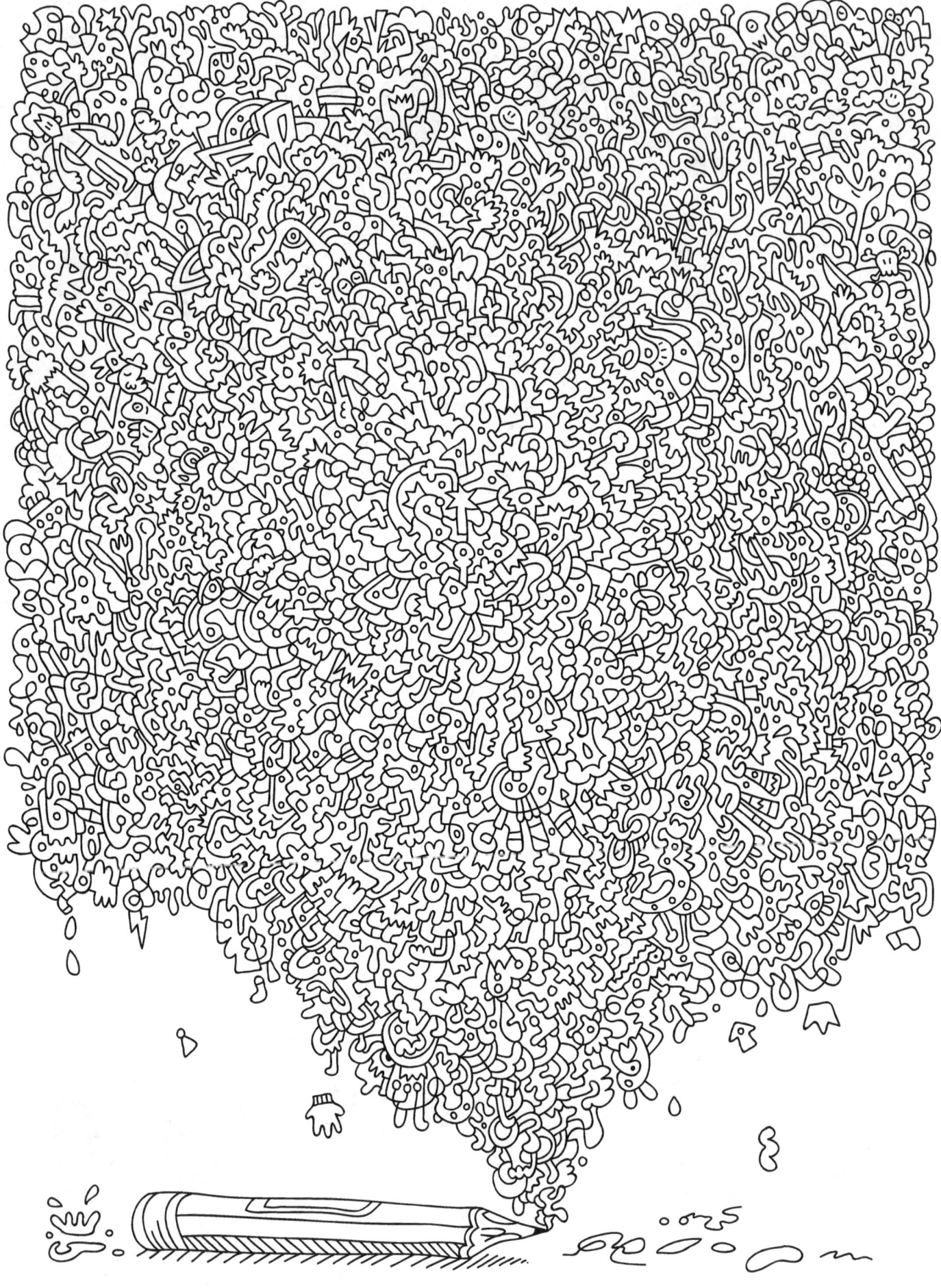

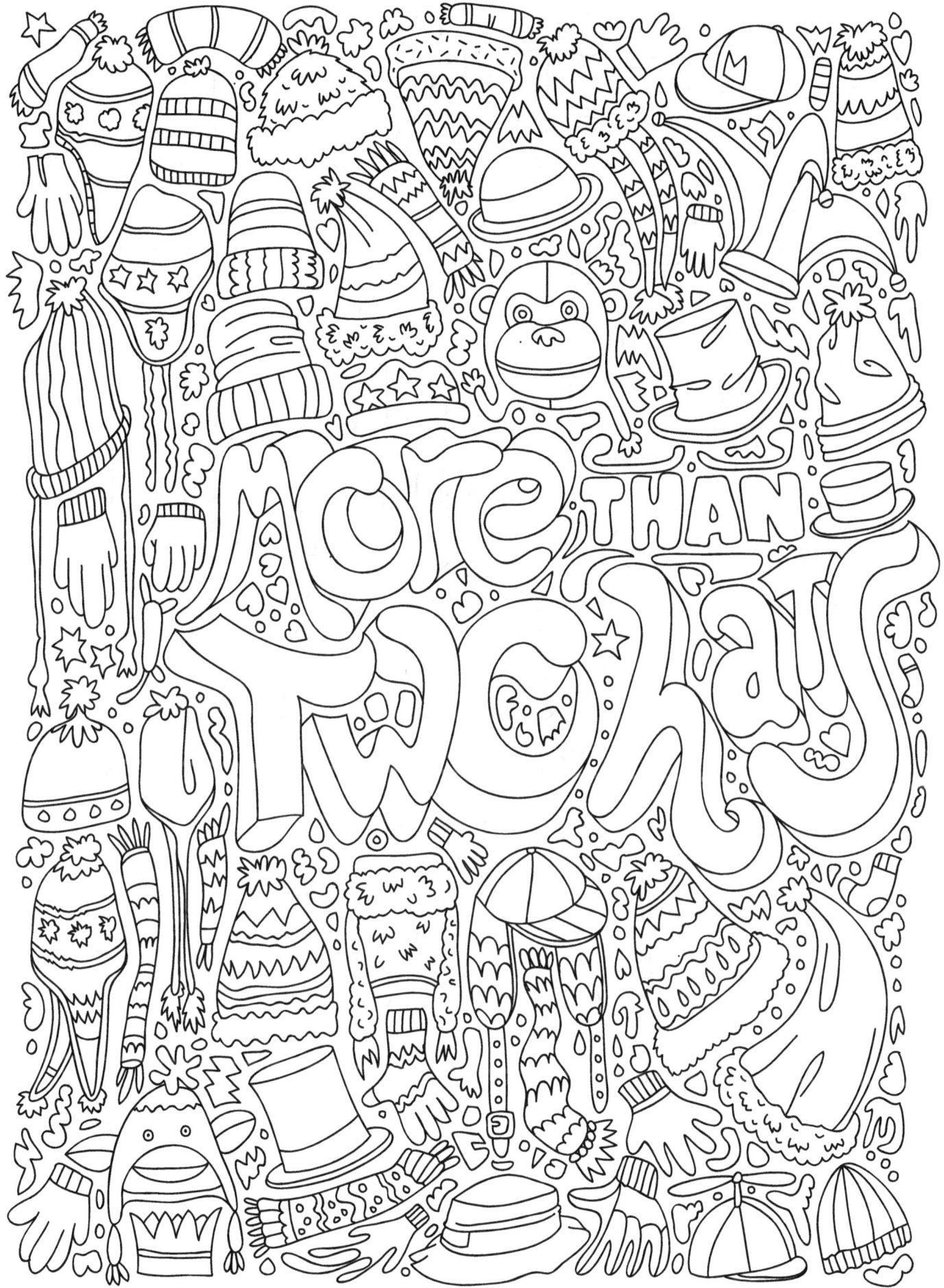

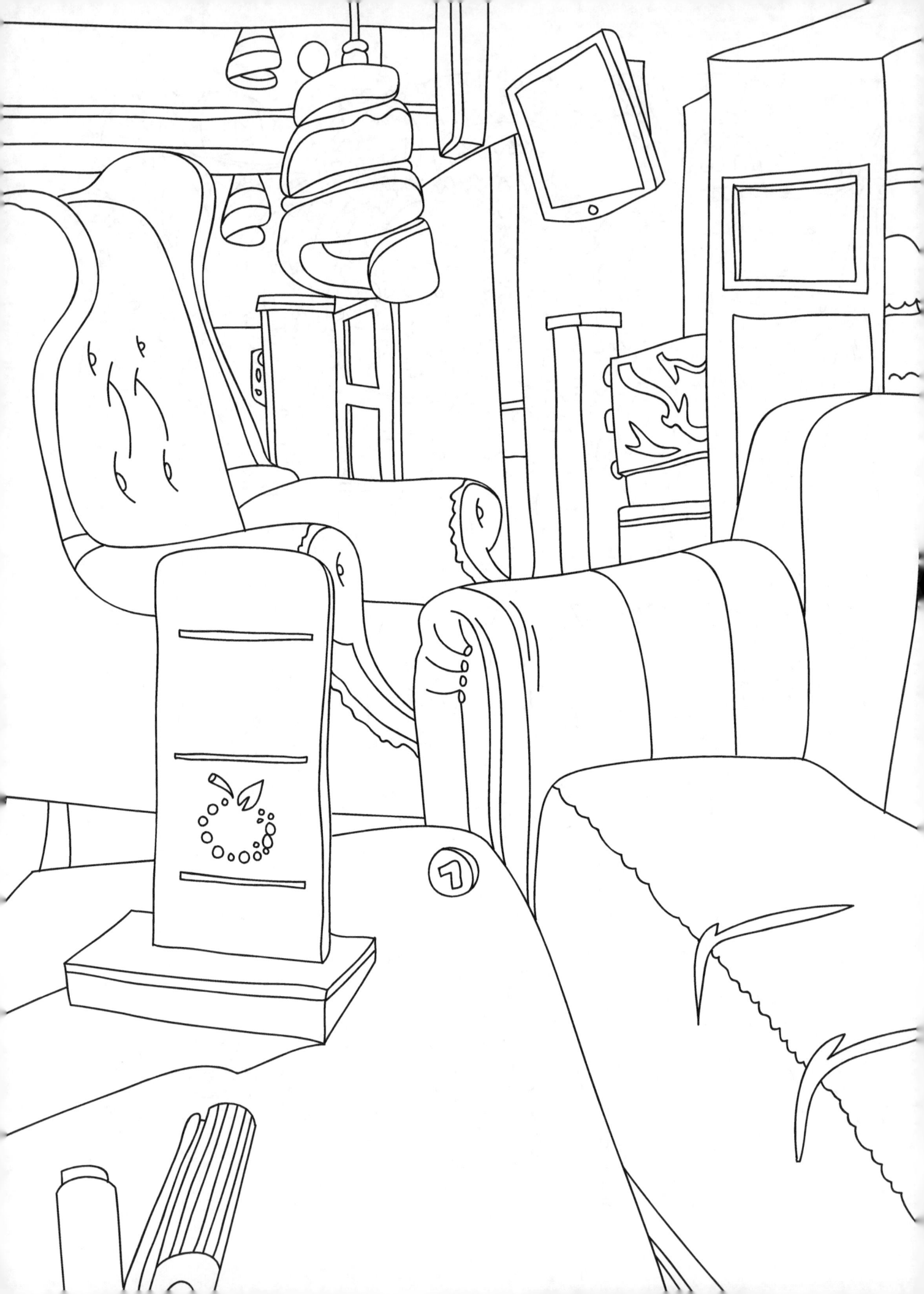

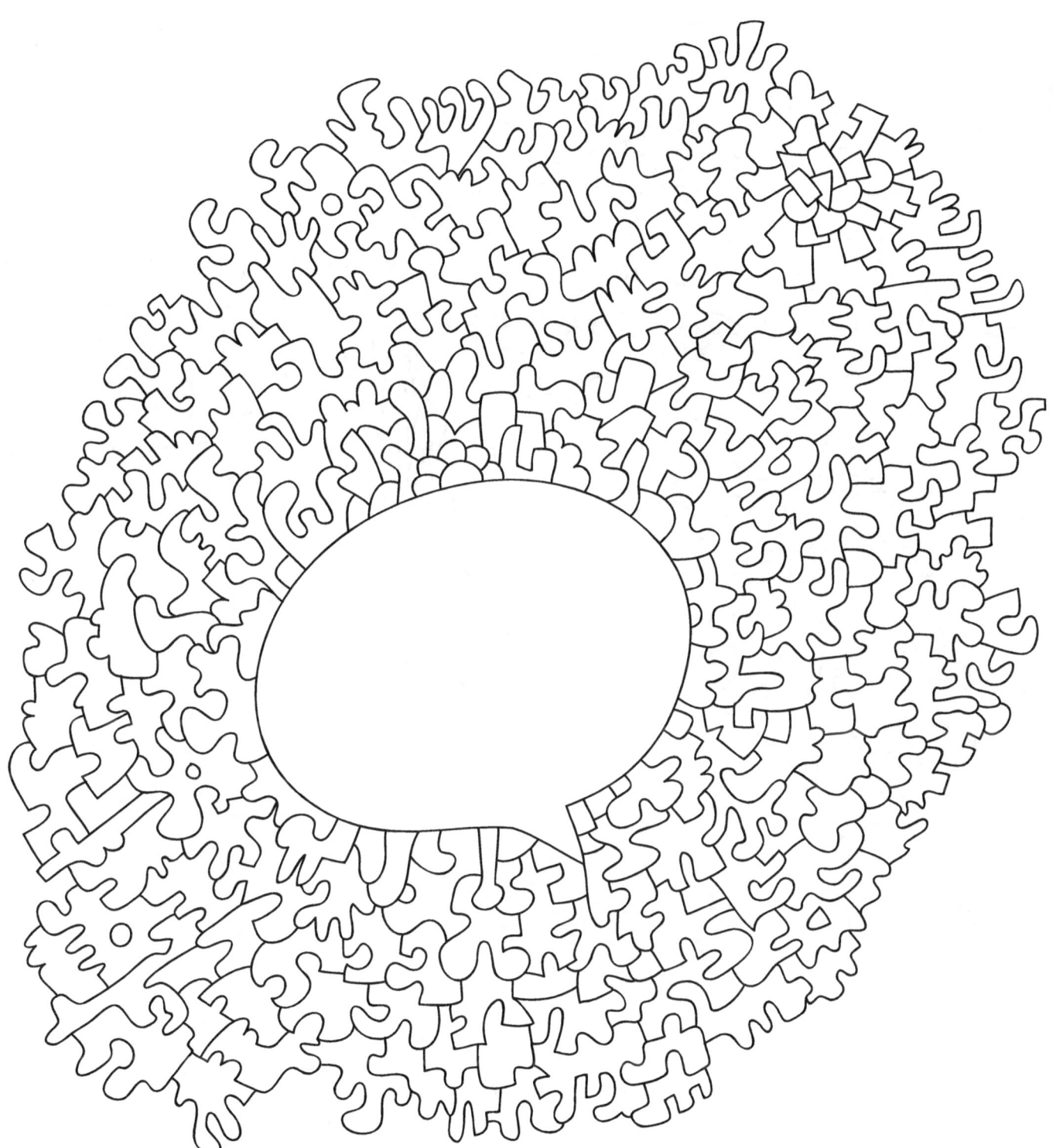

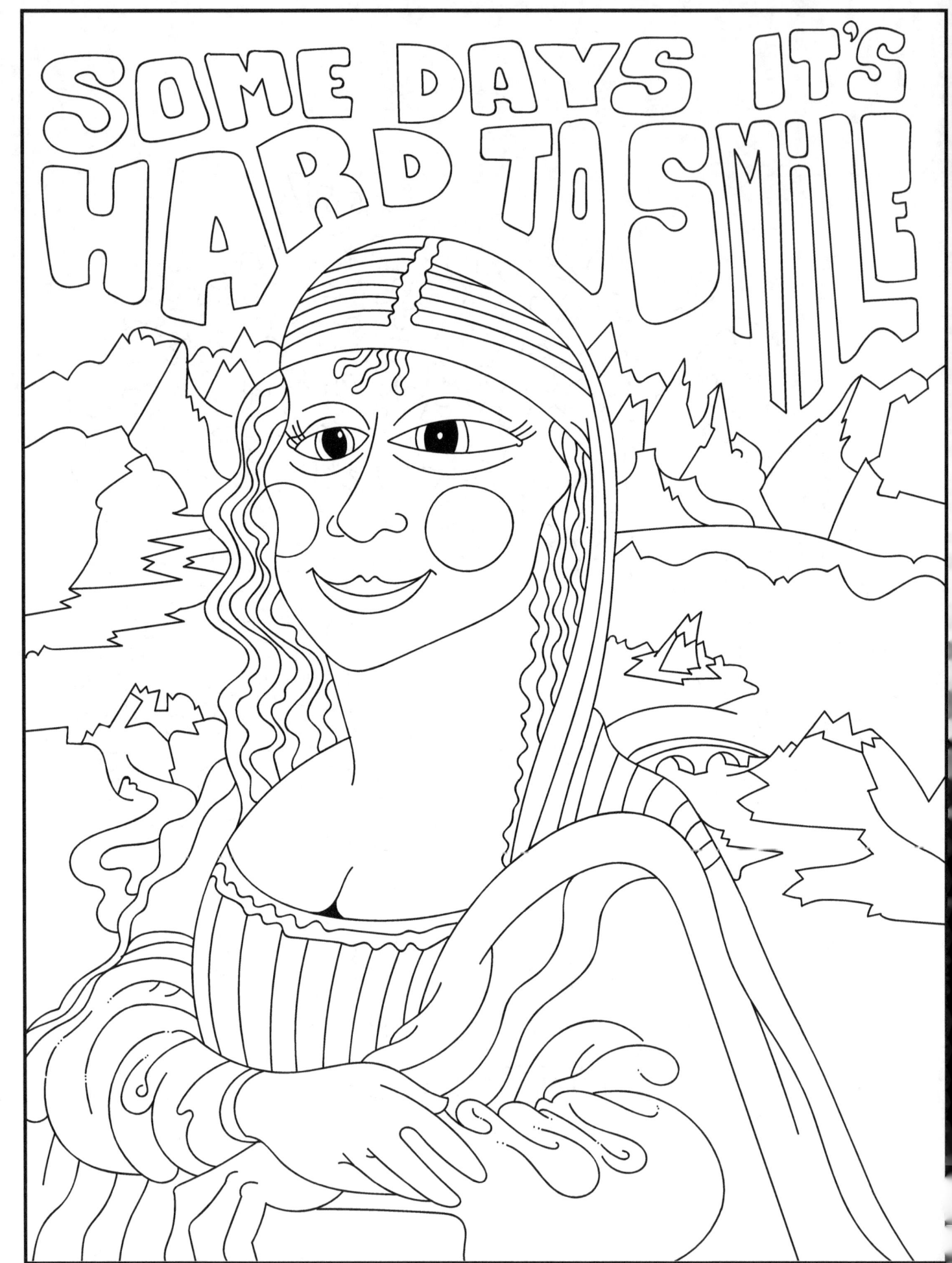

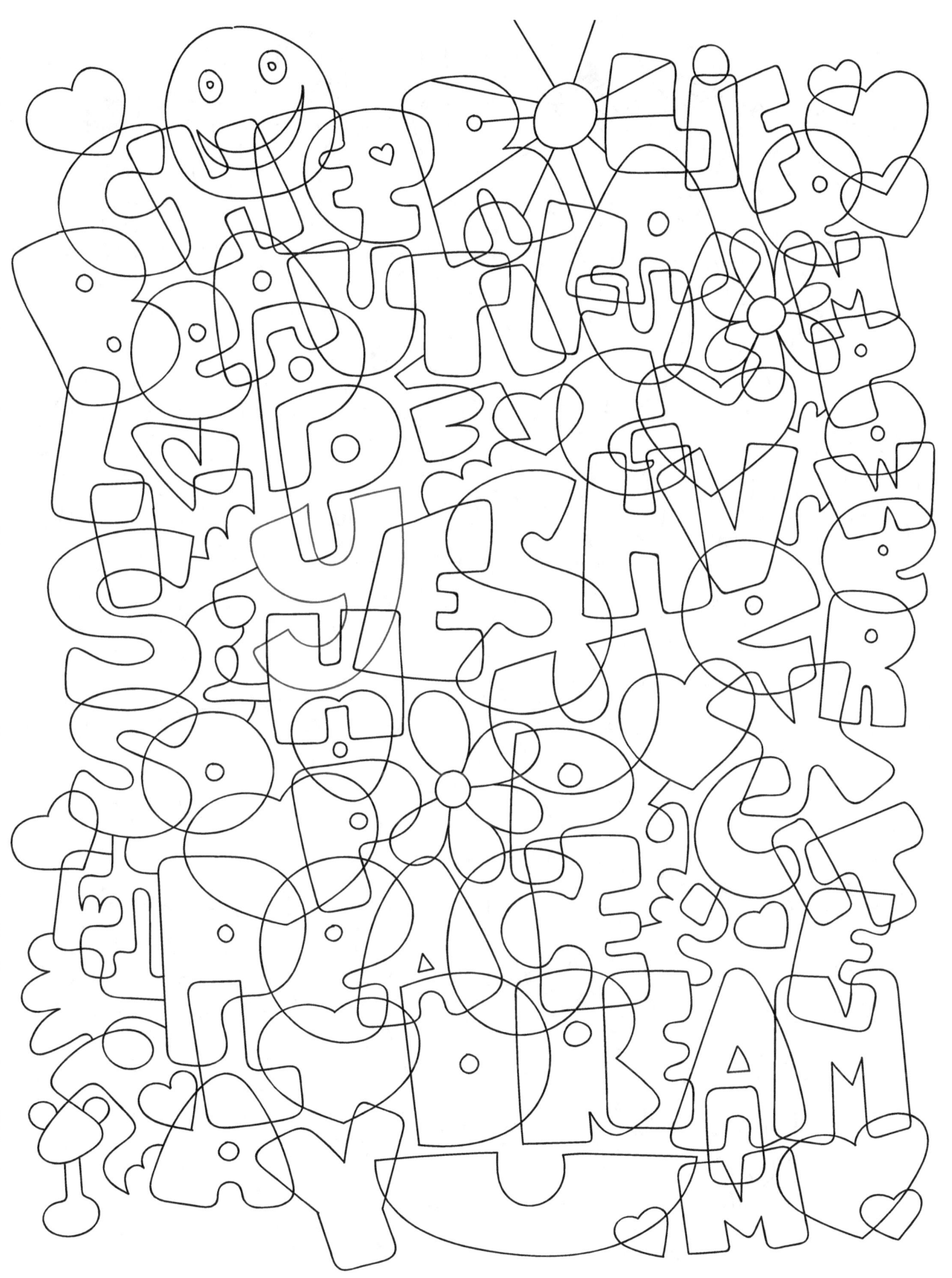

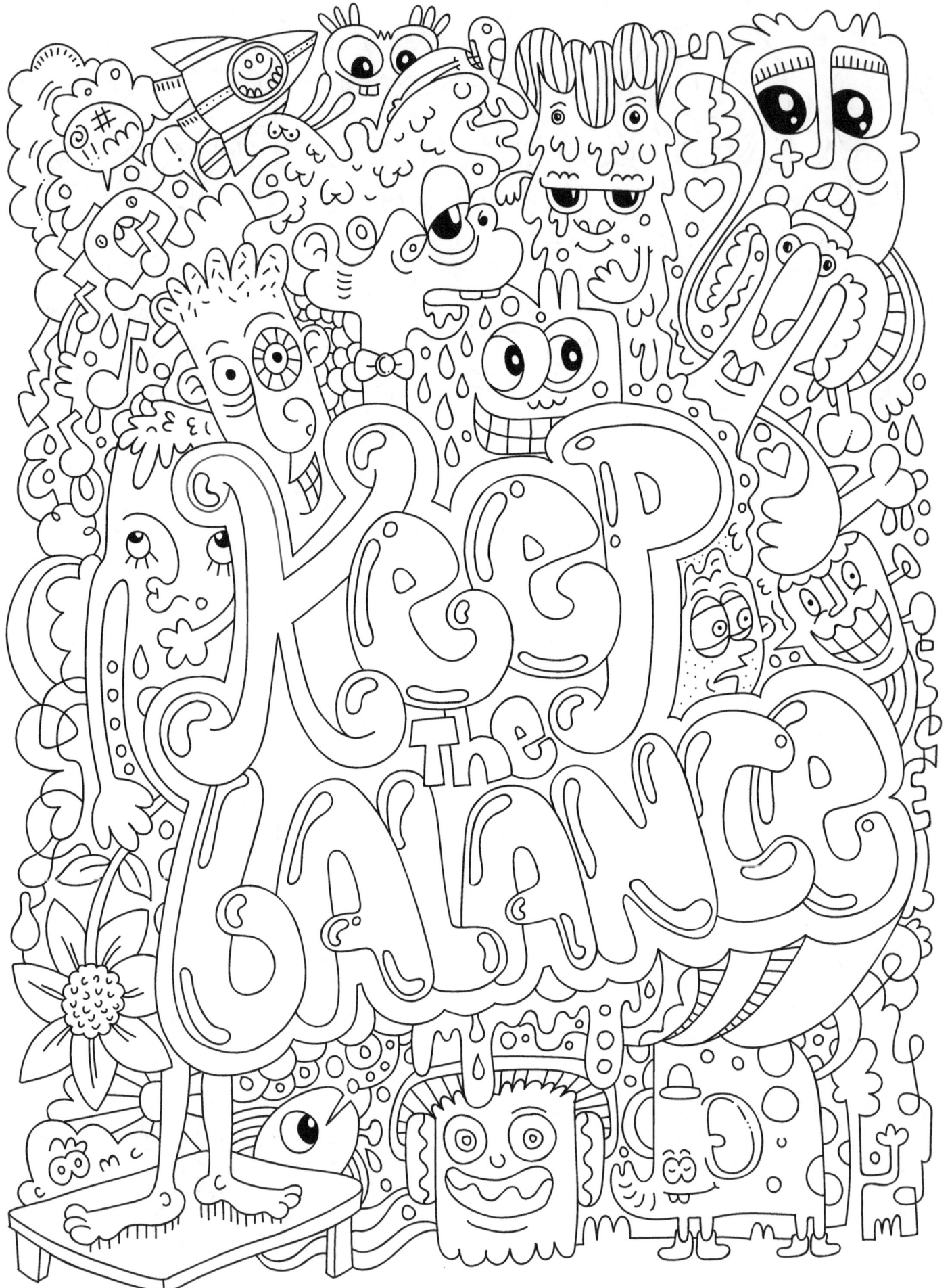

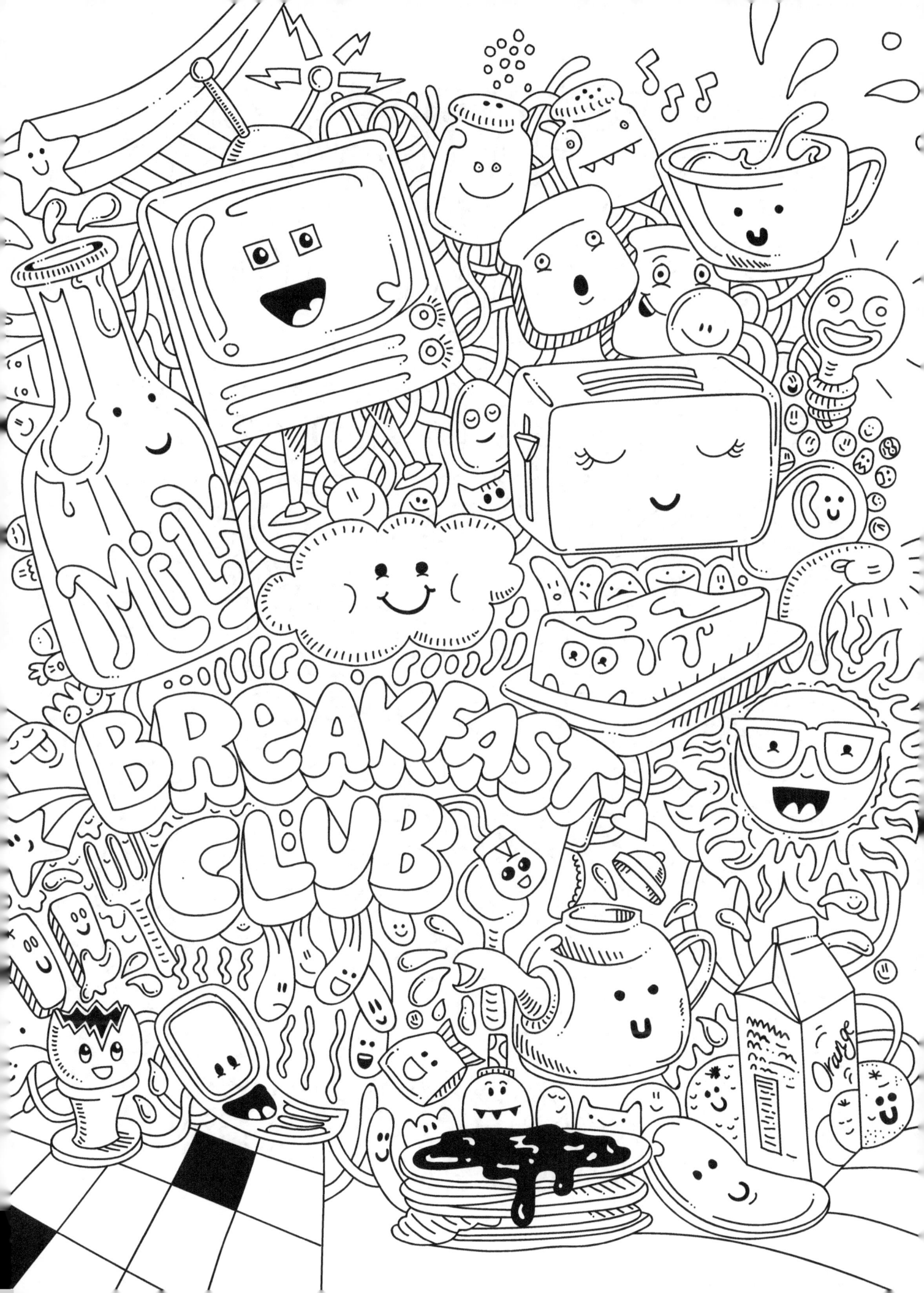

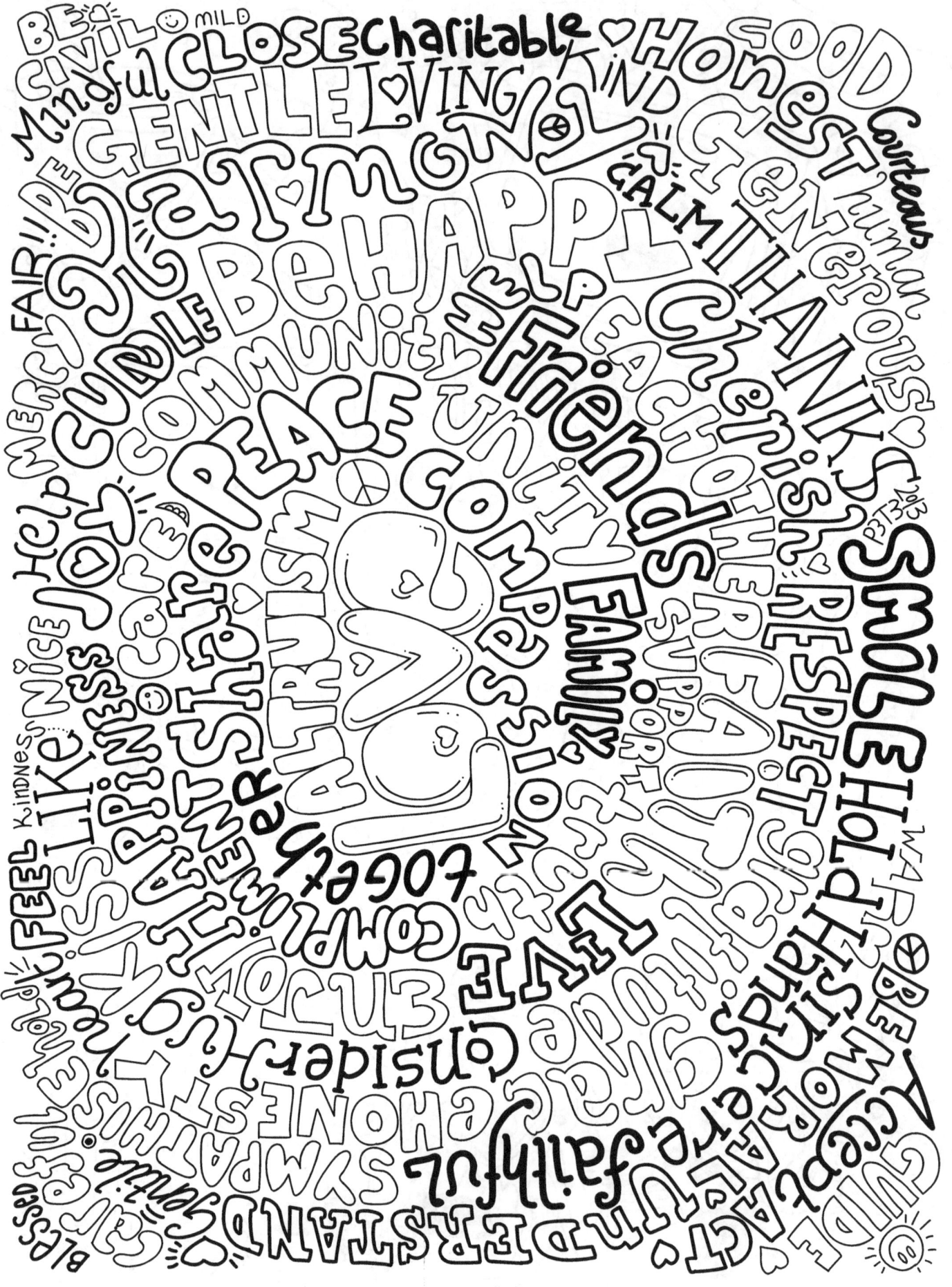

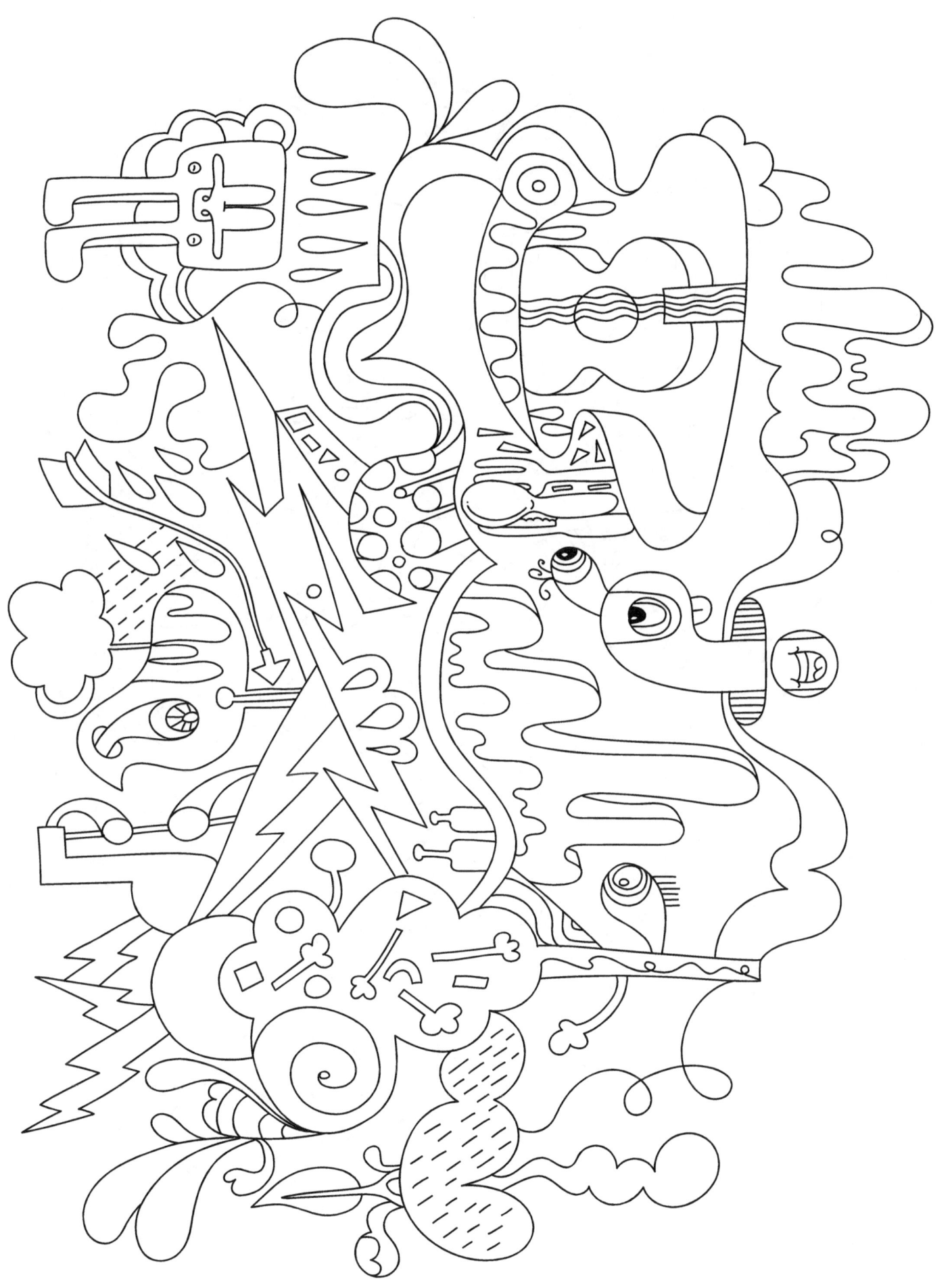

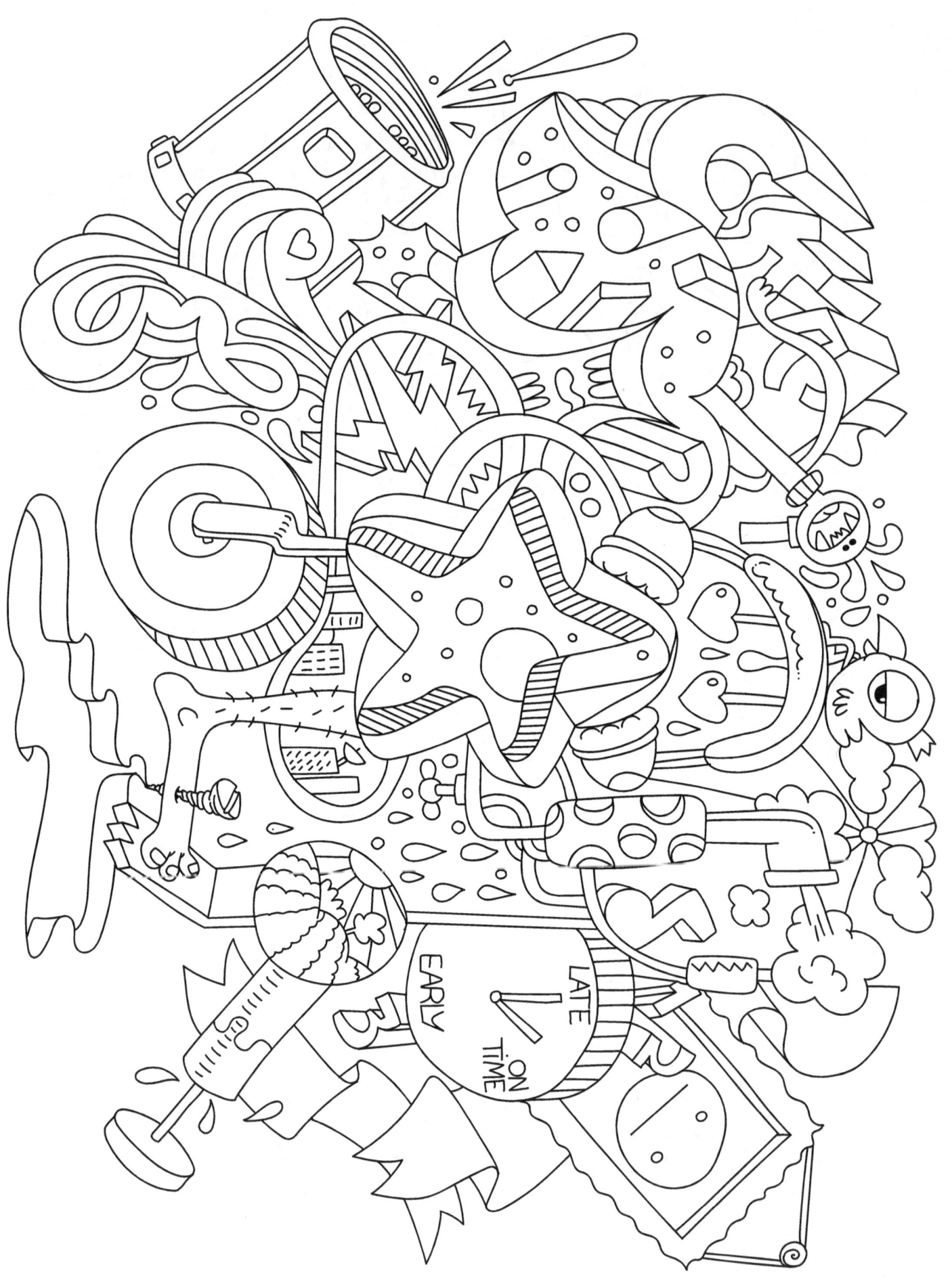

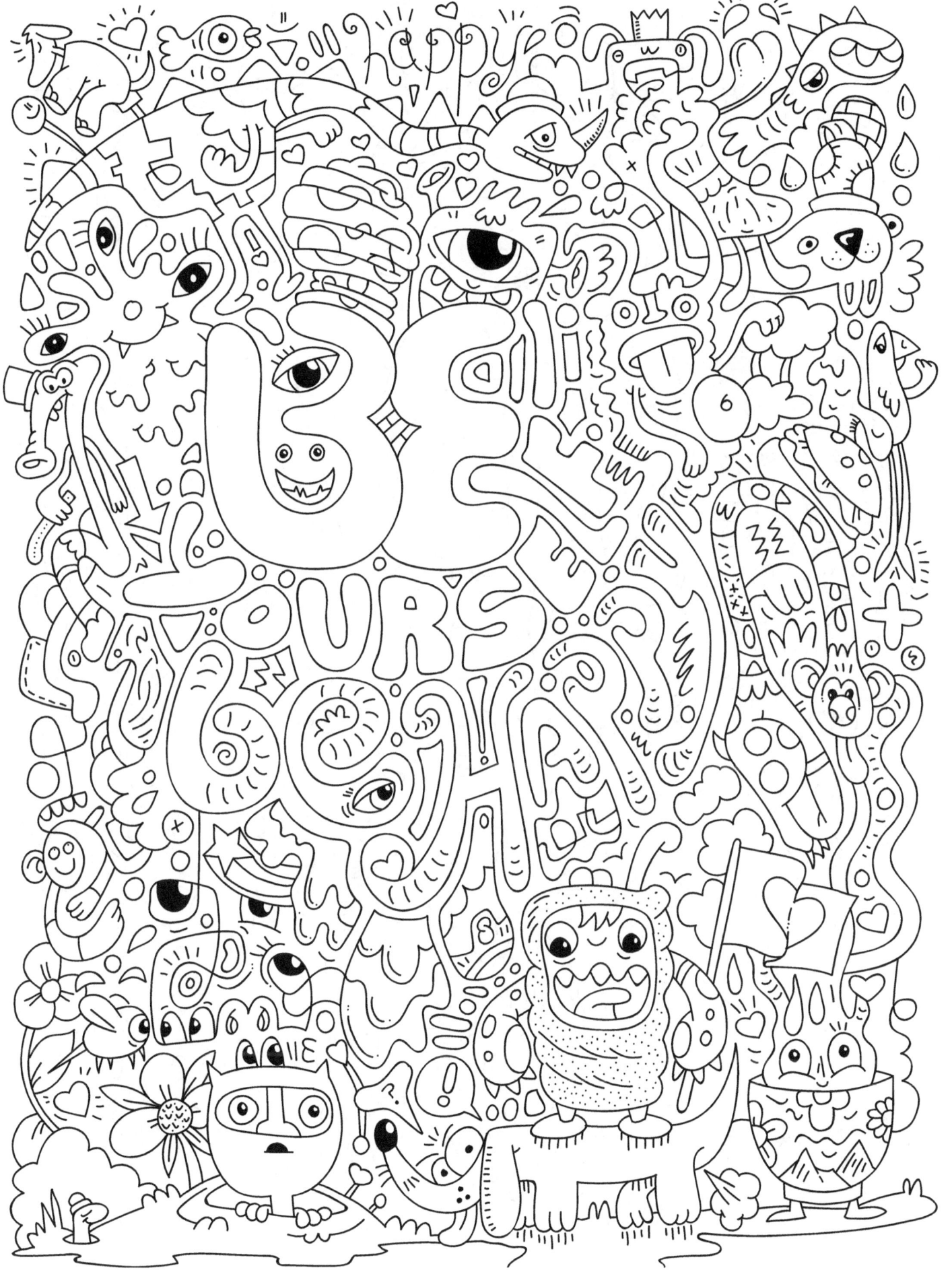

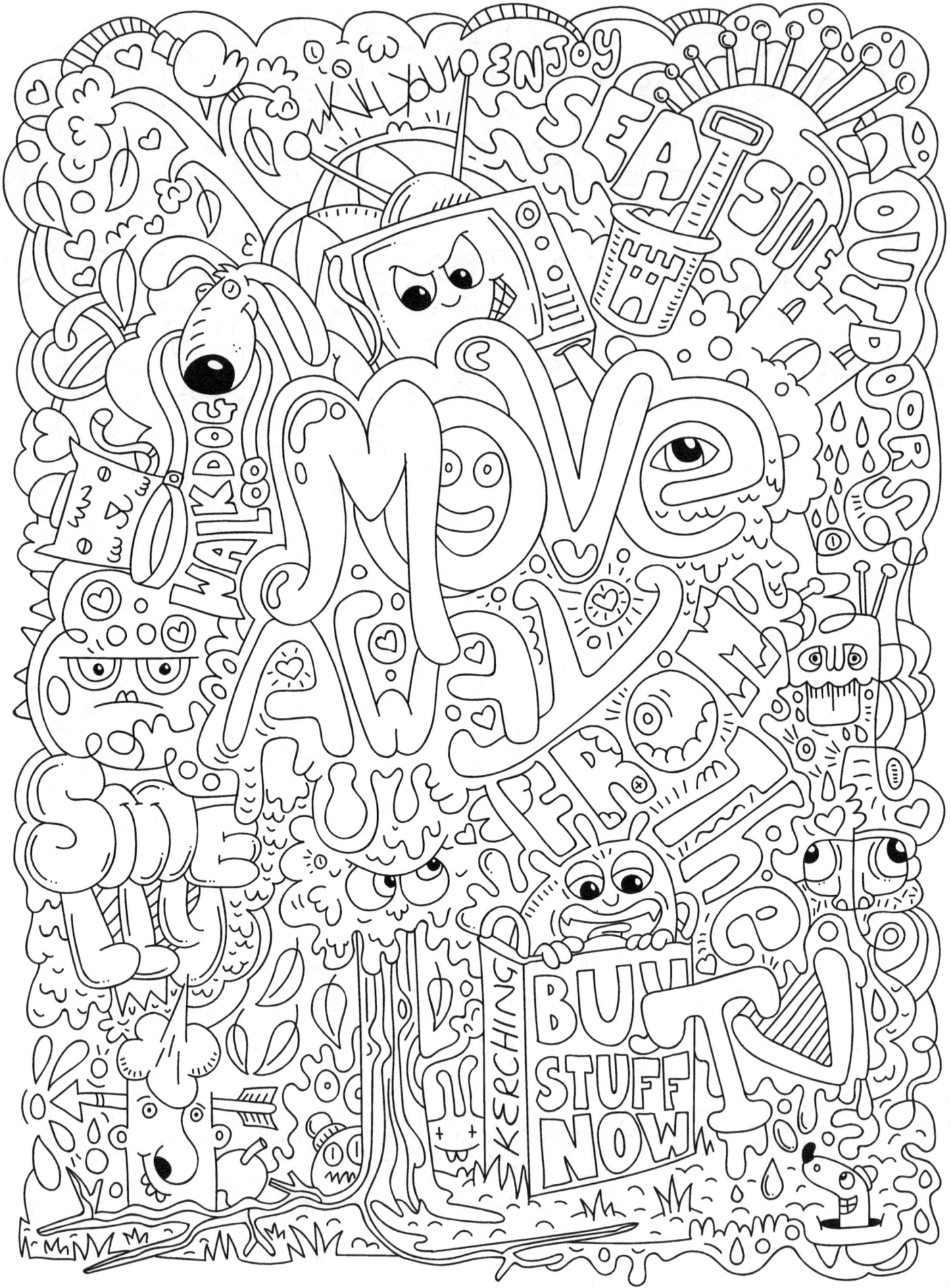

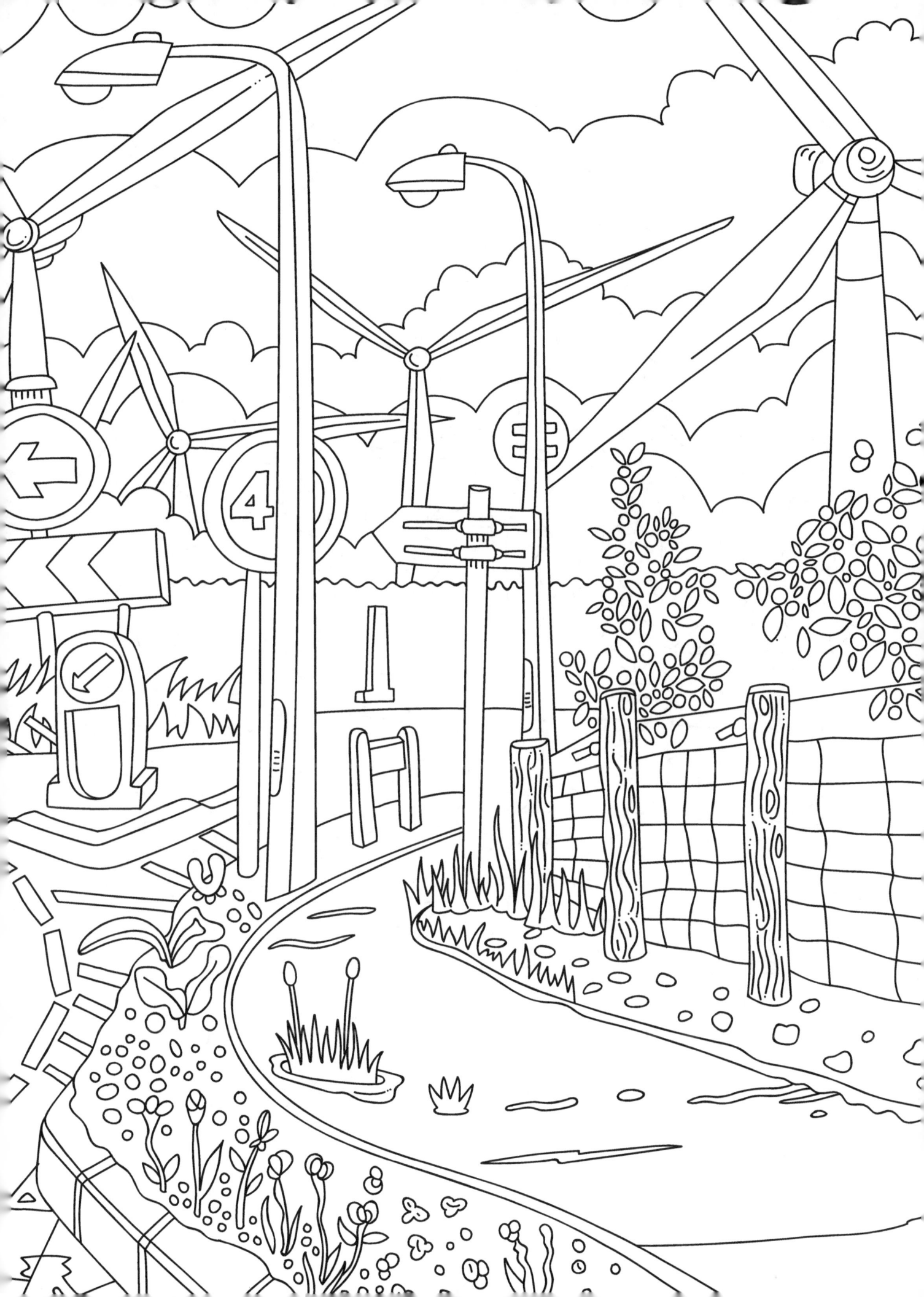

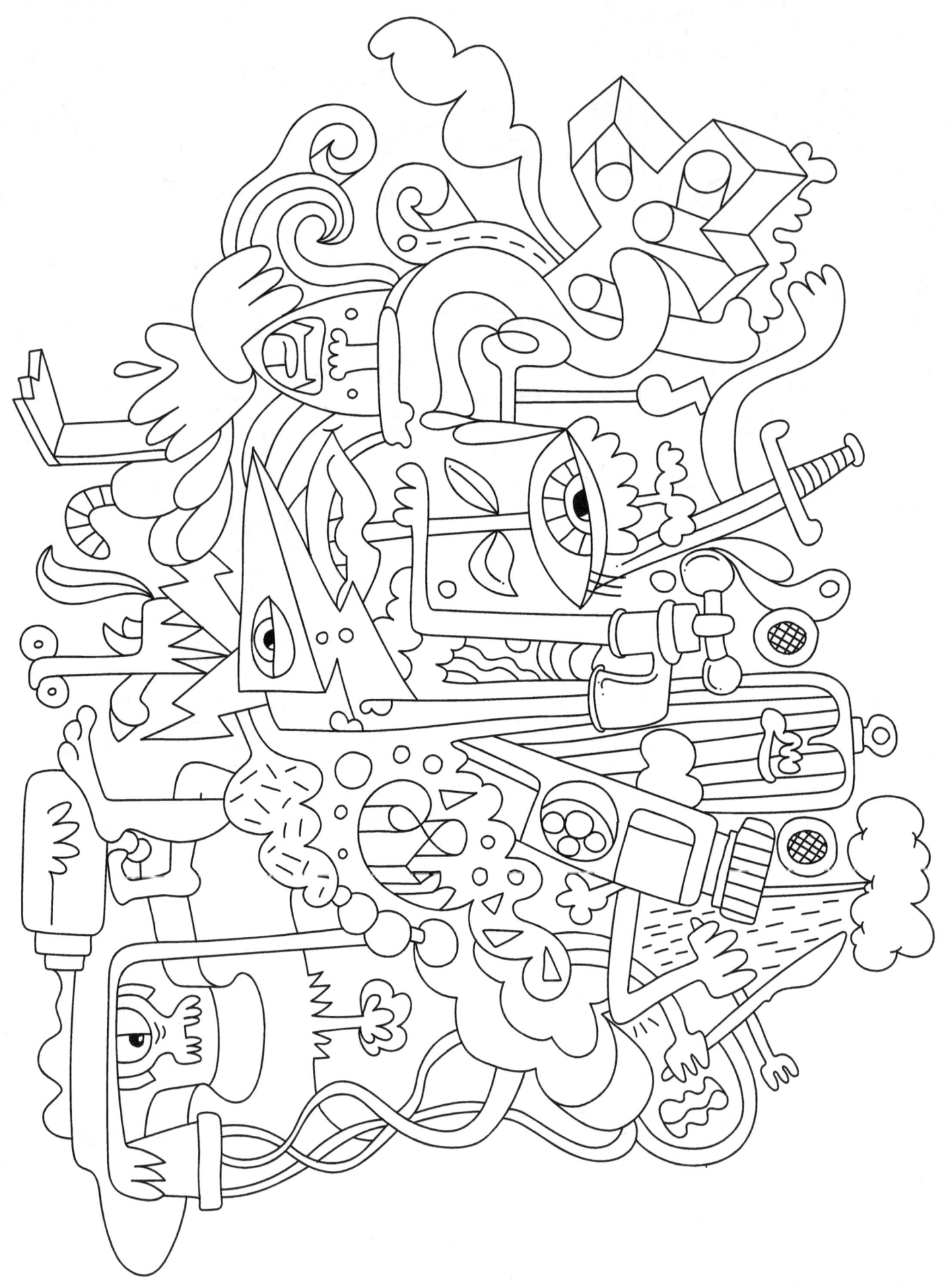

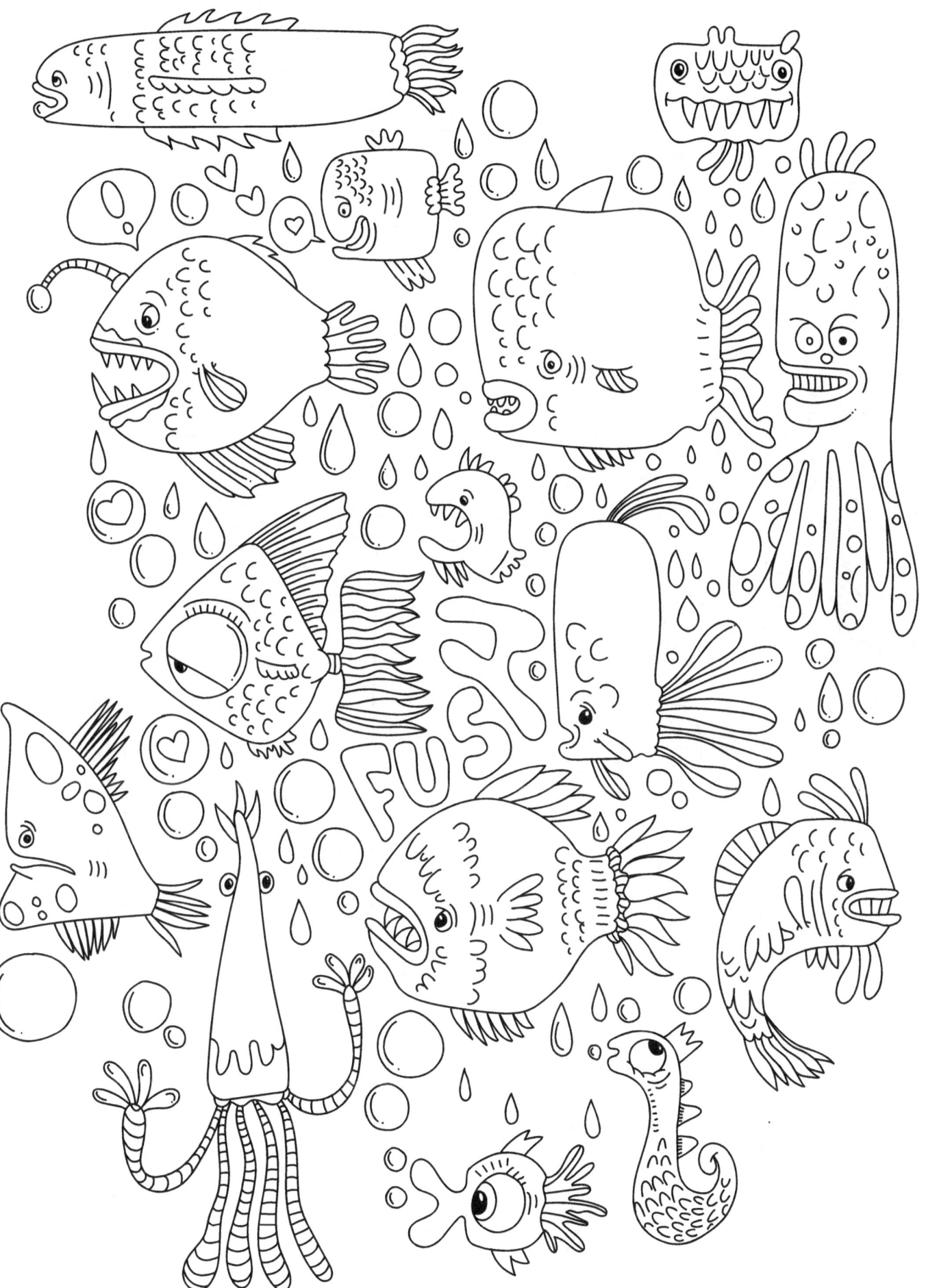

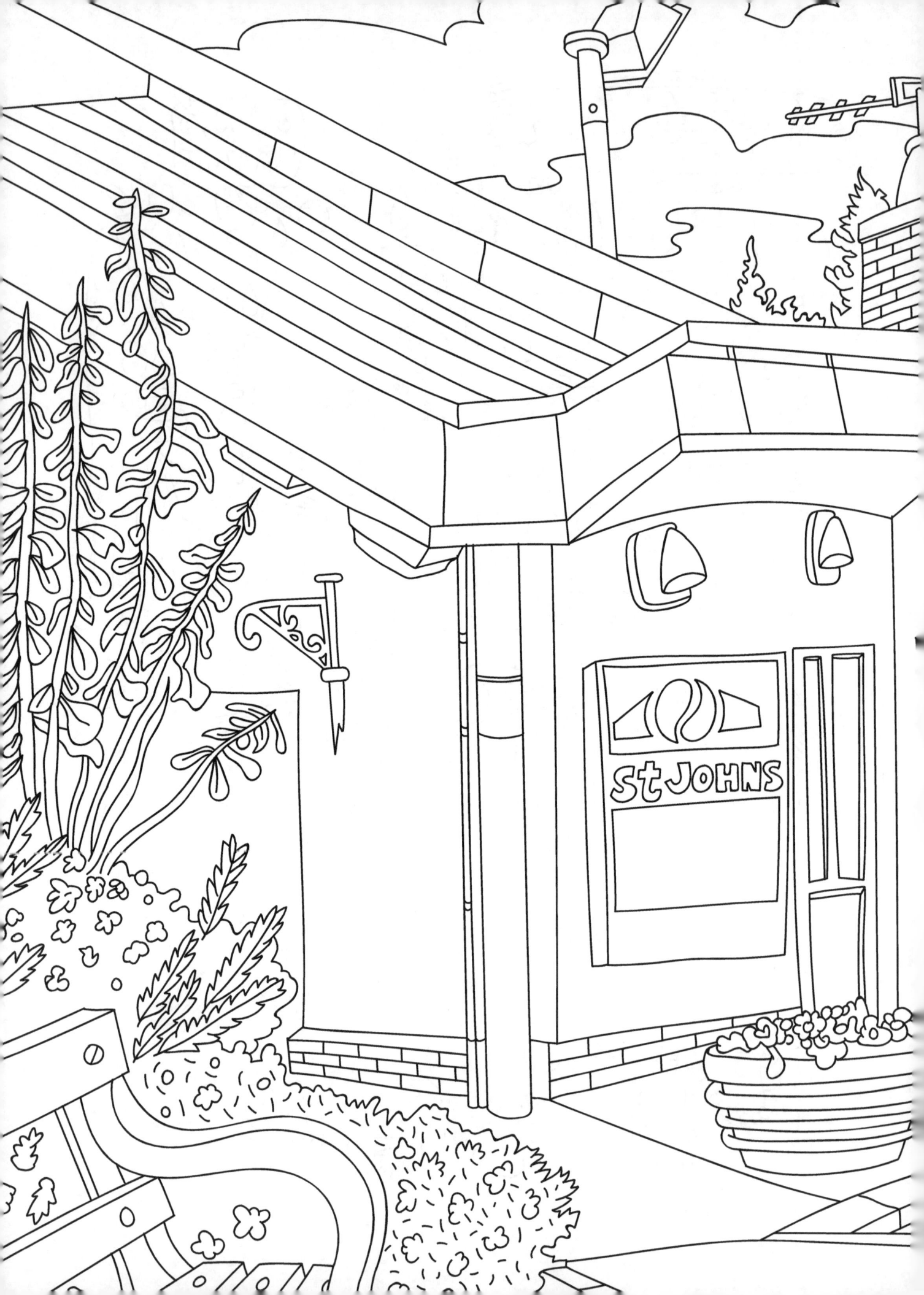

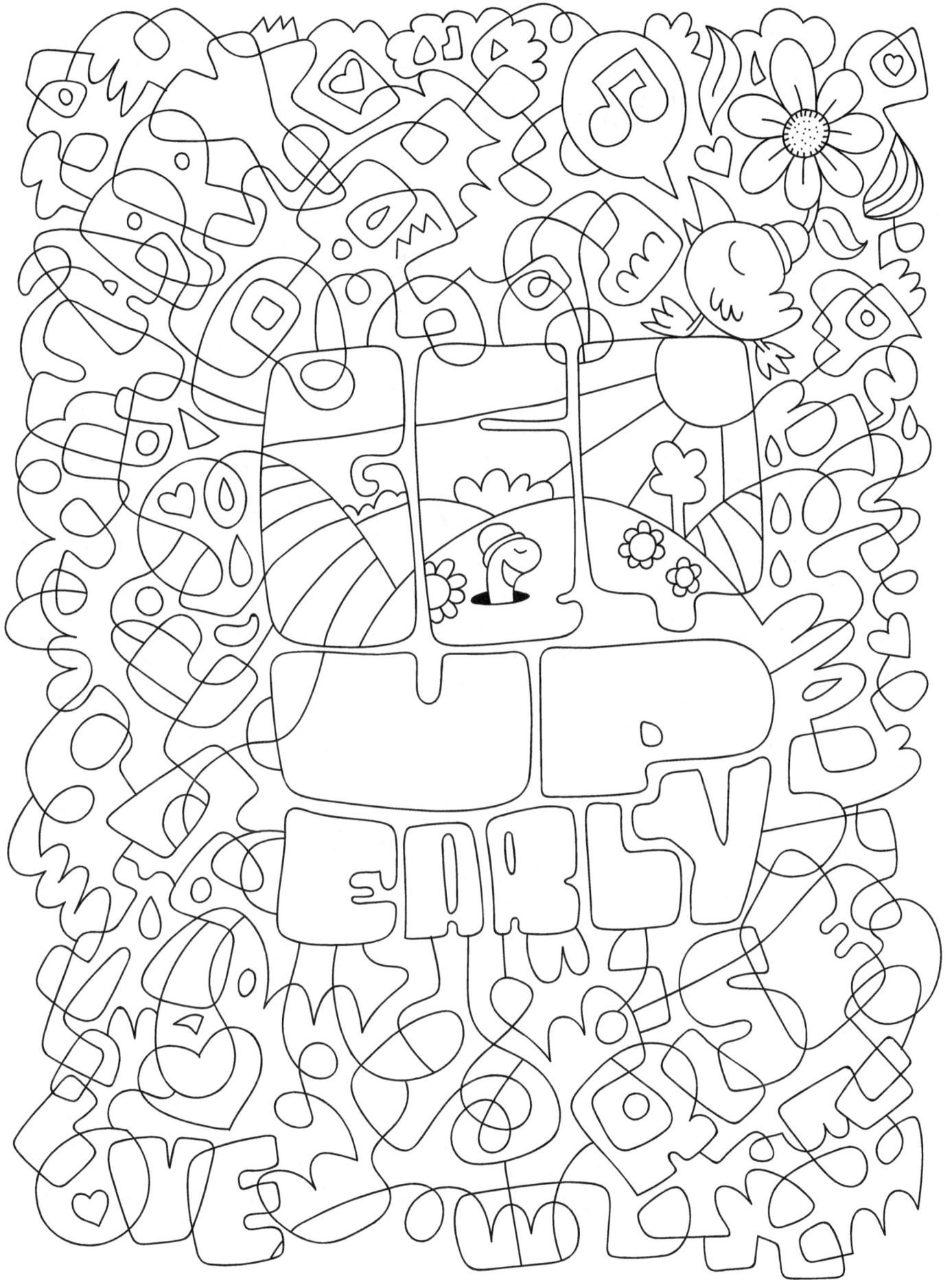

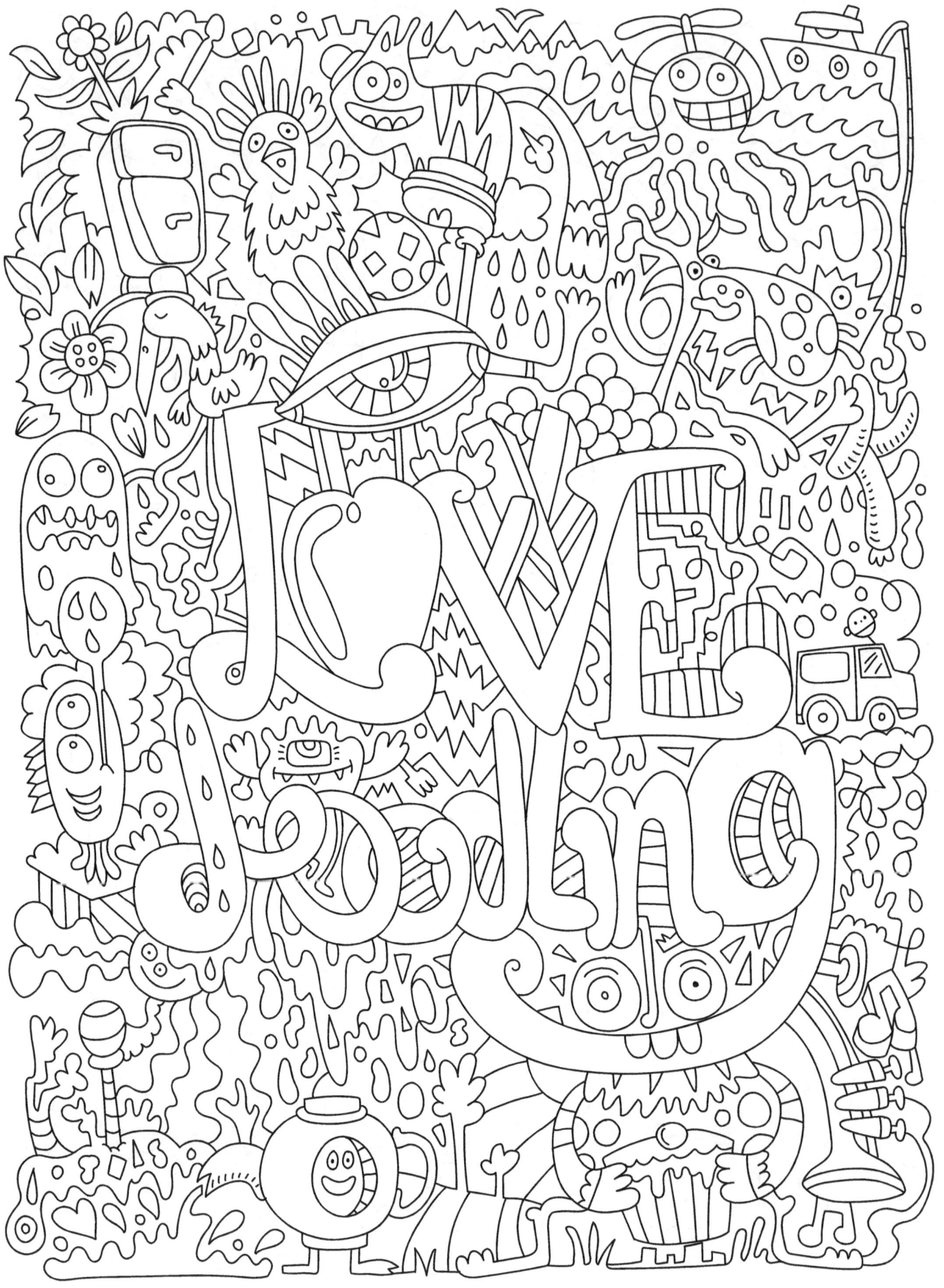

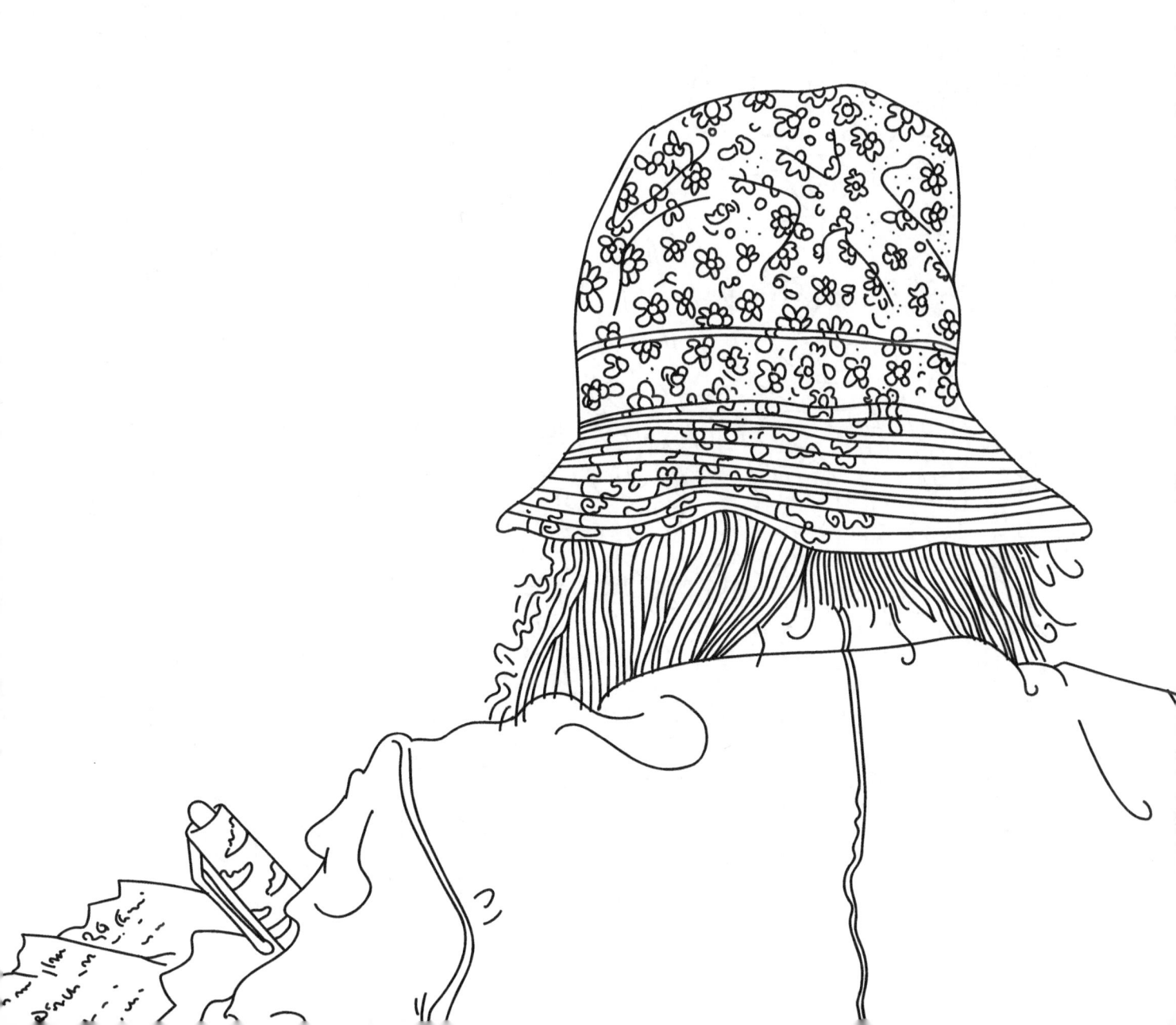

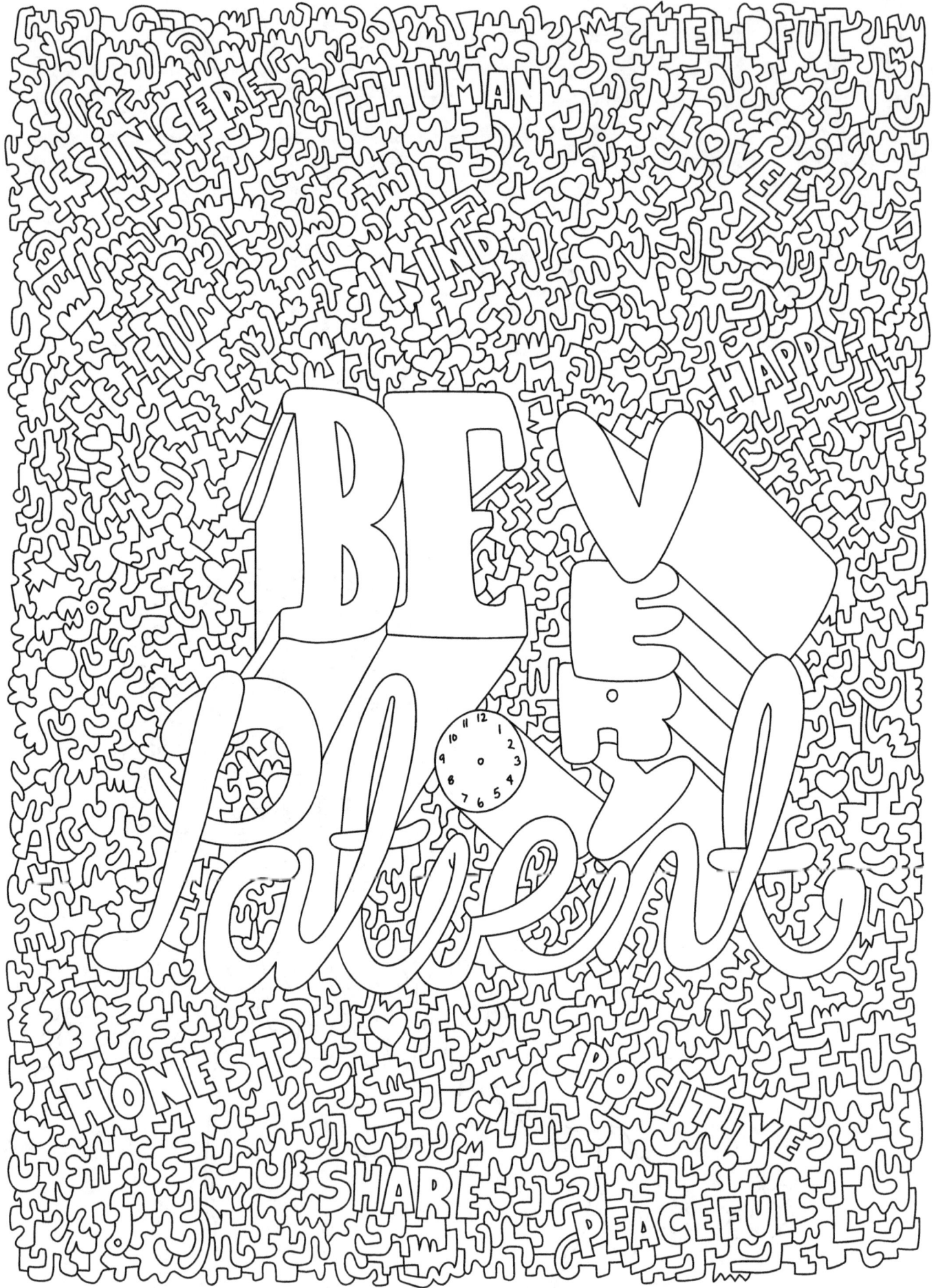

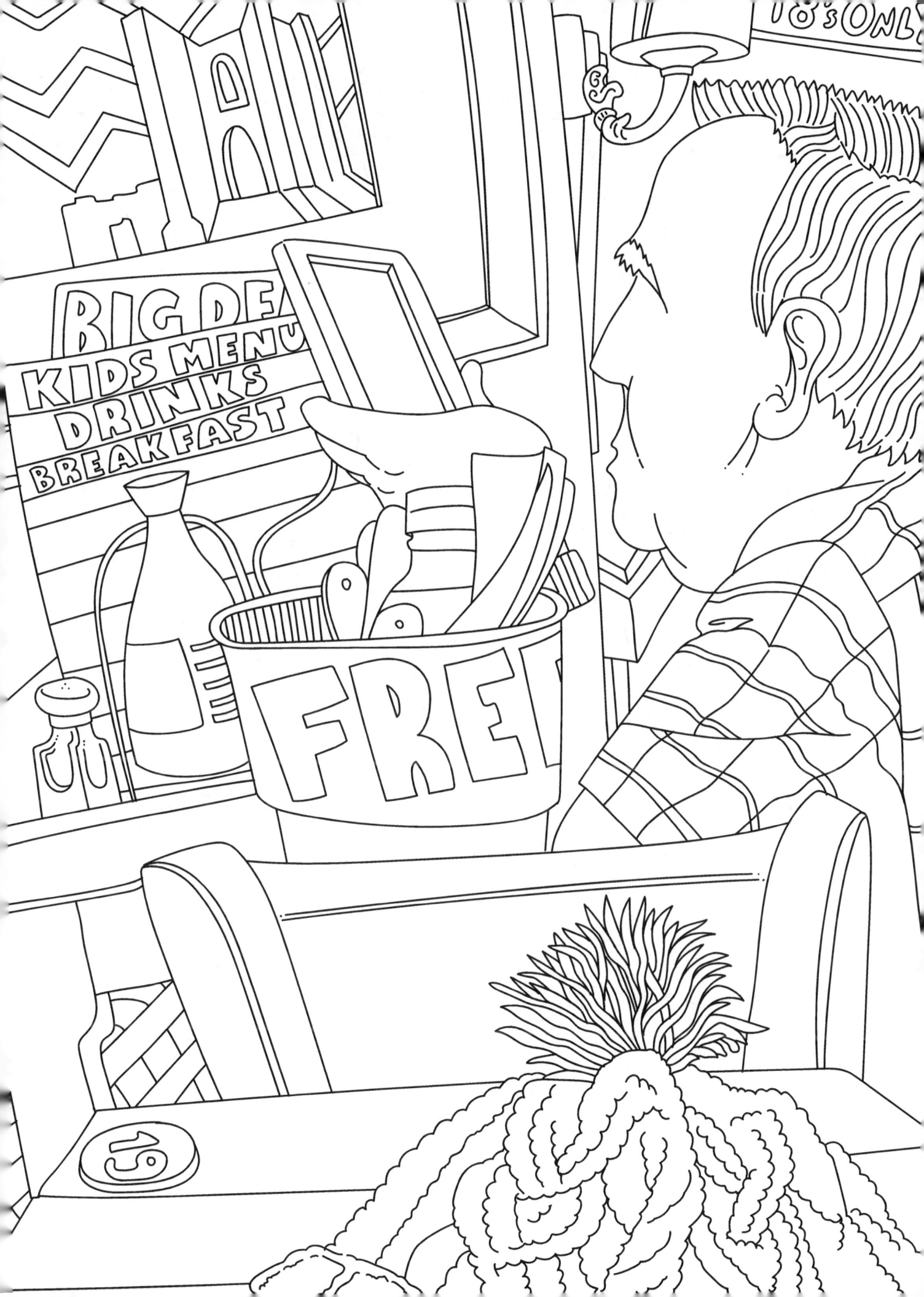

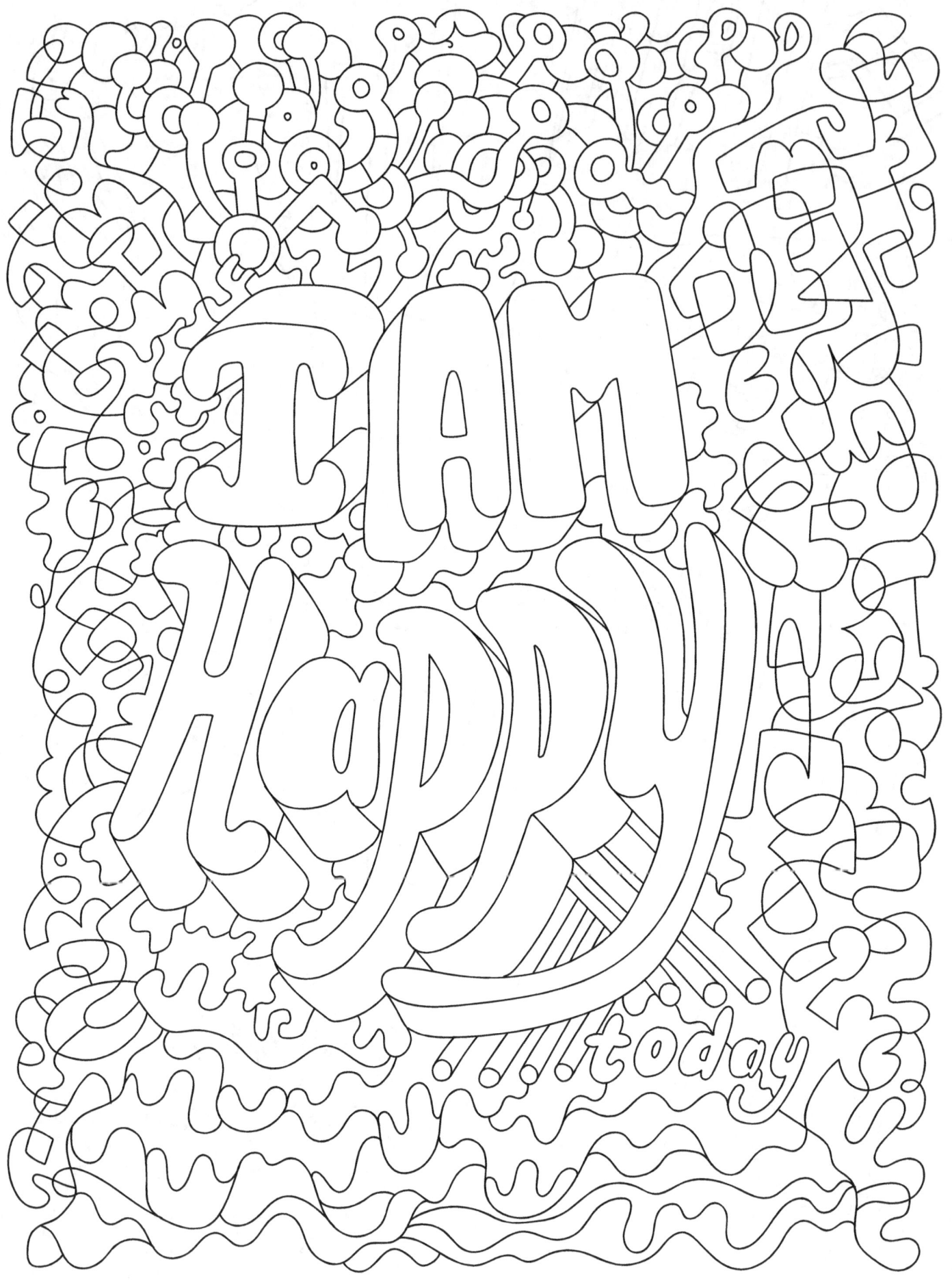

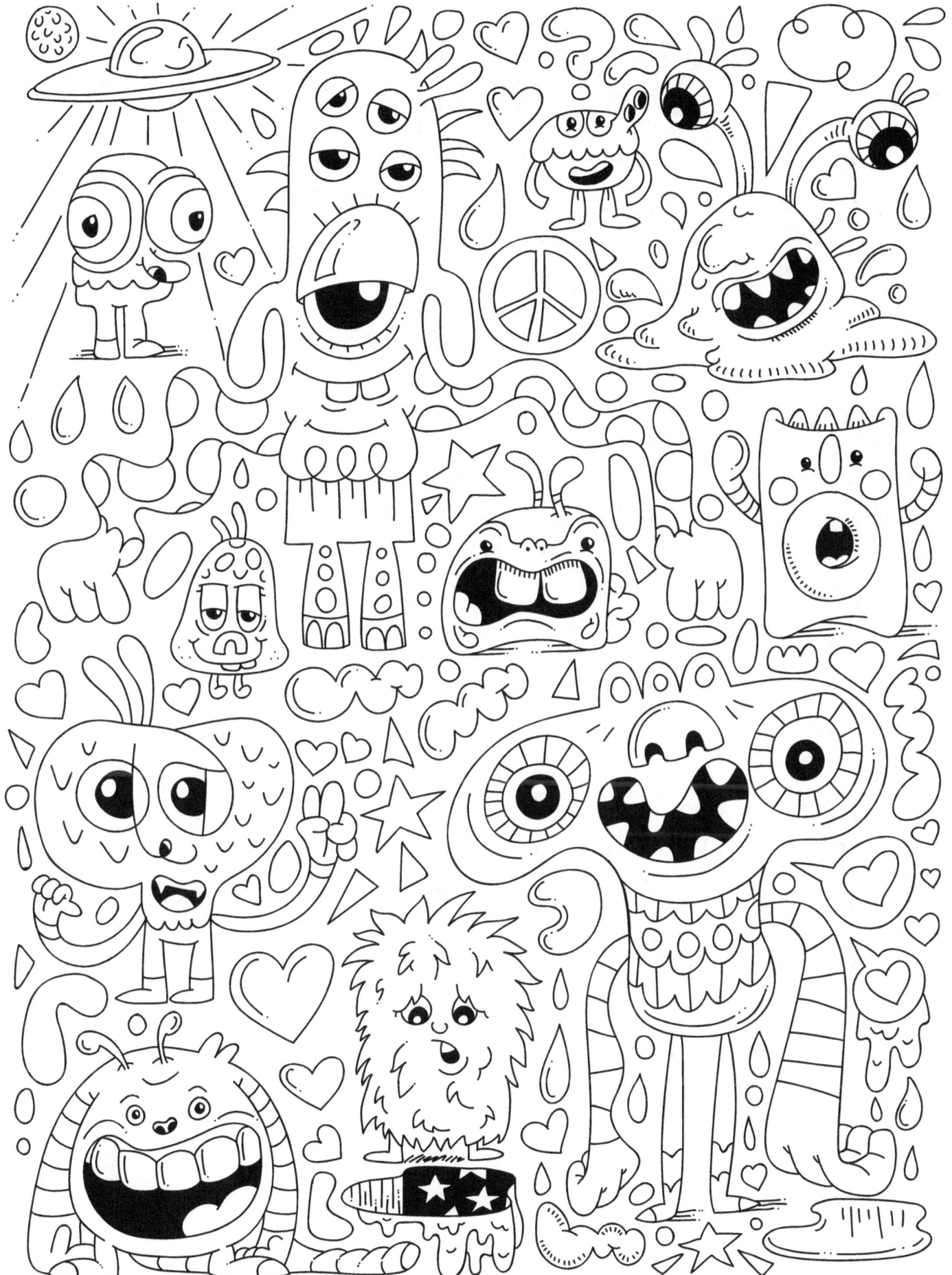

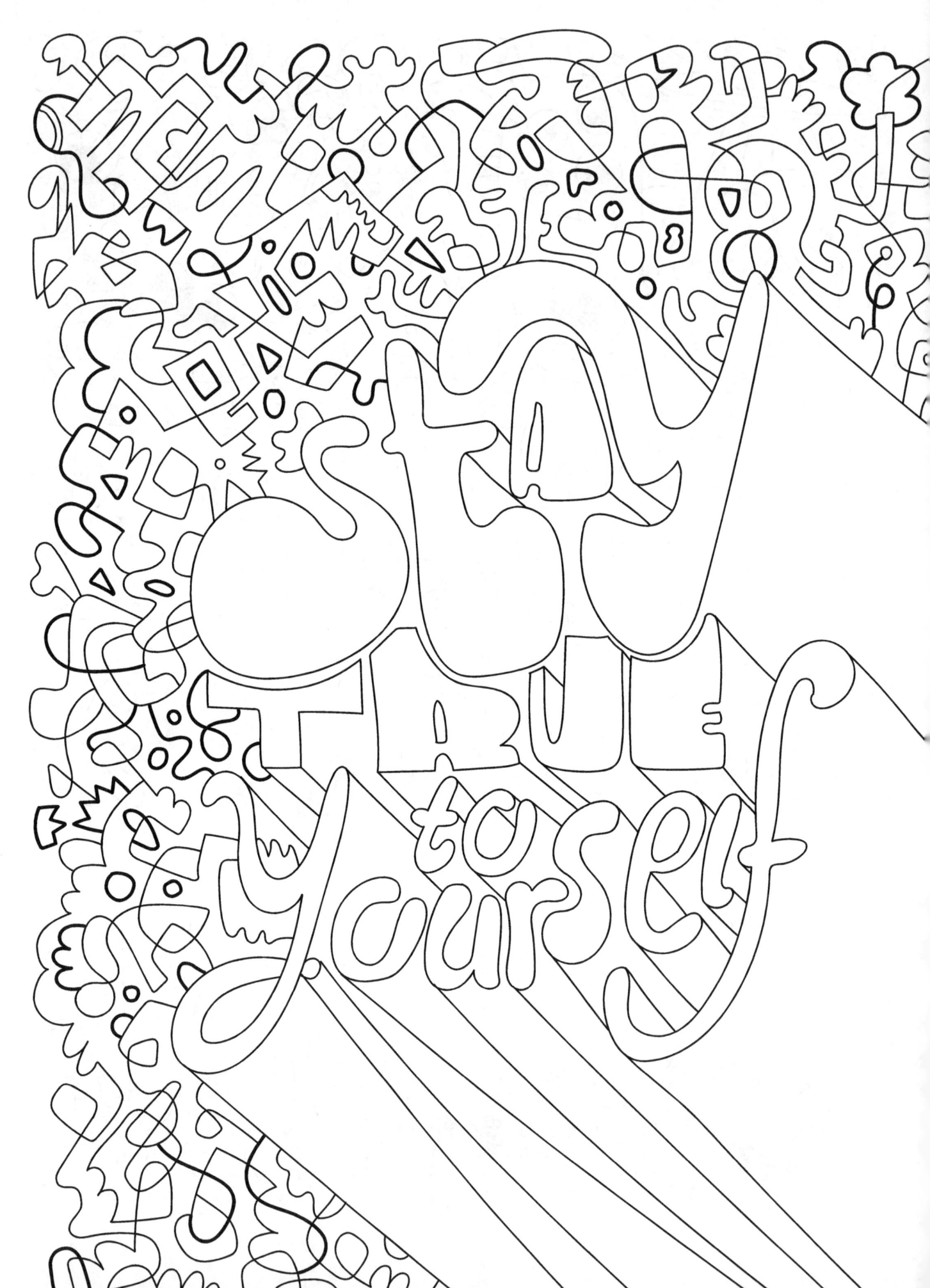

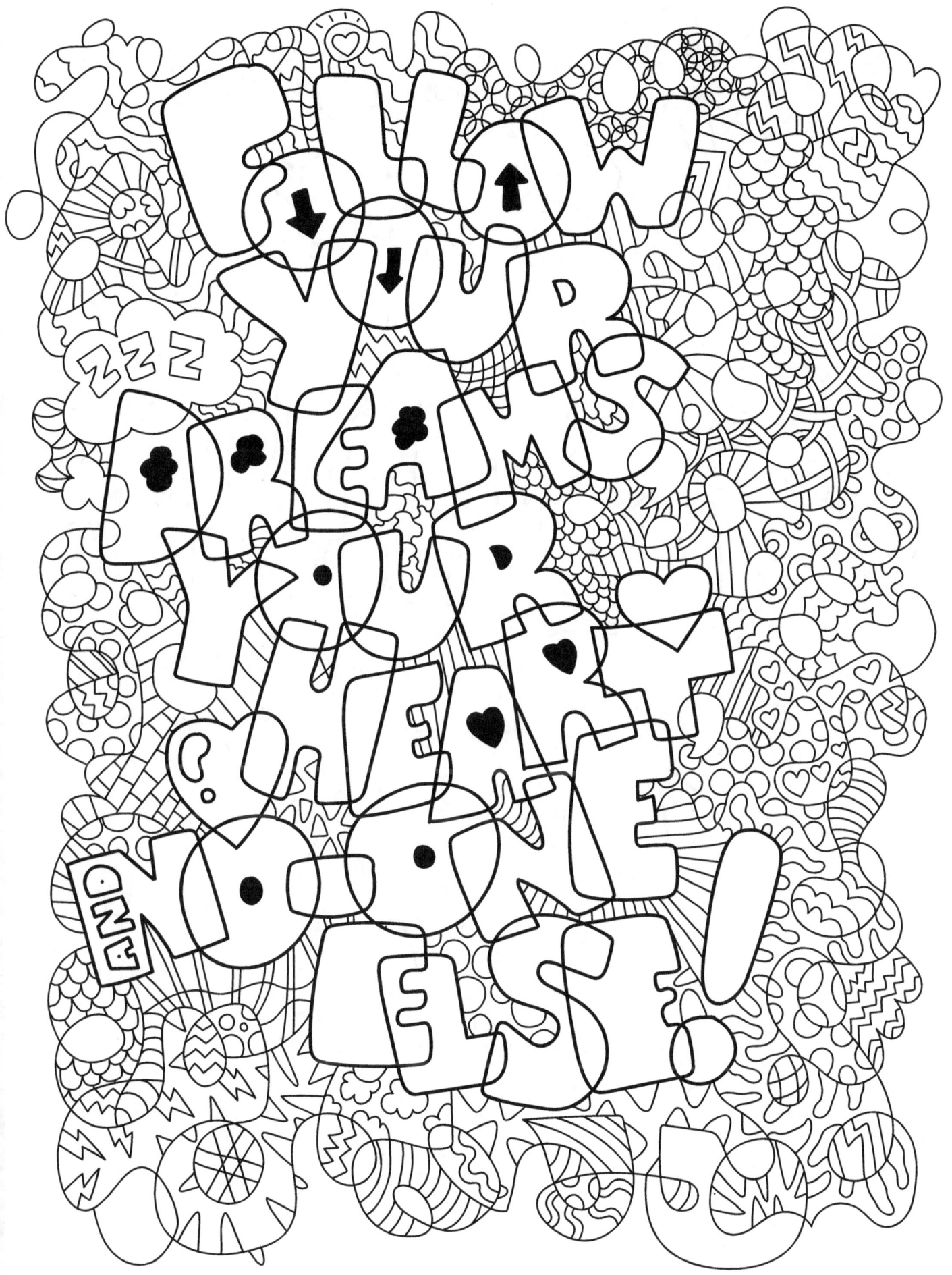

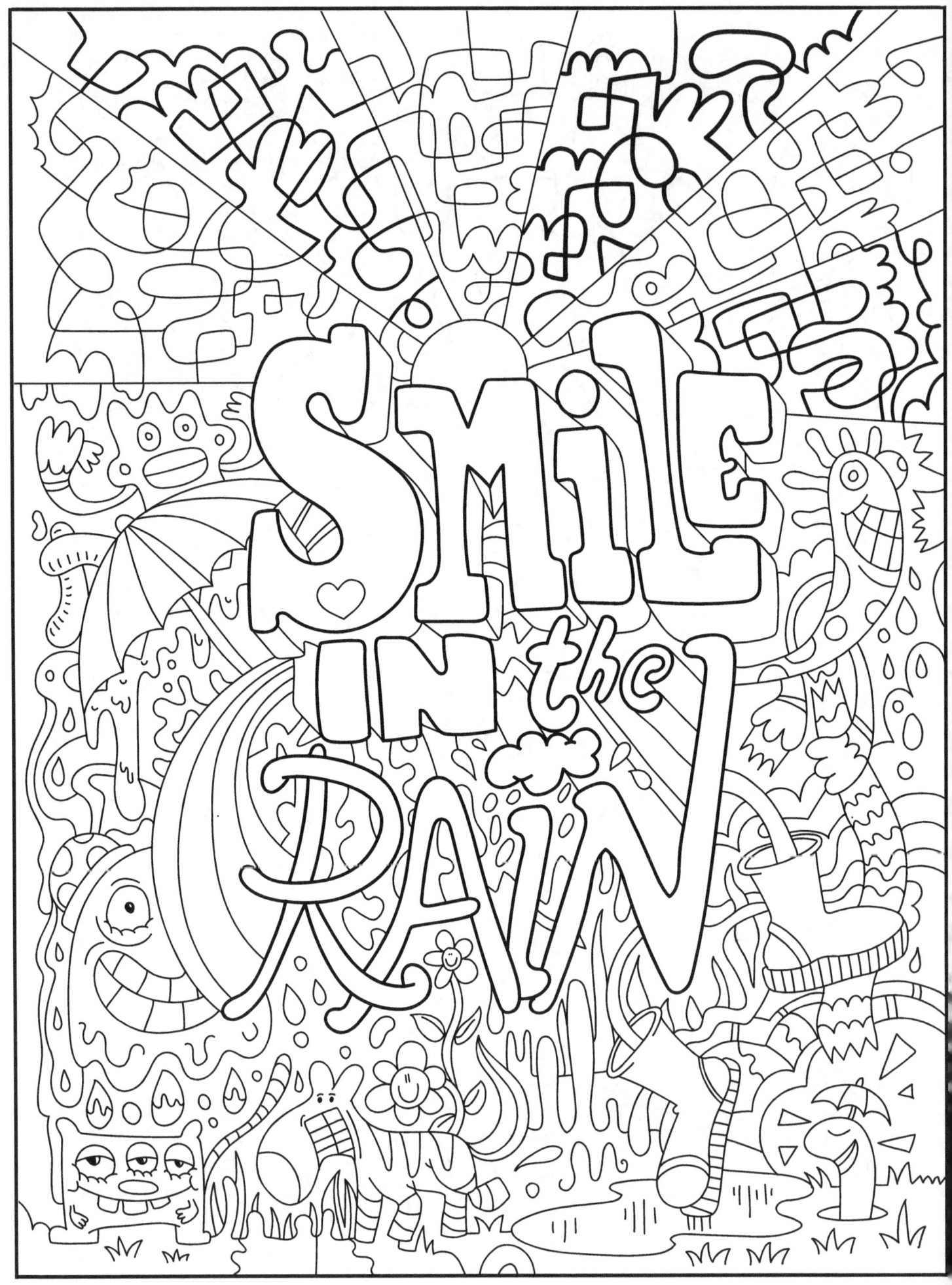

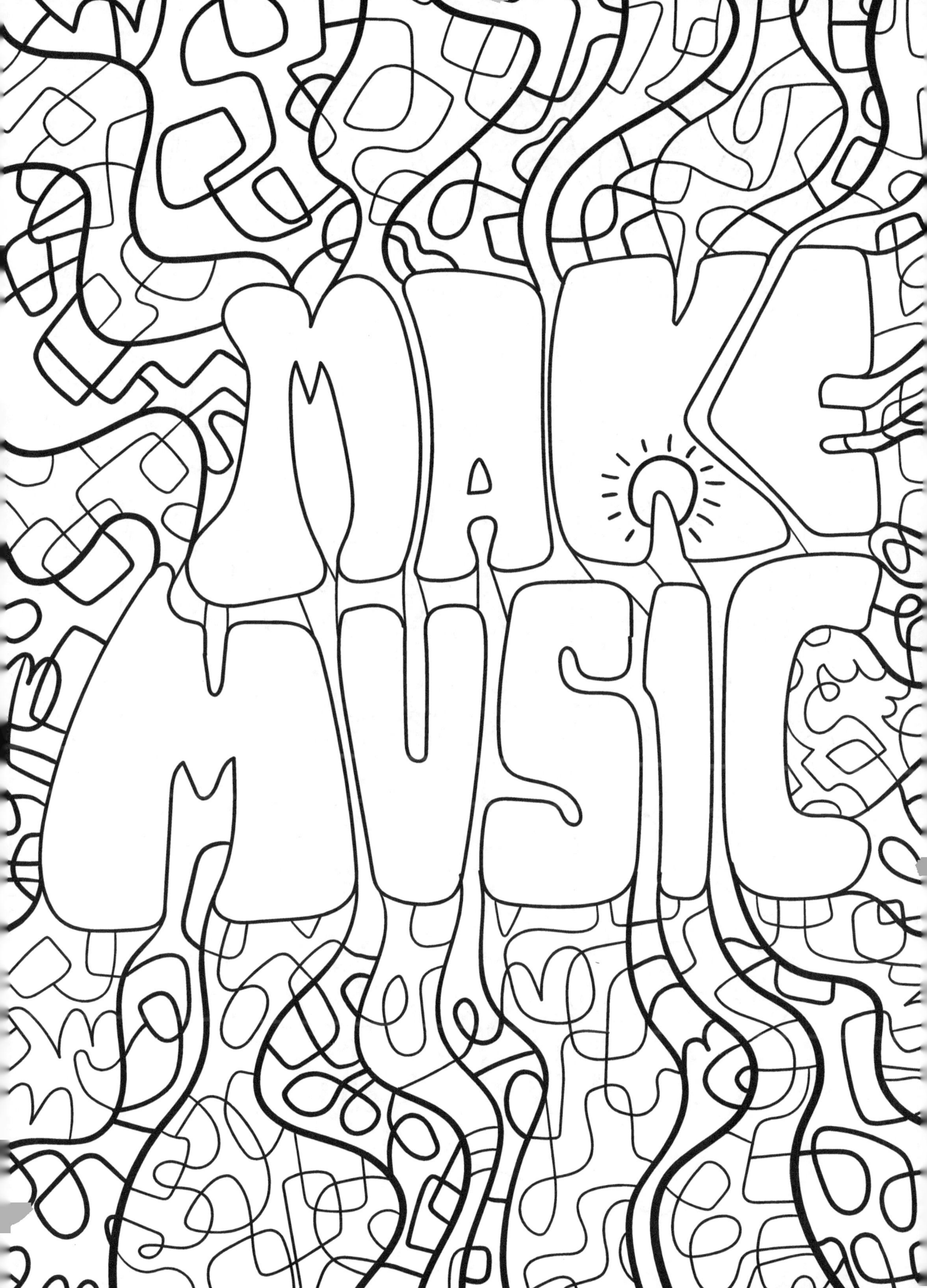

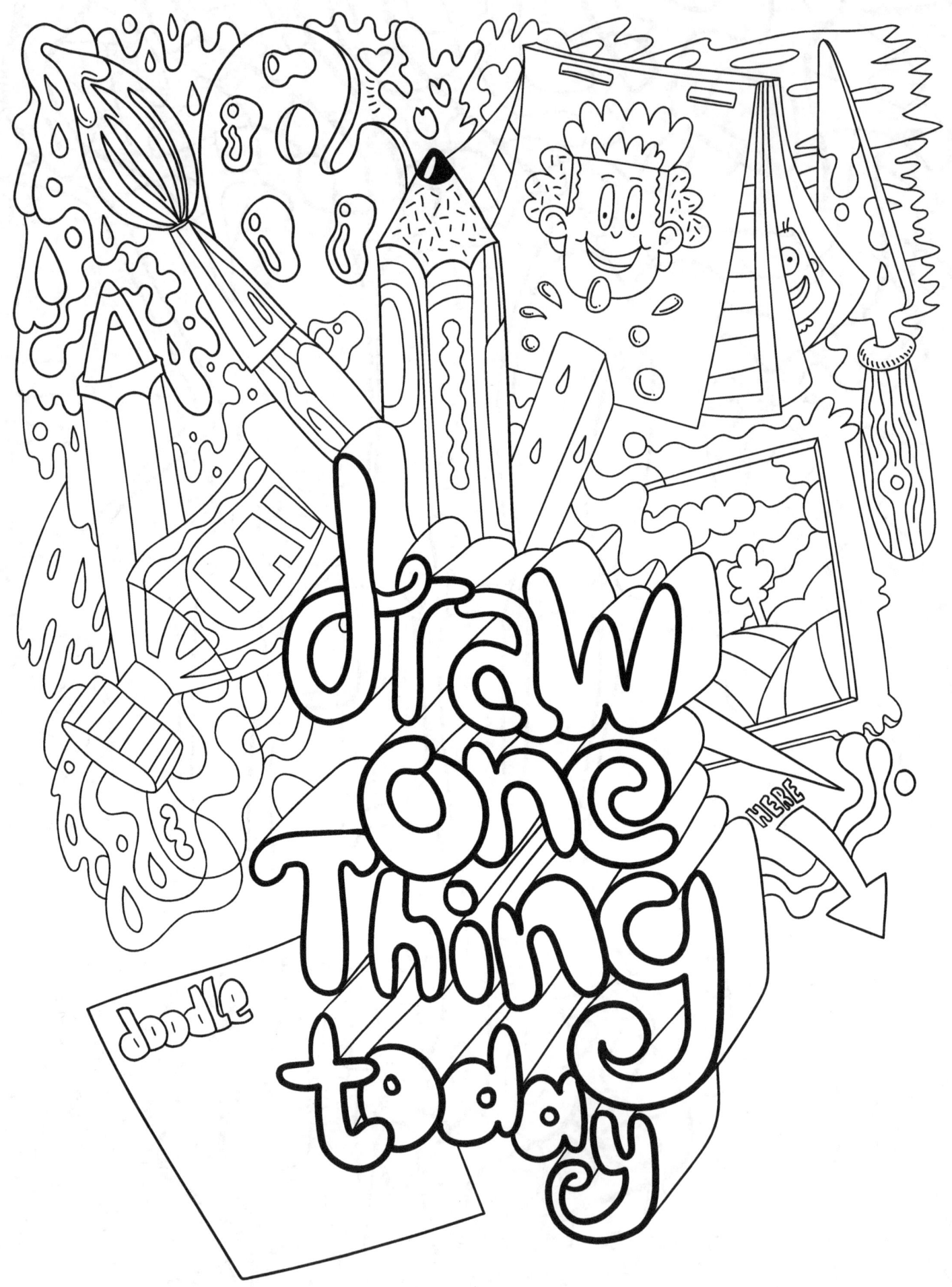

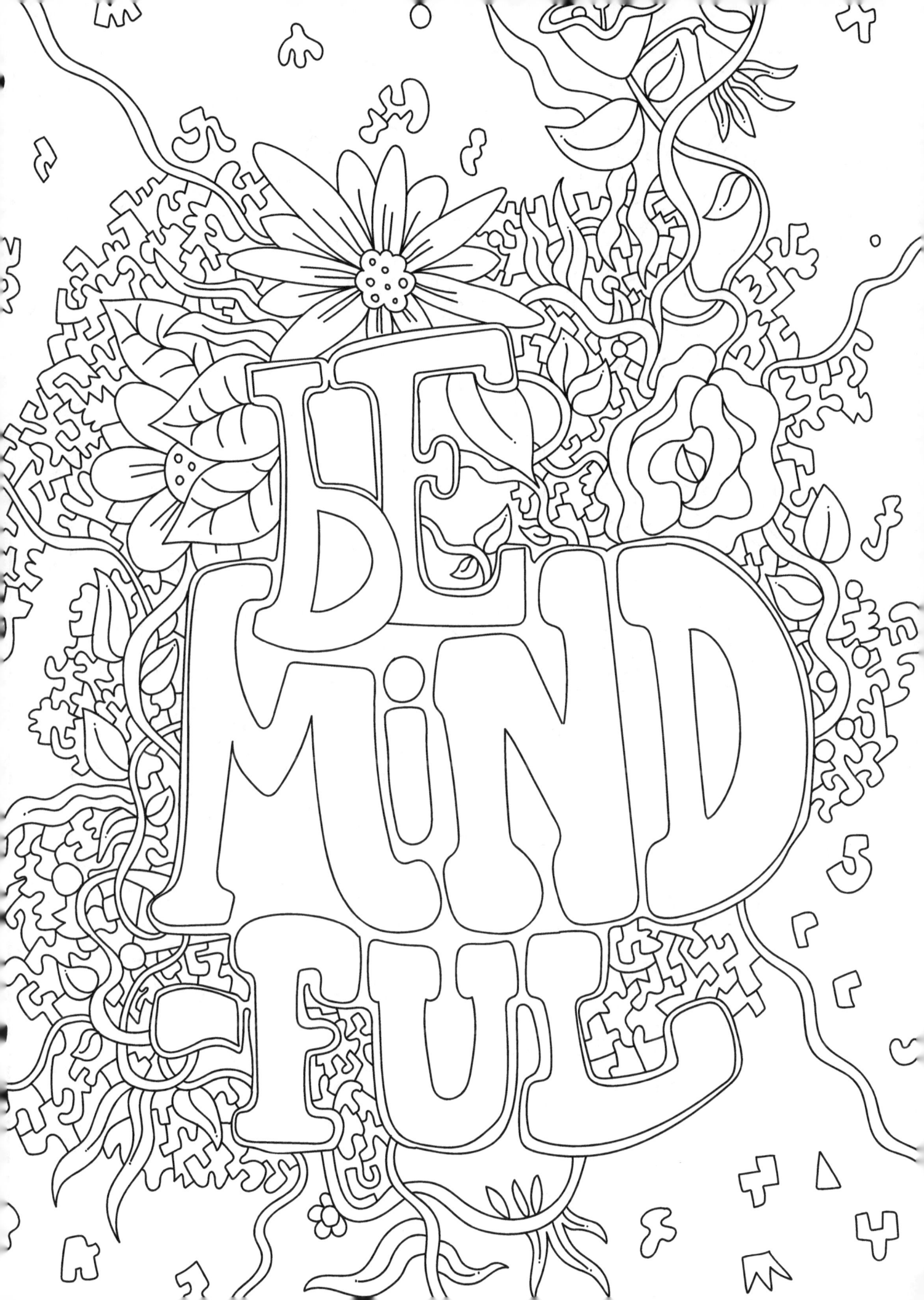

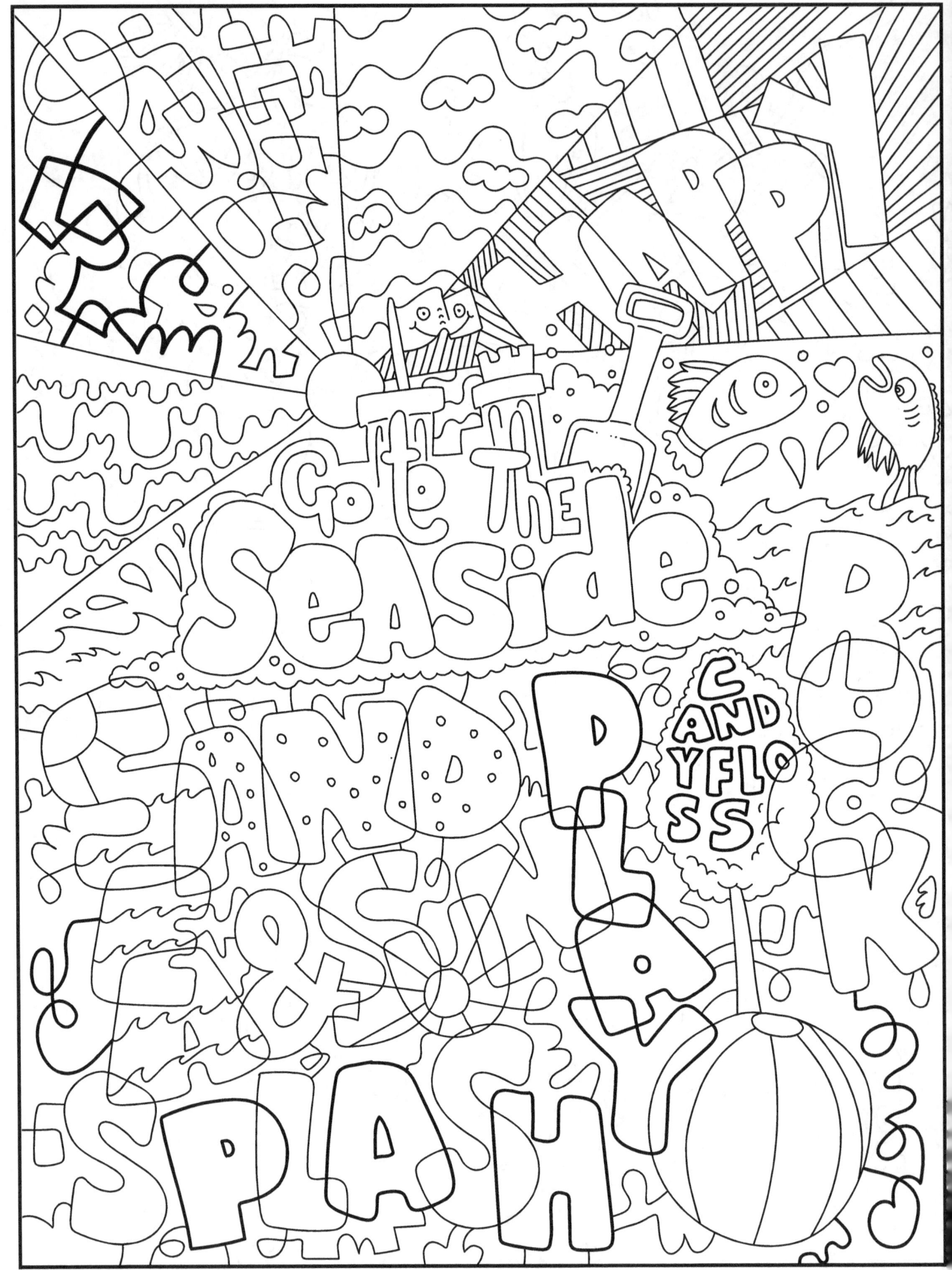

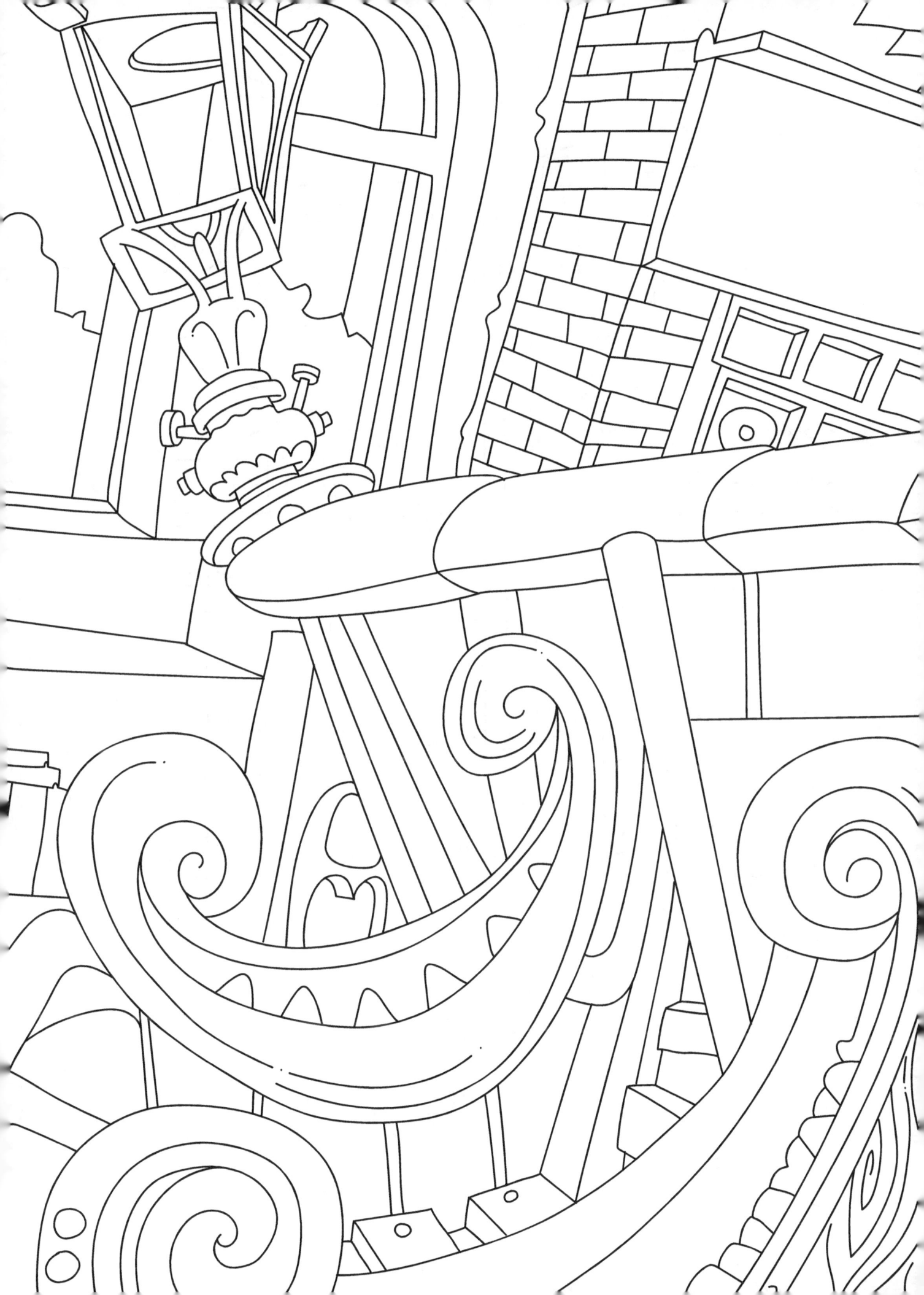

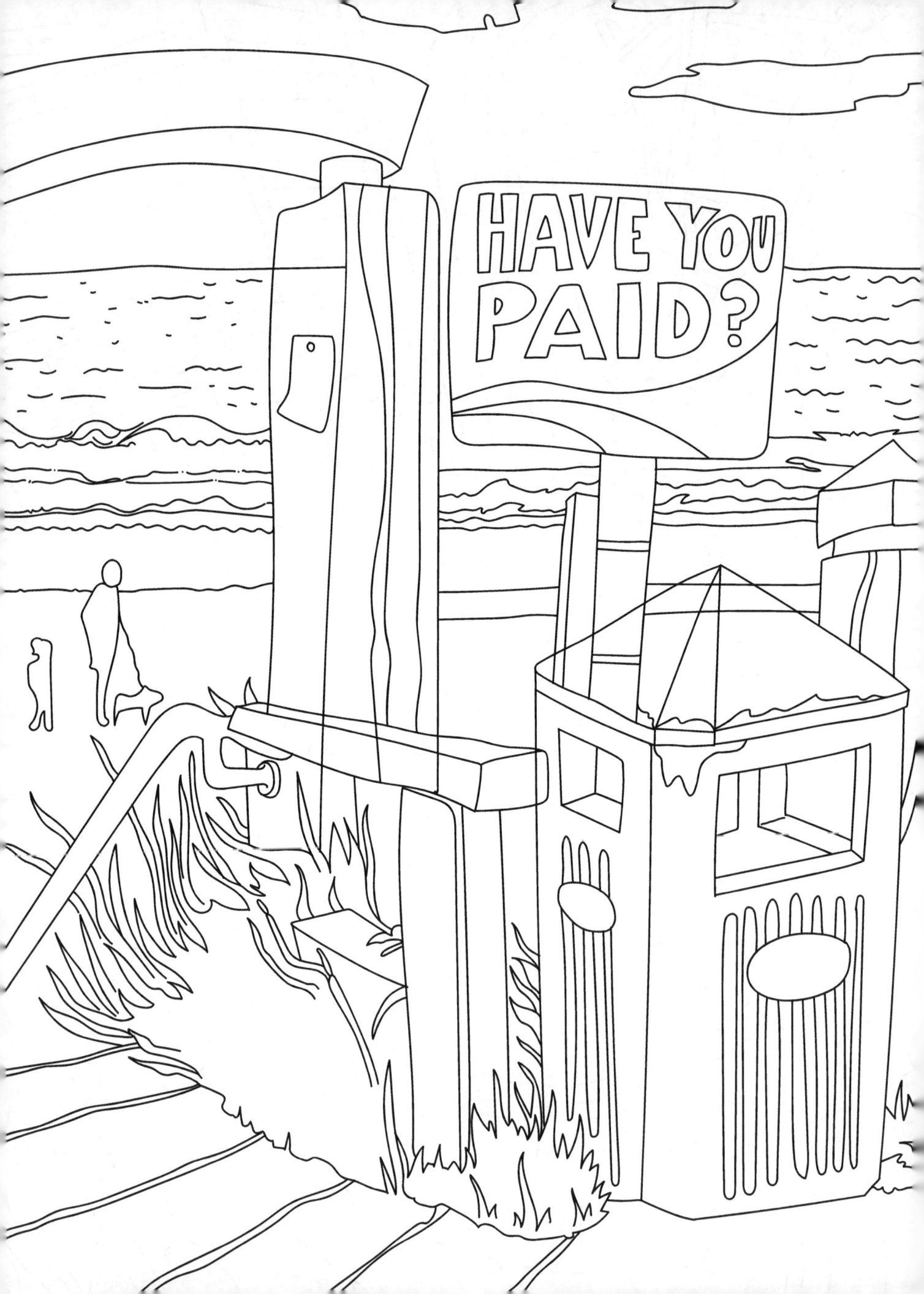

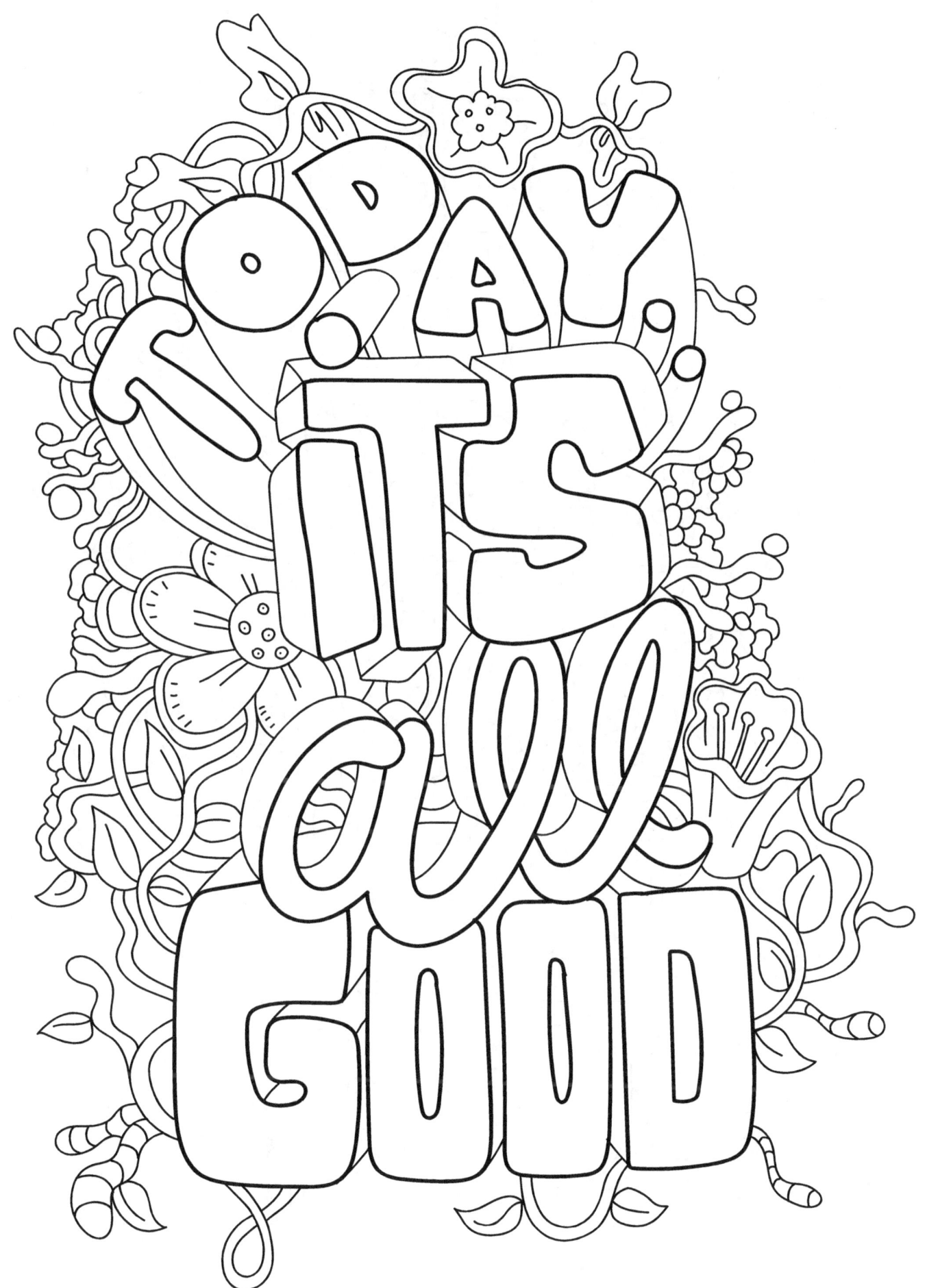

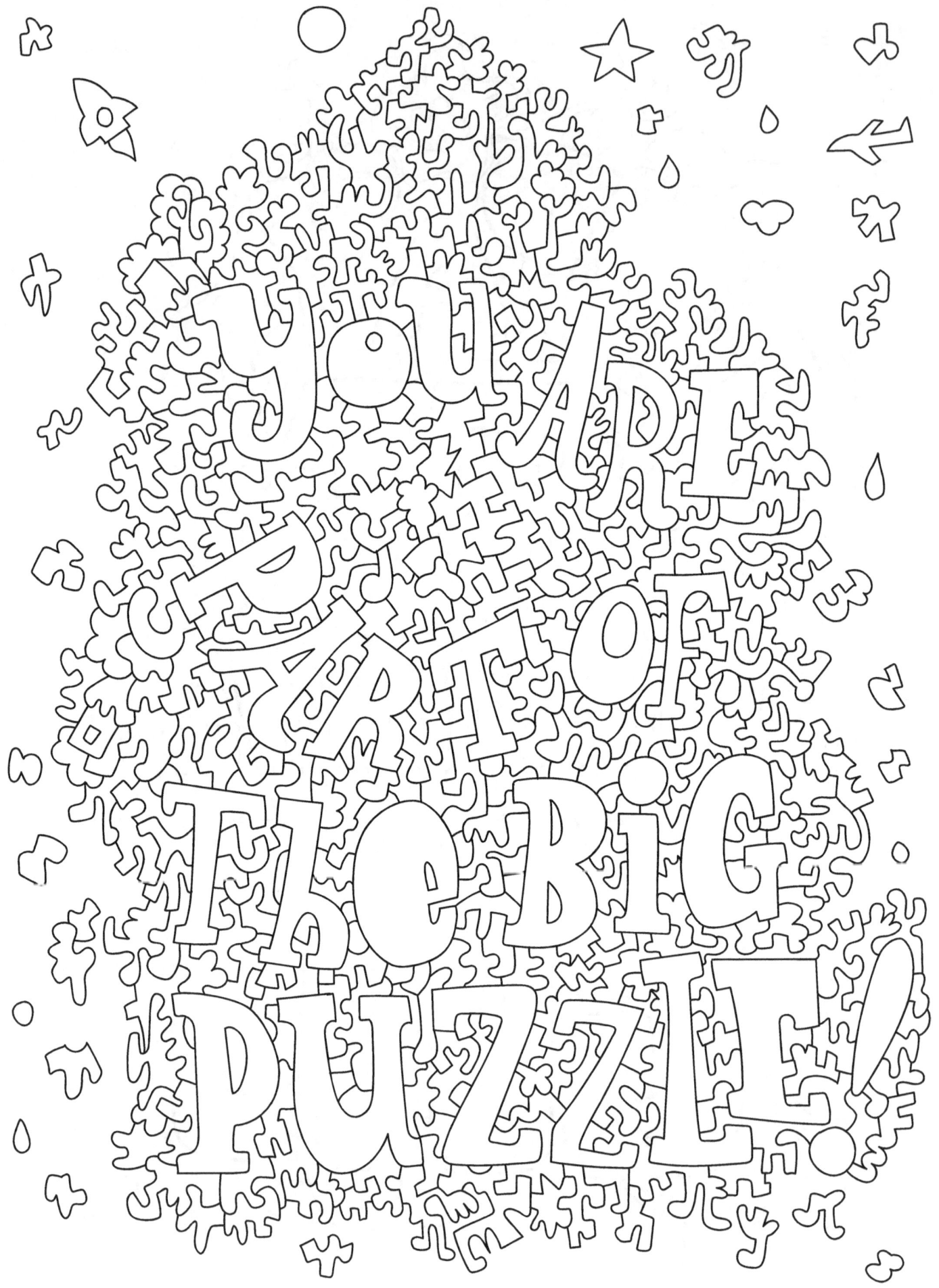

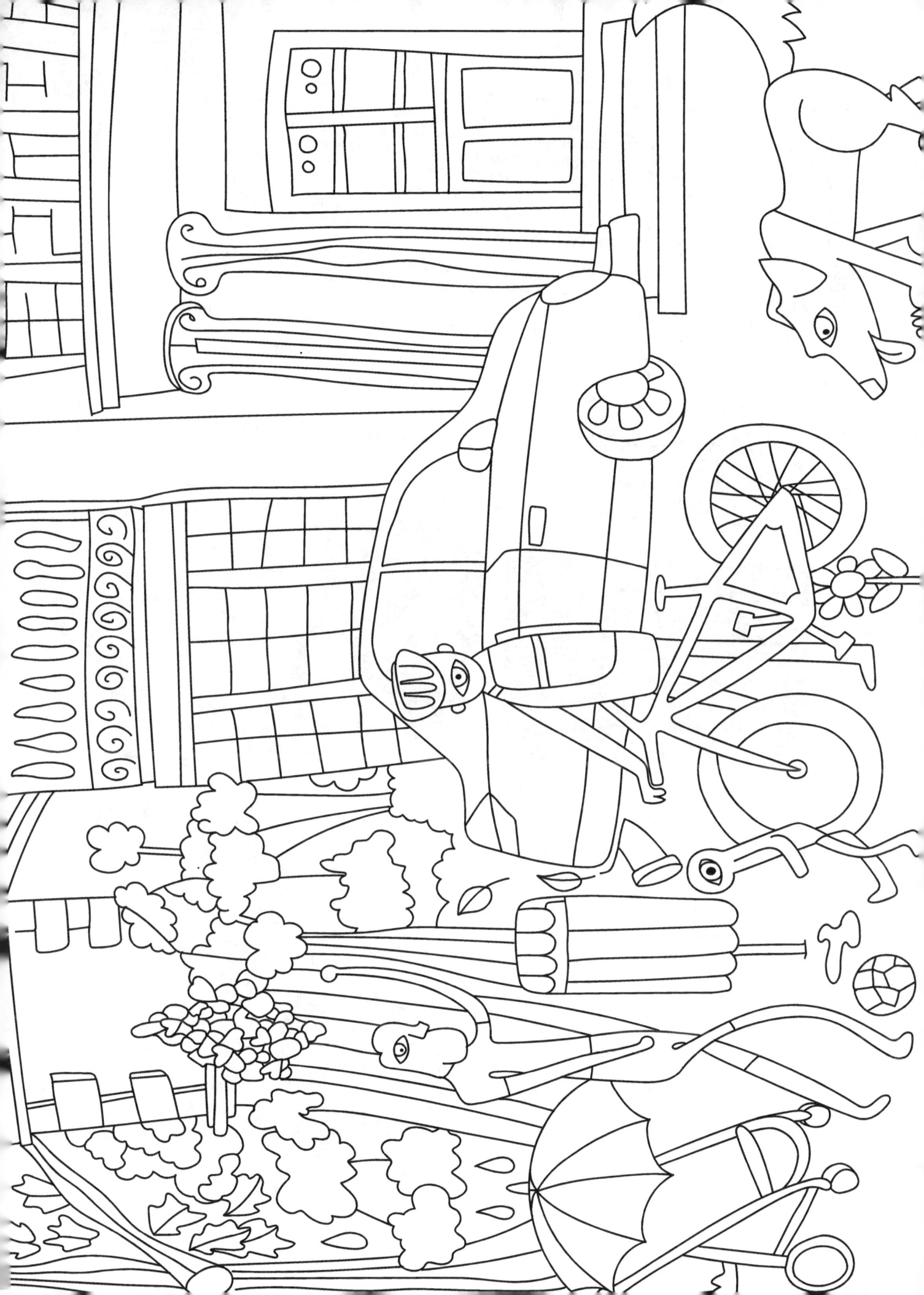

About the artist

"Pete the doodler" has been a graphic designer / web developer and illustrator for over 40 years. At the age of twelve he know what he wanted to be when he grew up. He wanted to be an artist. He simply wanted to create art for as long as he could. Before the age of 12 he doodled on walls, paper, card, napkins ... well anything he could get his hands on, really. He got into a lot of trouble. But it also brought lots of love.

Every weekend he would shop at Woolworths and buy black Berol pens to doodle with. And Doodle he did. Every day and every night. Unfortunately there are no doodles/art left from his past. But since 2011 he has saved every single one.

Peters favourite memories have been through art. It makes people happy and people make him happy when they appreciate his art.

And here is the culmination of only a small sample of that art. Enjoy.

About his art

Peter tries to combine all of the things he likes into his art. Computers, art, walking, doodling, peace, bacon, noodles, animals, cars, love, lasagne, cheese, fish, worms, snails, happiness, cartoons, silliness, doodles and eggy bread.

How is Peters art created?

Firstly, he doodles subconsciously in his Rymans sketchbooks. Letting his favourite UniPin brush pens wander and search the page for weird and unique ideas from the corners of his mind.

He is lucky enough to have a tablet and he loves to use it to complete his illustrations and add all the bright colours you see in these pages.

And finally, he goes onto his computer to create the books and finished art prints ready for his fans to buy and collect.

Where is Pete?

He is usually in his van Doodle, but if you want to find his art, you can find it here.
petejarvis.co.uk
thedoodlemonkey.com

Scribble Mouse

What else have I been doing?

I do not rest from being creative and arty. I have been creating my colouring books, NFT's, merchandise, children's picture books and doodle art for the last fifteen years for this book and other projects. Support my by scanning the QR codes below with your smartphone camera and visiting my creative websites and product sites.

AMAZON	REDBUBBLE	WEBSITE	THE DOODLE MONKEY

The future

I am working tirelessly on a new range of puzzles, art books, sticker books, art prints, 3D models of my characters, new colouring books, an NFT book and much much more. Please keep up-to-date, and let me know what you think to my crazy creativeness.

Social Links

 /doodlerpete

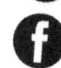 /thedoodlemonkey

Final words from the artist

You are helping me fulfill a life long dream of creating 1000 doodle colouring books, for everyone to colour, collect and enjoy.

All of my illustrations are hand-drawn, in his sketchbook, from my subconscious. They are true doodles. They are completely unplanned. He does not know what he is going to draw from one doodle to the next, which makes every single colouring book completely different from the previous issue.

I wish you a huge thank you and I hope you enjoy being on this amazing journey with me. It's certainly going to be a colourful and interesting ride.

Please, follow, share and like my work on these social platforms to receive exclusive doodle art and colouring pages before they are printed.

www.ingramcontent.com/pod-product-compliance
Lightning Source LLC
Chambersburg PA
CBHW080624190526
45169CB00009B/3282